JANE NICHOLAS

is one of the world's leading embroiderers and has worked in the field for over thirty years, specializing in stumpwork and goldwork. She has written ten books and has contributed widely to journals and magazines. She teaches in Australia, New Zealand, Canada and the US, and continues to research and develop new techniques, particularly in stumpwork. In 2005, Jane was awarded the Order of Australia Medal (OAM), for her 'services to hand embroidery as an artist, teacher and author'. Jane lives in New South Wales, Australia. For more information visit her website www.janenicholas.com

Japanese MOTIFS IN STUMPWORK & GOLDWORK

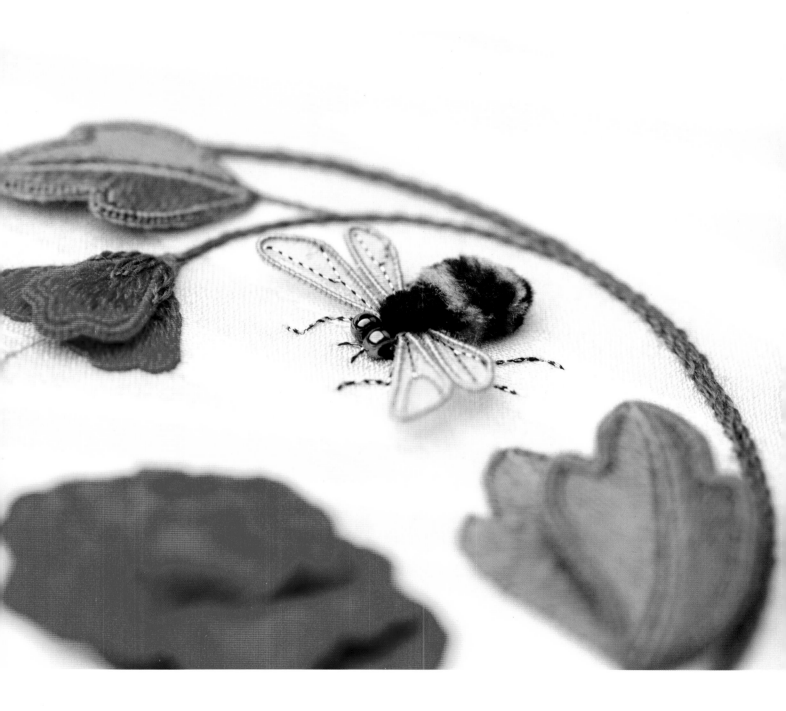

First published in 2023
Search Press Limited
Wellwood, North Farm Road,
Tunbridge Wells, Kent TN2 3DR

Illustrations and text copyright © Jane Nicholas, 2023
Inspiration for the designs from *Japanese Design Motifs:
4260 Illustrations of Japanese Crests*.
Compiled by the Matsuya Piece-Goods Store.
Dover Publications Inc., New York, 1972.
Every effort has been made to contact the publisher.

Photographs by Mark Davison at Search Press Studios
Photographs and design copyright © Search Press Ltd 2023

ISBN: 978-1-78221-679-7
ebook ISBN: 978-1-78126-593-2

The Publishers and author can accept no responsibility for
any consequences arising from the information, advice or
instructions given in this publication.

Suppliers

If you have difficulty in obtaining any of the materials and
equipment mentioned in this book, then please visit the
Search Press website for details of suppliers:
www.searchpress.com

You are invited to visit the author's website:
janenicholas.com

A mail-order service is offered by Jane Nicholas
Embroidery. Visit the website and view the range of books,
stumpwork and goldwork kits and supplies, including wires,
tweezers, hoops and needles.

The threads, beads and needlework products referred
to in this book are also available from specialist
needlework shops.

Extra copies of the templates are available to download
from www.bookmarkedhub.com

Acknowledgements

I would like to extend my gratitude to all those people
who continue to share their passion for embroidery
with me. Whether by correspondence or in class, your
enthusiasm provides invaluable motivation.

Special thanks to my wonderful family who continue
to provide wholehearted support and encouragement
for my work.

To my dear sewing group, I am thankful for your
friendship and the opportunity to share ideas and
cherished stitching time.

Finally, to all those involved in the production of this
book at Search Press – your expertise, and belief in my
work, is sincerely appreciated.

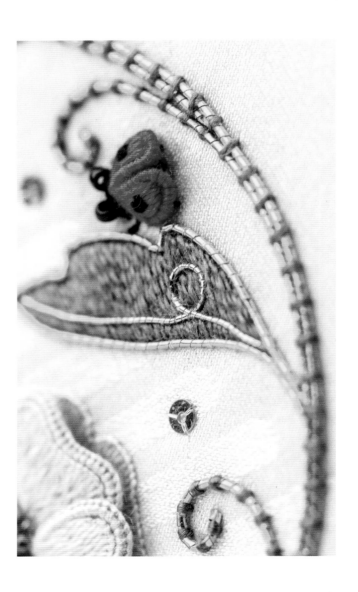

Japanese MOTIFS IN STUMPWORK & GOLDWORK

EMBROIDERED DESIGNS INSPIRED BY JAPANESE FAMILY CRESTS

JANE NICHOLAS

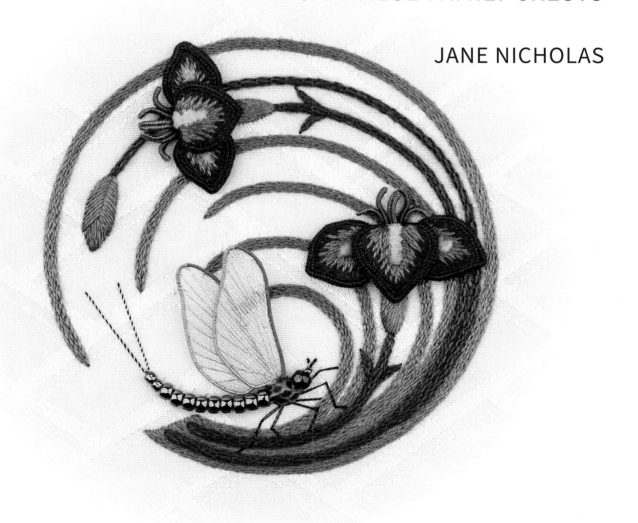

SEARCH PRESS

CONTENTS

1 Slate Butterfly 30

2 Copper Butterfly 40

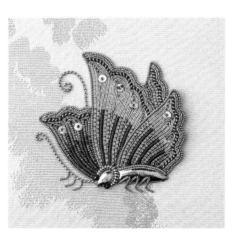

3 Amethyst Butterfly 52

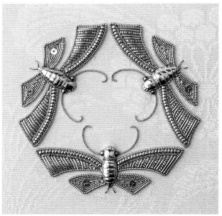

4 Gold Butterflies 64

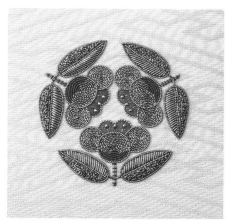

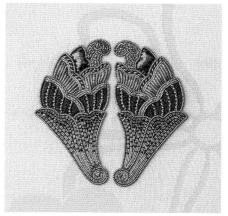

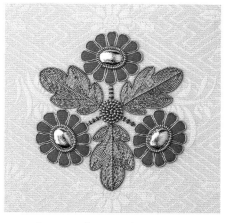

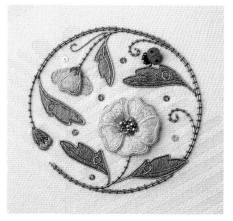

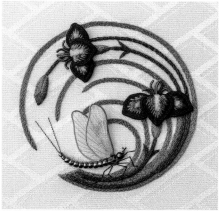

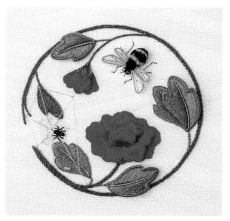

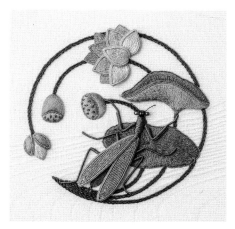

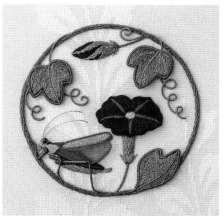

THE HISTORY OF JAPANESE FAMILY CRESTS

'It is in the nature of man to both think and express himself symbolically. Moreover, the power of symbols is magnified when a society has broadly shared experiences, a deep knowledge of its cultural traditions, and common sentiments about those experiences and traditions. The fact that these conditions exist in Japan to a striking degree has ensured that the country continues to enjoy a cultural life meaningfully enriched by the use of symbols.'

**– BAIRD, MERRILY, *Symbols of Japan*.
RIZZOLI INTERNATIONAL PUBLICATIONS, NEW YORK, 2001, PAGE 9.**

The Japanese family crest, *mon*, has a history that spans nearly a thousand years. The gradual emergence of patterns and designs as a mark of family identification among the aristocracy took place during the eleventh century, when each of the high-ranking courtiers began using a specific textile design for his most formal costume worn at the Imperial court. These designs, featuring elegant renderings of natural forms such as wisteria, peony, iris, bellflower and crane, emerged as symbols identifying a family name and came to be used on carriages for that purpose. From the twelfth century, the warrior classes gradually adopted the use of family emblems as identifiers on their banners, flags and virtually all items of martial equipment. The *mon* continued to be used to distinguish family from family, friend from foe, in the endless battles of the warring clans throughout the Middle Ages.

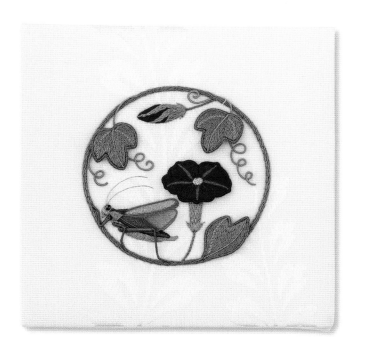
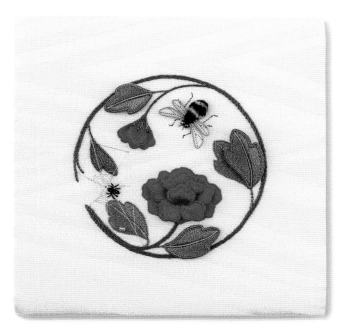
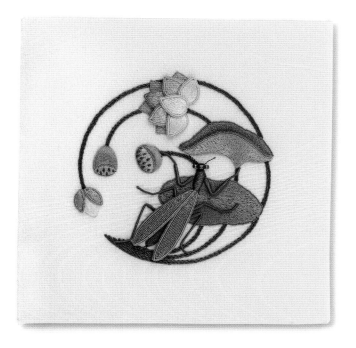
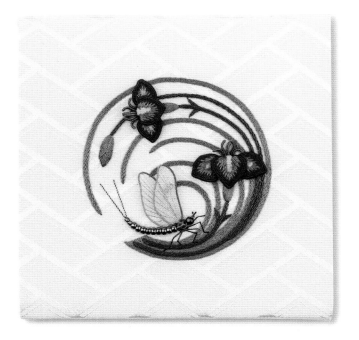

With the establishment of lasting peace in the seventeenth century, the family crest was no longer confined to the use of the nobility and the warrior classes. The general population began to use an emblem, not only to embellish formal costumes, but to decorate many family possessions such as travelling chests, carriages, furniture and lacquerware. Family crests were also embroidered on kimono, adding to their beauty. The placement of crests on garments became conventionalized at this time, occurring in either three or five places – on the centre of the upper back, on the sleeves by the shoulders and, occasionally, especially among the upper classes, on either side of the upper front. The crest could be stencilled, printed, resist-dyed, woven or embroidered, with the size being about 4cm (1½in) in diameter.

In addition to the exquisite designs, there was often an underlying meaning attached to the choice of a symbol for a family crest. Many symbols were considered to be auspicious, such as the white rabbit – regarded as embodying the spirit of the moon – while some had an underlying meaning, for example, a few warrior families used the crab motif as a family crest because of the martial significance of the crab's 'armour' and alert defensive position.

The Japanese family crest now appears to occupy a largely decorative position. With a significant history spanning a millennium (being enjoyed successively by courtier, warrior, entertainer and townsman), the *mon* became available to all families, to all cities and for myriad uses. Many Japanese corporations adapted the concept of the crest to create symbols that are now recognized worldwide.

Through constant variation and invention over the centuries, the Japanese family crest has become one of the richest graphic-art traditions in the world. It is a comparatively simple motif: most are circular, many are symmetrical, and they can all be fitted into a square. Within those parameters is a seemingly endless range of designs, beginning with the several hundred root motifs: chrysanthemum, gingko, rice plant, peony, iris, lotus, sun, moon, butterfly, pigeon, rabbit, tortoise, crab, dragon, comma, knots, cartwheel, vessel, ship and umbrella, to name but a few. Practically every kind of plant, bird, animal, natural phenomenon and man-made object of Japanese culture was at one time or another included in a family crest. In addition, each of the root designs was treated to dozens of imaginative variations, revealing the Japanese gift for composition and delight in infinite variety and subtle variations.

It is with great respect and much pleasure that I embarked on the journey of embroidering a selection of these family crests. The difficulty was choosing just twelve motifs from the more than 4,000 recorded individual designs. They have all been worked on squares of ivory kimono silk – each with a different woven background and many being just scraps of vintage fabric. The designs have been worked in goldwork or stumpwork embroidery, or a combination of both. All my designs were inspired by the family crests contained in the splendid repository *Japanese Design Motifs: 4260 Illustrations of Japanese Crests*, compiled by the Matsuya Piece-Goods Store, originally published in Japan c.1913. The original crest is displayed next to each design. I am grateful for the use of these motifs, and I hope that the resulting projects bring as much joy to you as they have to me.

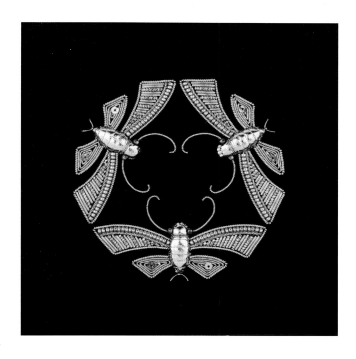

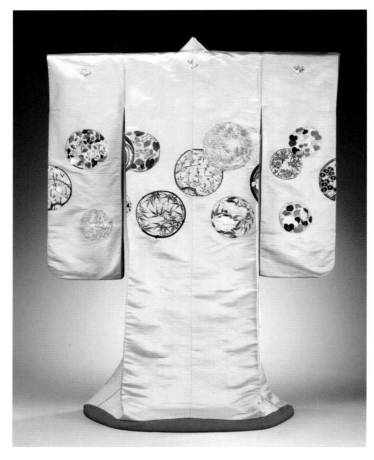

KIMONO FOR A WOMAN
Outer kimono (*uchikake*), green satin silk, with embroidery in silk and metallic threads of
floral and foliage roundels of hollyhocks and paulownia, lilies and pine trees.
The gold family crests (*mon*) of paulownia leaves, two on the front and three across the
back, suggest that she was probably a woman of the samurai class.
Japan, 1800–1850.
© Victoria and Albert Museum, London

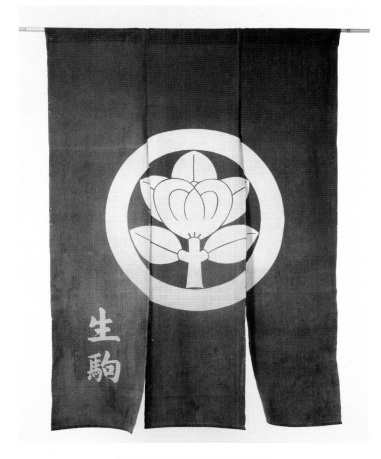

SHOP DOOR-CURTAIN (*NOREN*)
Door curtain (*noren*) of indigo blue cotton made from three sewn-together loom widths,
which are left partly unsewn to allow a passage through the doorway.
In the centre, reserved in white, is a crest (*mon*) depicting a tachibana (*flower*) in an arch.
At the bottom left are two characters which read 'Ikoma', a surname. Resist-dyed cotton.
Japan, 1870–1970.
© Victoria and Albert Museum, London

TOOLS
AND EQUIPMENT

The embroiderer's workbox should contain the following equipment
(although you won't require all these items for every project):

- **Good-quality embroidery hoops:** 10cm (4in), 12cm (5in), 15cm (6in), 20cm (8in) and 25cm (10in). Bind the inner ring of wooden hoops with cotton tape to prevent slipping. A small screwdriver and/or pair of pliers are useful to tighten the embroidery hoops. Plastic hoops with a lip on the inner ring are also suitable

- **Slate or square frames in various sizes** for larger embroideries and goldwork

- **Wooden tracing boards of various sizes** – to place under hoops of fabric when tracing – or use something like a hardbacked book

- **Tracing paper** (I use GLAD® baking parchment)

- **Sharp HB lead pencil or 0.5mm mechanical/ clutch pencil**

- **Pigma Micron™ pen size 01 in brown**

- **Stylus, Clover Tracer Pen or used (empty) ball-point pen** (for tracing)

- **Masking tape** (for tracing and to hold threads and wire tails to the back of the fabric)

- **Translucent removable adhesive tape** (I use Scotch® Removable Magic Tape)

- **PVA or UHU glue** to secure any accidentally cut threads

- **Needles**
 Crewel/embroidery sizes 3–10
 Milliners/straw sizes 1–9
 Sharps sizes 8–12
 Chenille sizes 18–24
 Tapestry sizes 26–28
 Sharp yarn darners sizes 14–18

- **Fine glass-headed pins**

- **Thimble**

- **Beeswax**

- **Embroidery scissors (small, with fine sharp points), goldwork scissors (small and strong with sharp points) and paper scissors**

- **Small wire cutters or old scissors** (for cutting wire)

- **Velvet board** (for cutting lengths of metal purl thread). A velvet board can be made by fusing or gluing a piece of velvet to a piece of thick cardboard

- **Stiletto** (to make holes between the fabric threads)

- **Mellor laying tool or metal nail file** (for easing threads or leather into place)

- **Assortment of tweezers** (from surgical suppliers)

- **Eyebrow comb** (for Turkey knots)

- **Sticky notes or 'removable' self-adhesive labels** (for templates)

- **Rulers** – 15cm (6in) and 30cm (12in)

- **A magnifier** (useful for very fine work)

- **An iron**

Tip
Photocopy a small ruler and cut it out. A paper ruler like the one below is very useful for goldwork.

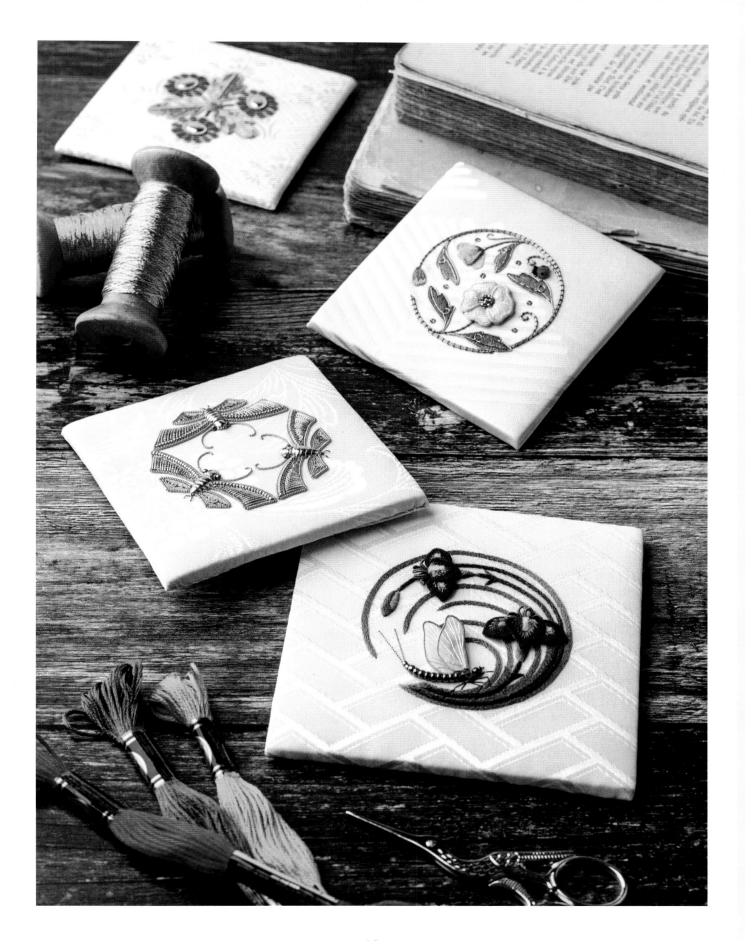

STITCH DIRECTORY

This glossary contains most of the stitches used in this book, in alphabetical order. For ease of explanation, some of the stitches have been illustrated with the needle entering and leaving the fabric in the same movement. When working in a hoop this is difficult (or should be if your fabric is tight enough), so the stitches have to be worked with a stabbing motion, in several stages.

BACKSTITCH

This is a useful stitch for outlining a shape. Bring the needle out at 1, insert at 2 (sharing the hole made by the preceding stitch) and out again at 3. Keep the stitches small and even. (See also split backstitch, page 20.)

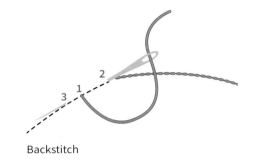

Backstitch

BUTTONHOLE STITCH

These stitches can be worked close together (second illustration) or slightly apart (first illustration). Working from left to right, bring the needle out on the line to be worked at 1 and insert at 2, holding the loop of thread with the left thumb. Bring the needle up on the line to be worked at 3 (directly below 2), over the thread loop and pull through to form a looped edge.

 If the stitch is shortened and worked close together over wire, it forms a secure edge for cut shapes, for example, a detached petal.

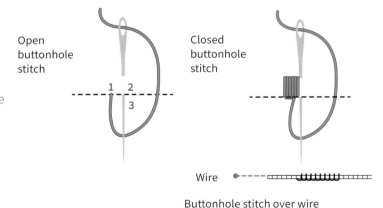

Open buttonhole stitch

Closed buttonhole stitch

Wire

Buttonhole stitch over wire

BUTTONHOLE STITCH: LONG AND SHORT

In long-and-short buttonhole stitch, there are alternately long and shorter stitches. Bring the needle out at 1, insert at 2 and up again at 3 (like an open detached chain stitch). When embroidering a shape like a petal, angle the stitches towards the centre of the flower.

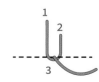

Open long-and-short buttonhole stitch

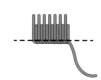

Closed long-and-short buttonhole stitch

Angled long-and-short buttonhole stitch

14

CHAIN STITCH

Bring the needle out at 1 and insert it again through the same hole, holding the loop of thread with the left thumb. Bring the needle up a short distance away at 2, through the loop, and pull the thread through. Insert the needle into the same hole at 2 (inside the loop) and make a second loop, hold, and come up at 3. Repeat to work a row of chain stitch, securing the final loop with a small straight stitch as for detached chain stitch, below.

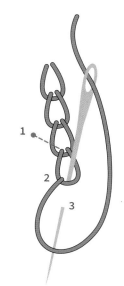

CHAIN STITCH: DETACHED

Detached chain stitch, also known as lazy daisy stitch, is worked in the same way as chain stitch except that each loop is secured individually with a small straight stitch. The securing stitch can be made longer if desired, as for fly stitch (page 17). Several detached chain stitches can be worked inside each other to pad a small shape.

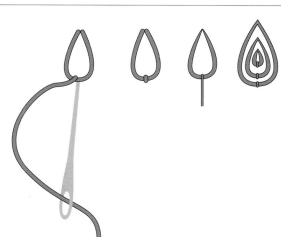

CHIPWORK/SEEDING

Chipwork or chipping, is a goldwork technique in which tiny pieces of purl – bright check, smooth or rough purl – are sewn down in random directions to fill a space. Sometimes referred to as seeding, this is a very useful method for filling small, awkwardly shaped areas.

Use fine sharp scissors to cut the purl into tiny pieces, approximately 1–2mm (¹⁄₁₆in) in length. Stitch with a single strand of waxed silk thread in a size 11 or 12 sharps needle.

Usually worked within an outline of pearl purl or twist, start the chipping at either a central point or an edge, depending on the shape, and work outwards to fill the space. Bring the needle up through the fabric, thread on a purl chip, guide it to the bottom of the thread then sew it down, making sure the length of the stitch is equal to the length of the cut chip. All the chips should lie in random directions so that the little pieces of purl sparkle as they catch the light.

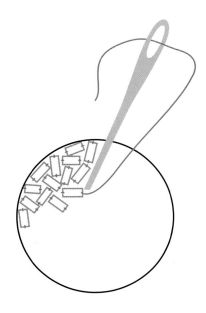

COUCHING

Couching is used to attach a thread, or bundle of threads, to a background fabric by means of small, vertical stitches worked at regular intervals. The laid thread is often thicker or more fragile, such as metallic thread, than the one used for stitching. Although often used to work single lines, couching may also be worked in multiple rows to fill larger areas. In goldwork, the metallic threads are frequently couched down two at a time.

To couch pearl purl, the needle comes up through the fabric, over the pearl purl, then down into the same hole. Gently pull on this thread so that it disappears between the coils. Continue couching, making a stitch between every second or third coil, depending on how intricate the line is.

Couching stitches are also used for attaching wire to the background fabric before embroidering detached shapes. See also overcast stitch, which is like couching but with the stitches close together.

Couching thread

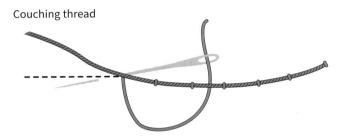

Couching two rows of metallic thread at a time

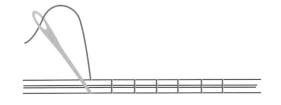

Couching pearl purl

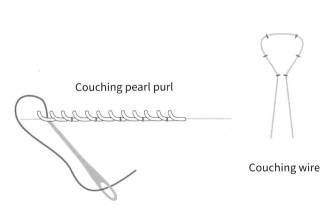

Couching wire

CUTWORK: SATIN-STITCH PURL

The goldwork technique known as graded cutwork or satin-stitch purl, may be worked with smooth purl, bright check purl and rough purl. The process requires the hollow purl thread be carefully cut into lengths to fit a shape, then sewn into place, like a flexible bugle bead. Use a single length of waxed silk thread in a size 11 or 12 sharps needle.

Cutwork can be worked directly onto the fabric, but is usually worked over a padded surface, often within an outline. Lay the purl across the shape and a cut a length to fit – a small paper ruler can be helpful with this. Bring the needle out at the edge of the shape, thread the cut length of purl onto the needle then lay it across the padding to check that it is the correct length – if it is too long, it will 'crack' when it is stitched over the padding, if it is too short, the padding might show at the edge. If it is too long, carefully move the purl back over the point of the needle and trim to the required length. Move the purl down to the base of the thread, check the length again, then insert the needle next to the edge on the other side of the shape. Bring the needle up close to the previous piece of purl and, working in a backstitch motion, continue to apply cut lengths of purl across the shape, creating a smooth satin-stitch effect. This technique takes some practice to master, but the result is worth the effort. Satin-stitched purl looks very effective when two different types of purls are stitched down alternately (see the Gold Butterflies, page 72).

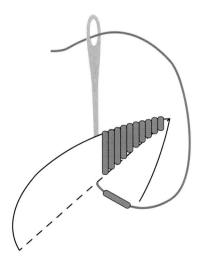

FEATHER STITCH

This stitch is made up of a series of loops, stitched alternately to the right and to the left, each one holding the previous loop in place. Come up on the line to be followed at 1. Insert the needle to the right at 2 and come up on the line again at 3, holding the thread under the needle with the left thumb. Repeat on the left side of the line, reversing the needle direction.

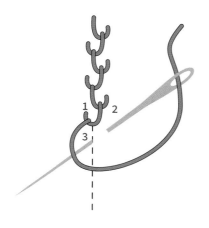

FEATHER STITCH: SINGLE

Work the feather stitch loops in one direction only, either to the right or to the left. This variation is useful for working the veins in the mayfly's wings (page 118).

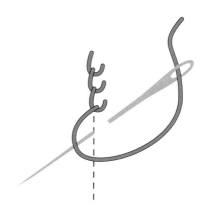

FISHBONE STITCH

This stitch is useful for filling small leaf shapes. Bring the thread out at the tip of the leaf at 1, and make a small straight stitch along the centre line (vein). Bring the needle out at 2, make a slanted stitch and go down on the right of the centre line. Bring the needle out at 3, make a slanted stitch and go down on the left of the centre line, overlapping the base of the previous stitch. Continue working slanted stitches alternately from left and right, close together, until the shape is filled.

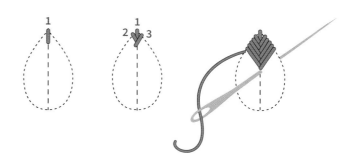

FLY STITCH

Fly stitch is actually an open detached chain stitch. Bring the needle out at 1 and insert at 2, holding the working thread with the left thumb. Come up again at 3 and pull through over the loop. Secure the loop with either a short anchoring stitch to create, for example, antennae, or a longer anchoring stitch to form, for example, the veins on a bee's wings (page 132).

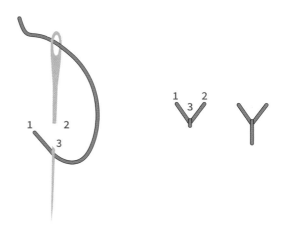

FRENCH KNOTS

These can be used individually or clustered together for texture (see the butterfly's hindwings on page 38). Using a milliners/straw needle, bring the thread through at the desired place, wrap the thread once around the point of the needle and re-insert the needle. Tighten the thread and hold taut while pulling the needle through. To increase the size of the knot, use more strands of thread, although more wraps can be made if desired.

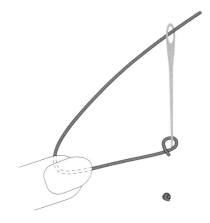

HERRINGBONE STITCH

Herringbone stitch is a border stitch, worked from left to right. It is used to make a crossed, zigzag line.It can also be used to fill shapes, such as dragonfly's wings.

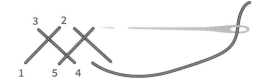

LONG-AND-SHORT STITCH

This stitch can be used to fill areas too large or irregular for satin stitch, or where shading is required. The first row, usually worked over a split-stitch outline, consists of alternating long and short satin stitches (or a row of long-and-short buttonhole stitch may be used, omitting the outline of split stitch). (See satin stitch, opposite page.) In the subsequent rows, the stitches are all of similar length, and fit into the spaces left by the preceding row. For a more realistic result when working petals, bring the needle through from the back, piercing the stitches of the preceding row and directing the stitches towards the centre of the flower. (See also buttonhole stitch: long and short, page 14.)

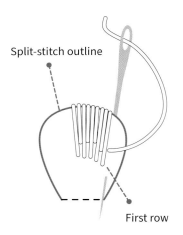

Split-stitch outline

First row

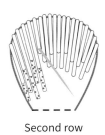

Second row

OVERCAST STITCH

This stitch is made up of tiny, vertical satin stitches, worked very close together over a laid thread or wire, resulting in a firm raised line. (See satin stitch, opposite page.) When worked over wire it gives a smooth, secure edge for cut shapes, for example, the detached bumble-bee wings (see page 118). Place the wire along the line to be covered. Working from left to right with a stabbing motion, cover the wire with small straight stitches, pulling the thread firmly so that there are no loose stitches which may be cut when the shape is cut out.

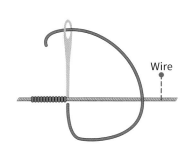

Wire

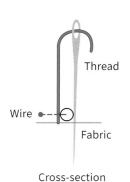

Thread

Wire

Fabric

Cross-section

PAD STITCH

Pad stitch is used as a foundation under satin stitch when a smooth, slightly raised surface is required. Padding stitches can be either straight stitches or chain stitches, worked in a different direction to the satin stitches. Felt can replace pad stitch for a more raised effect.

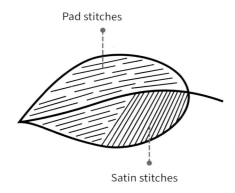

Pad stitches

Satin stitches

RAISED STEM STITCH

see
stem stitch: raised

RUNNING STITCH

see
tacking

SEEDING

see
chipwork

SATIN STITCH

Satin stitch is used to fill shapes such as petals or leaves. It consists of slanted, horizontal or vertical straight stitches, worked close enough together so that no fabric shows through, yet not overlapping each other. Satin stitch can be worked over a padding of felt or pad stitches, if desired. Smooth edges are easier to achieve if the shape is first outlined with split stitch (or split backstitch). (See also cutwork: satin-stitch purl, page 16.)

SLANTED SATIN STITCH

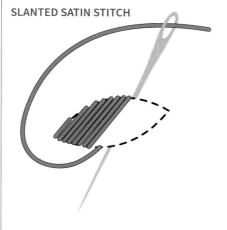

VERTICAL SATIN STITCH

SATIN STITCH ANGLED TO FIT THE SHAPE

SPLIT STITCH

Split stitch can be used either as an outline stitch or for smooth, solid fillings. Split stitch is worked in a similar way to stem stitch; however, the point of the needle splits the preceding stitch as it is brought out of the fabric. To start, make a straight stitch along the line to be worked. Bring the needle through to the front, splitting the straight stitch with the point of the needle. Insert the needle along the line then bring through to the front again to pierce the preceding stitch. Repeat to work a narrow line of stitching, resembling fine chain stitch.

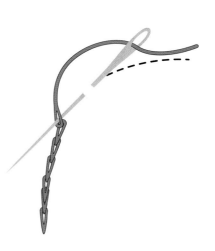

SPLIT BACKSTITCH

An easier version of split stitch, especially when using one strand of thread. Commence with a backstitch. Bring the needle out at 1, insert at 2 (splitting the preceding stitch) and out again at 3. This results in a fine, smooth line, ideal for stitching intricate curves.

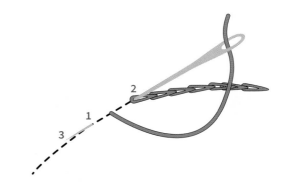

STAB STITCH

Stab stitch is used to apply leather or felt shapes to a background fabric. It consists of small straight stitches made from the background fabric over the edge of the applied shape, for example, felt padding. Bring the needle out at 1, and insert at 2, catching the edge of the applied piece.

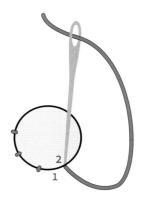

STEM STITCH

Worked from left to right, the stitches in stem stitch overlap each other to form a fine line suitable for outlines and stems. A straight (not slanted) form of stem stitch, in a stabbing motion, is ideal for stumpwork. To start, bring the needle out at 1 on the line to be worked. Go down at 2, come up at 3 and pull the thread through. Insert the needle at 4, holding the thread underneath the line with the left thumb, and come up again at 2 (sharing the hole made by the previous stitch) then pull the thread through. Go down at 5, hold the loop and come up again at 4, then pull the thread through. Repeat to work a narrow line.

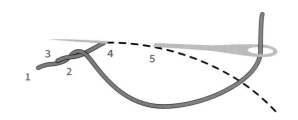

STEM STITCH: RAISED (STEM-STITCH BAND)

Stem stitch can be worked over a foundation of couched, padding thread to produce a raised, smooth, stem-stitch band, ideal for thicker stems. Lay a preliminary foundation of padding stitches worked with soft cotton or stranded thread. Across this padding, at fairly regular intervals, work straight (couching) stitches at right angles to the padding thread (do not make these stitches too tight). Then proceed to cover the padding by working rows of stem stitch over these straight stitches, using a tapestry needle so as not to pierce the padding thread. All the rows of stem stitch are worked in the same direction, starting and ending either at the one point, example 1, or as in satin stitch, example 2.

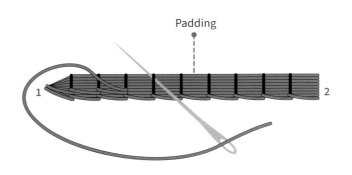

Padding

STRAIGHT STITCH

Individual straight stitches, of equal or varying length, can be stitched with a variety of threads to achieve interesting effects, for example, insect legs in metallic thread.

TACKING/RUNNING STITCH

Tacking, a dressmaking term, is a row of running stitches, longer on the top of the fabric, used to temporarily mark an outline or to hold two pieces of fabric together. It is also known as basting.

TURKEY KNOTS

Turkey knots are worked then cut to produce a soft velvety pile. Although there are several ways to work Turkey knots, the following method works well for small areas, such as the bumble-bee abdomen (see page 132). Use two strands of thread in a size 9 crewel or sharps needle.

Insert the needle into the fabric at 1, holding the tail of thread with the left thumb. Come out at 2 and go down at 3 to make a small securing stitch. Bring the needle out again at 1 (piercing the securing stitch), pull the thread down and also hold with the left thumb.

For the next Turkey knot, insert the needle to the right at 4 (still holding the tails of thread). Come out at 5 and go down at 2 to make a small securing stitch. Bring the needle out again at 4 (piercing the securing stitch), pull the thread down and hold with the left thumb as before. Repeat to work a row.

Work each successive row directly above the previous row, holding all the resulting tails with the left thumb. To complete, cut all the loops, comb with an eyebrow comb, and trim the pile to the desired length. The more the pile is combed the fluffier it becomes.

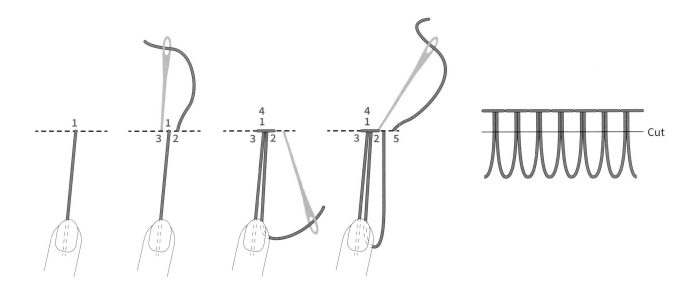

TECHNIQUES

PREPARING THE BACKGROUND FABRIC

These designs may be embroidered on a variety of background fabrics – silks, satins, cottons – plain, textured or patterned, with a backing fabric of firm cotton or calico.

My embroideries were worked on an assortment of ivory kimono silks – each with a different design woven into the background. Some of these silks were only scraps so they needed to be attached to a backing of cotton fabric before mounting into a hoop or frame. I used either a 20cm (8in) wooden embroidery hoop, or a slate frame to work these pieces. A wooden hoop that can be tightened with a screw is preferable. I also bind the inner ring of the hoop with cotton tape to help prevent the fabric from loosening in the hoop.

METHOD 1

If you have a piece of fabric large enough to fit your frame, use this method.

Mount the background fabric, and the cotton backing into the hoop or square frame, making sure both fabrics are drum tight.

YOU WILL NEED:

- **Background fabric:** a 28cm (11in) square of background fabric of your choice – silk, satin, cotton – plain, textured or patterned

- **Backing fabric:** a 28cm (11in) square of firm cotton or calico

- **Embroidery hoop:** a good-quality 20cm (8in) hoop or square frame

METHOD 2

Use this method of preparation if you have a small piece of special fabric that you would like to use as a background fabric. Some of the vintage kimono silks that I used were only scraps so I mounted them onto a backing of firm cotton before framing up.

Place the square of silk in the centre of the cotton square. Using polyester machine thread, apply the silk to the cotton with large herringbone stitches worked over the edges of the silk square (pictured below). Mount the cotton backing, with its applied square of background fabric, into the hoop or square frame, making sure that the fabric is drum tight.

YOU WILL NEED:

- **Background fabric:** a small square (15–18cm/6–7in) of kimono silk or the fabric of your choice

- **Backing fabric:** a 28cm (11in) square of firm cotton or calico

- **Embroidery hoop:** a good-quality 20cm (8in) hoop or square frame

TRANSFERRING THE DESIGN

Choose one of the following methods to transfer the design – the choice depends on the background fabric that you have selected. While I usually use method 1 to transfer a design, I choose method 2 if I am using a fabric with a distinct texture or pattern which will not accept a traced line easily.

METHOD 1

1 Mount the background fabric and cotton backing fabric into a 20cm (8in) hoop or square frame, making sure that both fabrics are drum tight.

2 Using a lead pencil and ruler, draw a 10cm (4in) square outline in the centre of a sheet of white paper. Using paper scissors, cut along the pencil outlines to make a square 'window' template (pictured below).

3 Centre this window template over the fabric in the hoop, aligning the edges of the square with the straight grain of the background fabric (taking heed of any pattern in the fabric) – temporarily hold the paper in place with translucent removable adhesive tape. Using fine silk thread in a suitable needle, work a row of long tacking (running) stitches inside the edges of the square window. Remove the paper template, leaving a stitched square outline on the background fabric.

4 Using a fine lead pencil, trace the Design Outline, and surrounding square, onto one side of tracing paper (I use baking parchment). This will be the 'right side' of the tracing paper (you might like to indicate this). Turn the tracing paper over and draw over the *design outlines only* on the back (do not draw over the square lines).

5 With the tracing paper right side up, position the tracing over the background fabric, lining up the traced square lines with the tacked square. Temporarily secure the edges of the tracing paper to the background fabric with strips of masking tape or translucent removable adhesive tape. Using a stylus, draw over the design lines to transfer the outlines to the background fabric (it helps to have a board or small book underneath the frame of fabric to provide a firm surface).

YOU WILL NEED:

- Sharp HB lead pencil or 0.5mm mechanical/clutch pencil
- Ruler
- Sheet of white paper
- Paper scissors
- Translucent removable adhesive tape (I use Scotch® Removable Magic Tape)
- Fine silk thread in a size 12 sharps needle
- Tracing paper (I use GLAD® baking parchment)
- Stylus, Clover Tracer Pen or used (empty) ball point pen
- Wooden tracing board that will fit inside the hoop (or a small book)

Cut away

Stitched square

Author's note

Always use the minimum amount of lead when tracing. If your outlines are too dark, gently press the traced outlines with pieces of masking tape to remove any excess graphite.

METHOD 2

Steps 1–3 are the same as those given for method 1, page 23.

1 Mount the background fabric and cotton backing fabric into a 20cm (8in) hoop or square frame, making sure that both fabrics are drum tight.

2 Using a lead pencil and ruler, draw a 10cm (4in) square outline in the centre of a sheet of white paper. Using paper scissors, cut along the pencil outlines to make a square 'window' template.

3 Centre this window template over the fabric in the hoop, aligning the edges of the square with the straight grain of the background fabric (taking heed of any pattern in the fabric) – temporarily hold the paper in place with translucent removable adhesive tape. Using fine silk thread in a suitable needle, work a row of long tacking (running) stitches inside the edges of the square window. Remove the paper template, leaving a stitched square outline on the background fabric.

4 Trace the Placement Outline and surrounding square onto tracing paper. Set aside – this tracing will be used to accurately position the design in step 6.

5 Fuse a 10cm (4in) square of silk organza to a 10cm (4in) square of paper-backed fusible web, using baking parchment, or a non-stick pressing sheet, to protect the iron and ironing surface. Place the fused organza/paper over the Design Outline, *organza side up*, and trace the Design Outline and all internal lines onto the organza, using a Pigma Micron™ pen size 01 (brown) or a fine lead pencil. I prefer to use a Pigma Micron™ pen as the lead pencil lines tend to smudge.

6 With small sharp scissors, carefully cut out the traced organza design shape (around the outside edge). Carefully peel the paper away, leaving the traced organza design shape with its backing of fusible web. Place the organza shape, fusible-web side down, onto the background fabric, inside the tacked square, using the traced Placement Outline as a guide to accurate placement. Fuse the traced organza shape to the background fabric, using a layer of baking parchment between the organza and the iron (for protection), and a tracing board (or small book) inside the back of the hoop for support.

YOU WILL NEED:

- Sharp HB lead pencil or 0.5mm mechanical/clutch pencil

- Ruler

- Sheet of white paper

- Paper scissors

- Translucent removable adhesive tape (I use Scotch® Removable Magic Tape)

- Fine silk thread in a size 12 sharps needle

- Tracing paper (I use GLAD® baking parchment)

- Stylus, Clover Tracer Pen or used (empty) ball point pen

- Wooden tracing board that will fit inside the hoop (or a small book)

- 10cm (4in) square white silk organza

- 10cm (4in) square paper-backed fusible web (eg Vliesofix®)

- Baking parchment or a non-stick pressing sheet

- Iron

- Pigma Micron™ pen size 01 in brown

- Small sharp scissors

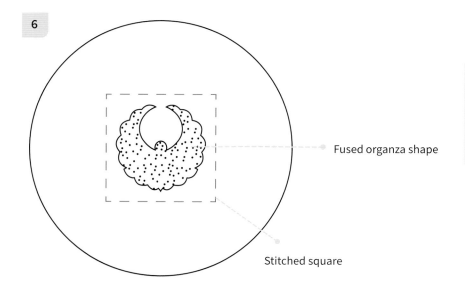

Fused organza shape

Stitched square

Author's note
The embroidery will be worked over this organza design shape.

SINKING/PLUNGING TAILS OF GOLD THREAD

Tails of gold thread, such as Japanese gold and twists, may be taken through to the back of the work with either a chenille needle or with the use of a 'lasso'. Make your own lasso by threading a 15cm (6in) length of extra-strong sewing thread (Gütermann Strong Thread) into the eye of a chenille needle (size 18 works well). Both ends are threaded into the eye of the needle, in opposite directions, leaving a loop of strong thread which is used to pull the tail of gold thread through. Insert the needle where the thread is to be plunged – place only the end of the gold thread into the lasso, then carefully pull it through to the back.

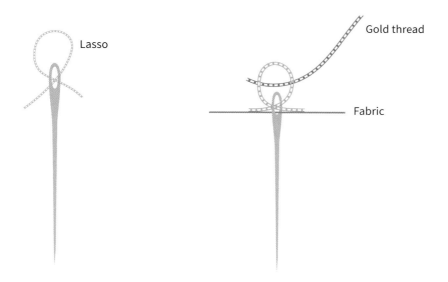

Lasso

Gold thread

Fabric

WORKING WITH PAPER-BACKED FUSIBLE WEB

Paper-backed fusible web (also known as Vliesofix®, Bondaweb® and other brand names) is used to fuse or bond one material to another by applying heat with an iron. I use paper-backed fusible web to obtain a precise design outline on felt – it is very difficult to trace a small shape onto felt and to cut it out accurately!

To fuse a design outline onto felt:

1 Trace the outline onto the paper side of the fusible web then fuse to the felt (fusible web/glue side down!) with a medium-hot dry iron.

2 Cut out the shape along the outlines. Remove the paper before stitching the felt shape to the background fabric, for example, for a flower centre or insect's abdomen.

Author's note
I usually prefer to apply the felt *web-side down* so that there is no chance of the web/glue affecting the gold thread. The only time I apply the felt *web-side up* is when the shapes are so small that there is a chance of the felt shredding when being stitched.

I always allow for the reversing of the felt shapes when they are turned over – unless the shape is symmetrical.

WORKING WITH WIRE

Cake decorator's wire is used to form the detached, wired and embroidered shapes characteristic of stumpwork. I find the following gauges are the most useful:

30-GAUGE COVERED WIRE

This sturdy wire has a tightly wrapped, thin paper covering and is available in green and white (which may be coloured as described opposite). This wire is useful for larger detached shapes (where more strength is required), wrapped stems and insect legs.

33-GAUGE COVERED WIRE

A fine wire with a tightly wrapped, thin white paper covering which can be coloured, if desired (see opposite). This wire is ideal for small, detailed, detached shapes, such as flower petals and narrow leaves.

FLOWER WIRE

A very fine wire covered with tightly wrapped thread. It is similar to 33-gauge paper-covered wire, and may be used in the same way.

28-GAUGE UNCOVERED WIRE

Uncovered wire (silver in colour) is used when a finer edge is required. Use it for small and detailed shapes, such as bee wings. It may also be threaded through pearl purl when a detached shape is required in a goldwork piece.

STITCHING WIRE TO FABRIC

– When stitching wire to fabric, either with overcast stitch (see page 18) or buttonhole stitch (see page 14), make sure that the needle enters the fabric at right-angles, very close to the wire (not angled under the wire). The stitches need to be worked very closely together, with an up-and-down stabbing motion, using a firm and even tension.

– Using very sharp scissors with fine points, cut out the wired shape as close to the stitching as possible (stroke the cut edge with your fingernail to reveal any stray threads). If you happen to cut a stitch, use the point of a pin to apply a minute amount of PVA glue to the cut thread. This will dry matt and clear.

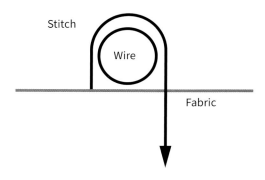

CROSS-SECTION OF FABRIC, WIRE AND STITCH

COLOURING WIRE

White, paper-covered wire may be coloured with a waterproof ink or paint if desired. This is optional. When I colour wires, I use COPIC Markers, which are available from art-supply stores. These markers are fast-drying and refillable and come in a huge range of colours.

ATTACHING WIRED SHAPES TO A BACKGROUND FABRIC

Detached wire shapes are applied to a background fabric by inserting the wire tails through a 'tunnel' formed by the eye of a large yarn darner needle.

1 Pierce the background fabric at the required point with the yarn darner and push it through until the eye of the needle is halfway through the fabric (this forms a 'tunnel' through to the back of the fabric).

2 Insert the wire tail(s) into the 'tunnel' formed by the eye of the darner, through to the back of the fabric. Thread tails can also be taken through at the same time.

3 Gently pull the darner all the way through, leaving the wire tail(s) in the hole.

4 Stitch the wire tails to the backing fabric with small stitches, preferably behind an embroidered area (make sure the securing stitches will be hidden behind embroidery or underneath a detached shape).

5 Use tweezers to bend the wired shape as required then trim the wire tails. I do not cut any wire tails until the subject is finished (just in case I need to unpick and re-do!). Do not let any wire protrude into an unembroidered area as the tails may show when the piece is framed.

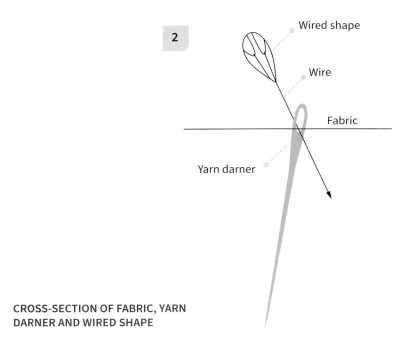

CROSS-SECTION OF FABRIC, YARN DARNER AND WIRED SHAPE

27

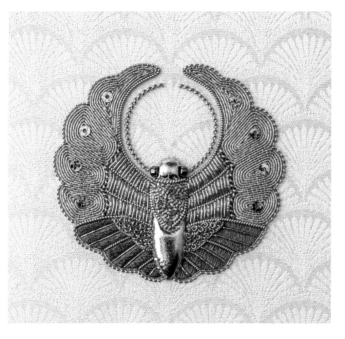

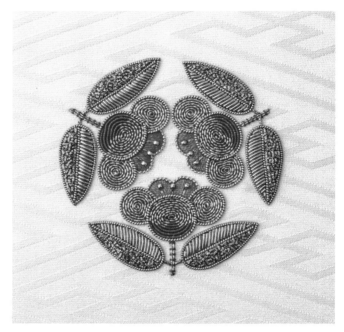

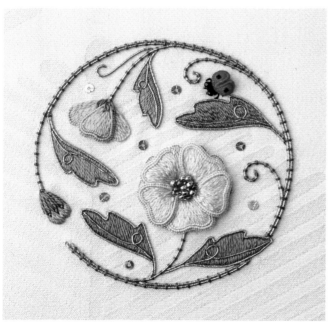

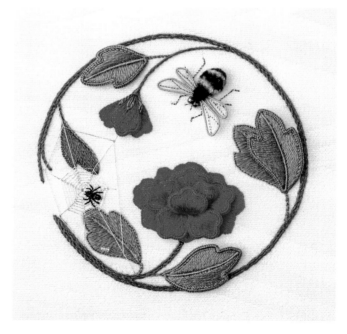

THE
projects

The projects that follow are worked with goldwork, stumpwork and surface embroidery techniques. Before you begin, please note the following information:

- These embroideries may be worked on a variety of background fabrics. Please refer to each project for fabric suggestions and preparation methods.

- To transfer the design to your prepared background fabric, choose one of the two methods described in the techniques section (see pages 23–24).

- Read through all the instructions before commencing work on any of the projects. As a general rule, work all surface embroidery before applying any detached elements.

- The design outlines and diagrams for each project are in the templates section at the back of the book. They are actual size and are traceable. The explanatory drawings and photographs accompanying the instructions have often been enlarged for clarity.

- The embroidery is worked with one strand of thread unless otherwise stipulated.

- For general information regarding tools and equipment, stitches or techniques, please refer to the 'Tools and equipment', 'Stitch directory' and 'Techniques' sections (pages 12–27).

- The projects have been made using metric measurements, and the imperial equivalents provided have been calculated following standard conversion practices. The imperial measurements are often rounded to the nearest $\frac{1}{16}$in for ease of use except in rare circumstances; however, if you need more exact measurements, there are a number of excellent online converters that you can use. Always use either metric or imperial measurements, not a combination of both.

1
SLATE BUTTERFLY

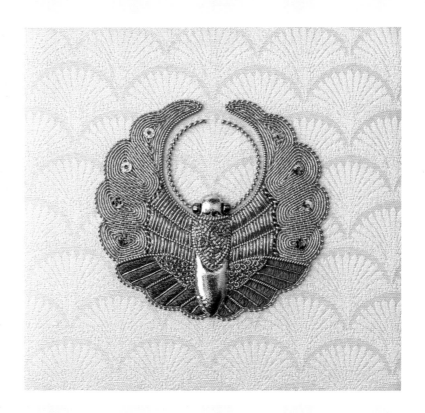

The design for the Slate Butterfly was inspired by one of the many Japanese family crests featuring a butterfly. Employing traditional goldwork techniques, and a variety of gold and silk threads, gold kid and beads, this symmetrical medallion was embroidered on a scrap of old kimono silk. The finished piece would look beautiful as a brooch.

Butterfly (*cho*)

Introduced as a design motif by the Chinese in the eighth century, the butterfly has become one of the most ubiquitous and beloved of subjects in Japanese decorative arts. While many Japanese artists have specialized in rendering the butterfly in exquisite detail, after close observation, the more popular practice over many centuries has been to interpret these creatures in a stylized manner that makes no attempt to identify the specific species. The butterfly may be found adorning all manner of items including kites, porcelain, *tsubas* (sword guards) and boxes and, in combination with flowers, decorating textiles, especially kimono, and painted screens.

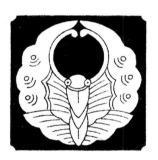

Butterfly *mon*

YOU WILL NEED

TEMPLATES:

- For full-size, traceable outlines, please see page 170.

EQUIPMENT:

- Embroidery hoop or square frame –
 20cm (8in)

NEEDLES:

- Crewel/embroidery sizes 3 and 10

- Milliners/straw sizes 5 or 6 and 9

- Sharps sizes 9 and 12

- Chenille size 22

- Sharp yarn darner size 18

- Embroidery equipment (see page 12)

MATERIALS:

- Background fabric –
 28cm (11in) square of the background fabric of your choice
 (see page 22 for suggestions and preparation)

- Backing fabric –
 28cm (11in) square of firm cotton fabric (calico/muslin)

- Tracing paper –
 15cm (6in) square (I use baking parchment)

- Plain white paper (e.g. photocopy paper) –
 20cm (8in) square

- Non-stick pressing sheet or baking parchment

- Sticky notes

- White silk organza –
 10cm (4in) square (if using transfer method 2)

- Paper-backed fusible web –
 two 10cm (4in) square pieces: one for organza (if using
 transfer method 2) and one for felt

- Yellow felt –
 10cm (4in) square

- Gold kid leather –
 5cm (2in) square

- 3mm (1/8in) grey glass beads –
 Mill Hill Size 8° glass beads col. 18081 (x 2)

- 3mm (1/8in) grey-black hologram sequins (x 8)

METAL THREADS:

- Gilt Very Fine Pearl Purl – 10cm (4in)

- Gilt Super Pearl Purl – 1m (1yd)

- Gilt No.1 Pearl Purl – 10cm (4in)

- Gilt No.2 Pearl Purl – 5cm (2in)

- Gilt No.8 Bright Check Purl – 1m (1yd)

- Gilt No.8 Smooth Purl – 1.1m (1¼yd)

- Gilt No.6 Smooth Passing Thread – 5m (5½yd)

- Dark Gold Couching Thread 371 – 5m (5½yd)

SEWING AND EMBROIDERY THREADS:

- **Fine gold metallic thread** –
 YLI Metallic Yarn 601 col. Gold or
 Kreinik Japan Thread 002J

- **Gold silk thread** –
 YLI Silk Thread #50 col. 79

- **Slate-blue stranded thread** –
 Soie d'Alger 1735 or DMC 931

- **Gold polyester sewing thread** –
 Gütermann Polyester Thread col. 488

- **Clear nylon thread** –
 Madeira Monofil No.60 col. 1001

PREPARATION

The Slate Butterfly may be embroidered on a variety of background fabrics. Please refer to page 22 for suggestions and preparation.

TRANSFERRING THE DESIGN

I used method 2 on page 24 to transfer the design, as I found that the kimono silk that I had chosen for this design was not accepting the traced pencil line as produced in method 1. Test your fabric and use method 1 if preferred.

ORDER OF WORK

BUTTERFLY BODY PADDING

3

The body of the butterfly is padded with two layers of yellow felt:

1 Using a fine lead pencil, trace the body padding outlines onto the paper side of the fusible web, then fuse to the yellow felt. Carefully cut out both shapes and remove the paper backing.

2 Using gold polyester thread in a size 10 crewel needle, apply both layers of felt (web side down) to the background fabric with small stab stitches around the outside edge, applying the smaller layer first. Use the traced body outline as a guide to placement.

3 To shape the padding, work a row of backstitches between the head and the thorax, and the thorax and the abdomen, as indicated by the red dotted lines, stitching through both layers of felt to the back.

ABDOMEN

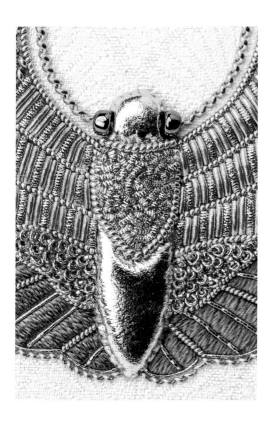

The abdomen and head of the butterfly are covered with gold kid leather, stitched in place with nylon thread in a size 12 sharps needle.

1 Trace the abdomen leather outline onto a sticky note, making sure that the traced outline is over the sticky end of the sticky note. Cut out the abdomen shape from the sticky note – just at the edge of the traced line, and place over the padded abdomen to check for size. Adjust if necessary – it should just cover the padding. Stick the abdomen shape to the right side of the gold kid and cut out around the edge of the shape.

2 Using nylon thread, stitch the kid over the padded abdomen with small stab stitches, working the stitches from the background into the leather shape. Start by working a stitch at each upper corner, lower point then each side edge, then continue stitching around the outside edge – working the stitches alternately from one side of the shape to the other to achieve the best shape.

HEAD

Trace the Head Leather Outline onto a sticky note and cut out the shape. Check for size, then stick to the right side of the gold kid and cut out the shape. Apply the kid over the padded head with small stab stitches using nylon thread. Work a stitch at each lower corner and upper head, then all around the outside edge. Smooth the edges of the kid with a mellor or nail file.

THORAX

1 The thorax is outlined with Gilt No.1 Pearl Purl, stitched in place with waxed silk thread in a size 12 sharps needle. Cut a 5cm (2in) length of purl and bend gently in half. Working the first stitch at the lower point of the thorax (over the bend in the purl), couch one half of the purl along one side of the thorax padding. Bend the purl at the corner then couch across the top of the thorax, below the head. Trim excess purl. Return to the lower point and couch the remaining purl along the other side of the thorax padding, trimming at the top corner.

2 The thorax is filled with cut chips of Gilt No.8 Bright Check Purl. Using waxed silk thread in a size 12 sharps needle, fill the thorax with small purl chips, sewn on individually and in as many different directions as possible.

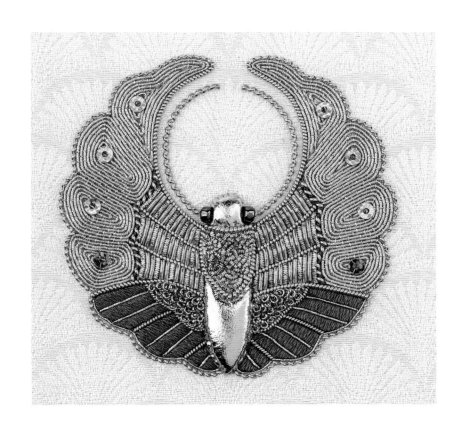

FOREWINGS

OUTER SEGMENTS

The outer segments of the forewings are filled with rows of Gilt No.6 Smooth Passing Thread, couched with fine gold metallic thread in a size 9 sharps or milliners needle.

1 Starting at the lower inner corner of the lowest segment (leaving the tail of passing thread on the surface), couch a row of smooth passing thread around the perimeter of the segment, placing the passing thread next to the traced line. Continue stitching consecutive rounds of passing thread, couching in a brick fashion where possible, until the shape is filled, leaving a tiny space in the centre of the wing (this will be covered by a sequin later). Using a fine yarn darner or chenille needle, sink both tails of passing thread through to the back and secure behind the segment.

2 Work the remaining segments in the same way, always commencing at the lower inner corner, and working the upper segment last. When working the upper segment, sink the tails of thread as required as some of the angles are quite sharp.

3 The forewing is outlined with Gilt Super Pearl Purl – unstretched along the inner edge of the wing and expanded around the outer edge. Cut 9cm (3½in) of pearl purl and gently bend in half (4.5cm/1¾in on each side of the bend). Expand one half of the purl from 4.5cm (1¾in) to 9cm (3½in) as follows – using your fingernails, hold the purl at the bend and at one end, then pull apart gently until it measures 9cm (3½in) from the bend.

4 Starting with the bend in the purl at the upper corner of the wing, couch the unstretched purl along the inner edge of the wing with silk thread, trimming the excess purl next to the thorax as required. Return to the bend in the purl and, using nylon thread, couch the expanded purl around the outer edge of the wing, trimming the excess purl at the lower outer corner.

5 Using silk thread, couch a length of Gilt Super Pearl Purl along the lower edge of the forewing (upper edge of the hindwing).

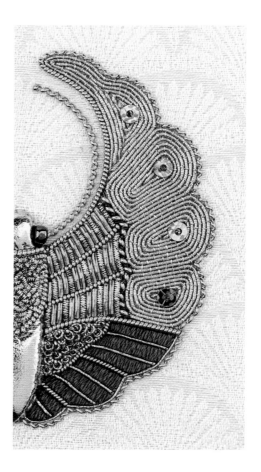

INNER SEGMENTS

A row of expanded pearl purl, wrapped with slate-blue thread, is couched along the line between the outer and inner segments of the forewings.

1 Cut a 1.5cm (⅝in) length of Gilt No.1 Pearl Purl and stretch to 3cm (1¼in) by holding a coil of purl at each end and pulling apart gently. Using three strands of slate-blue thread, 25cm (10in) in length, carefully wrap the purl between each coil, leaving a tail of thread at each end. Sink one tail of wrapping thread at the lower corner of the upper segment, and hold at the back with masking tape. With one strand of slate-blue thread in a crewel needle, couch the wrapped purl around the inner edge of the outer segments, shaping the wrapped purl around the curves, and working a stitch at an angle over the wrapped purl, one stitch for every coil. Just before the end of the line is reached, unwrap the slate-blue thread, cut the purl to the correct length, rewrap the end of the purl then sink the wrapping thread through to the back at the lower corner. Secure both ends of slate-blue thread at the back.

2 Using waxed silk thread, couch Gilt Super Pearl Purl along both inner vein lines, between the wrapped purl and the thorax.

3 Trace the forewing padding outlines onto the paper side of the fusible web then fuse to yellow felt. Carefully cut out the shapes and remove the paper backing.

4 Using polyester thread and small stab stitches, stitch a layer of felt (web side down) inside each wing segment. The felt will need to be trimmed so that it fits inside the purl edges of the segment, leaving a fingernail-width gap all around.

5 Each inner wing segment is covered with pieces of Gilt No.8 Bright Check Purl and Gilt No.8 Smooth Purl, cut to the appropriate length and couched over the padding, between the pearl purl edges (satin-stitched purl). Using waxed silk thread in a size 12 sharps needle, and starting at the outer edge, stitch down, alternately, one length of bright check purl then two lengths of smooth purl.

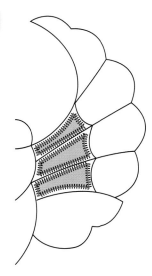

HINDWINGS

OUTER SEGMENTS

1 With one strand of slate-blue thread in a size 10 crewel needle, cover each outer segment (three segments) with long satin stitches, working the stitches parallel to the outer edge.

2 Using nylon thread, couch a length of Couching Thread 371 around the outer edge of the hindwing (at the edge of the satin stitch), sinking the tails of thread at the corners. Secure.

3 With silk thread, couch lengths of Gilt Very Fine Pearl Purl, cut to size, along the two main vein lines, between the satin-stitched segments.

4 To form the remaining five vein lines, make long straight stitches over the satin-stitched segments with Couching Thread 371, in a size 3 crewel needle, working the stitches towards the outer edge. Hold these straight stitches in place with small couching stitches, worked into the satin stitch, using nylon thread.

5 Couch a length of Very Fine Pearl Purl along the inner edge of the outer wing segments, using silk thread.

6 Cut a 4cm (1½in) length of Gilt Super Pearl Purl and stretch to 8cm (3in). Using nylon thread, couch the stretched super pearl purl around the outer edge of the hindwing, starting at the upper corner and trimming the excess purl at the lower corner of the wing.

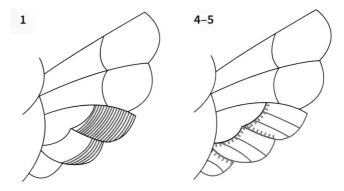

INNER SEGMENTS

The inner segments of the hindwings are filled with loose French knots, two wraps, worked with Couching Thread 371 in a size 5 or 6 milliners needle. I found it easier to work these French knots in rows, working the first row next to the inner edge of the outer segment.

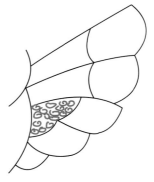

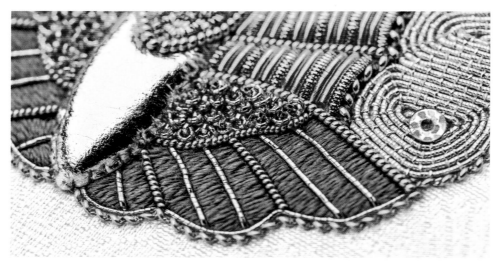

COMPLETING THE BUTTERFLY

1 Using nylon thread, stitch a grey glass bead on either side of the head for eyes, working the stitches, alternately, through one bead and then the other, pulling them towards the head.

2 Using the dots on the Placement Outline as a guide, and nylon thread, stitch a grey-black sequin in the centre of each forewing segment, working three stitches into each sequin.

3 The antennae are worked with stretched Gilt No.2 Pearl Purl couched in place with nylon thread. Cut a 4cm (1½in) length of purl and stretch to 8cm (3in). Starting at the eyes, and using the Placement Outline as a guide, couch the purl inside the upper wing outline to form the antennae, trimming to length as desired.

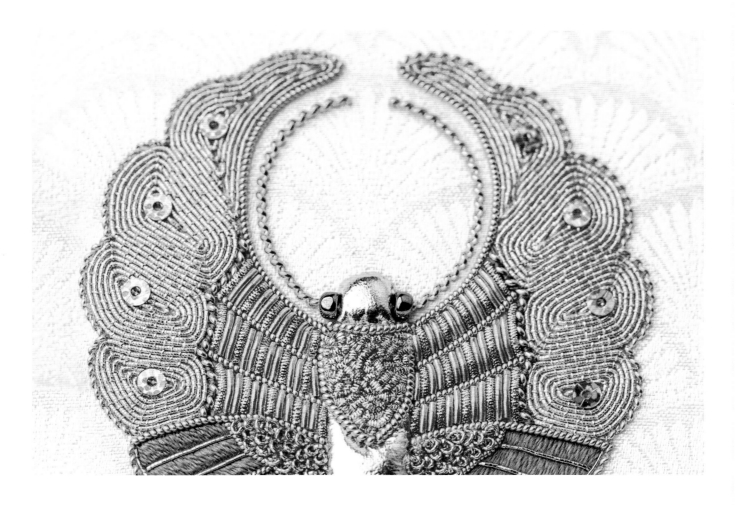

2
COPPER BUTTERFLY

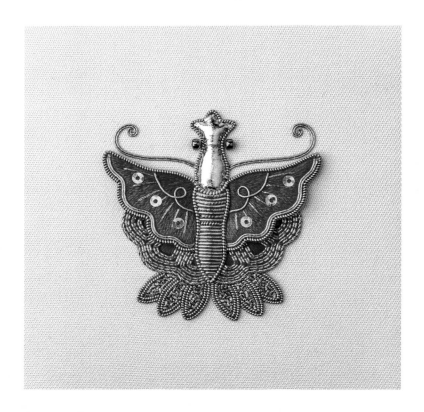

Raised detached forewings are the main feature of the
Copper Butterfly. Using a combination of stumpwork and
goldwork techniques, this interpretation of a Japanese family
crest uses a variety of gold metallic threads, gold kid and
sequins, and has been worked on a background of cream and
gold shot kimono silk.

Butterfly (*cho*)

The decorative possibilities of the butterfly made it one of the most popular motifs for the creation of family crests by both the court aristocracy and the warrior class. Interestingly, many plants motifs were also rendered as butterfly shapes for family crests – examples include the balloon-flower (*kikyo*), pine (*matsu*) and wood sorrel (*katabami*).

Balloon-flower (*kikyo*)

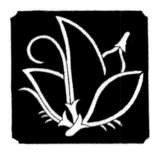

Pine (*matsu*)

Wood sorrel (*katabami*)

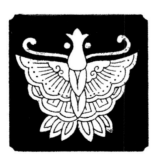

Butterfly *mon*

YOU WILL NEED

TEMPLATES:

- For full-size, traceable outlines, please see page 171.

EQUIPMENT:

- Embroidery hoop or square frame –
 20cm (8in)
 12cm (4¾in)

NEEDLES:

- Crewel/embroidery size 10

- Sharps sizes 9 and 12

- Sharp yarn darner size 16

- Embroidery equipment (see page 12)

MATERIALS:

- Background fabric –
 28cm (11in) square of the background fabric of your choice
 (see page 22 for suggestions and preparation)

- Backing fabric –
 28cm (11in) square of firm cotton fabric (calico/muslin)

- Tracing paper –
 15cm (6in) square (I use baking parchment)

- Plain white paper (e.g. photocopy paper) –
 20cm (8in) square

- Non-stick pressing sheet or baking parchment

- Sticky notes

- Quilter's muslin (medium-weight cotton fabric) –
 20cm (8in) square

- White silk organza –
 10cm (4in) square (if using transfer method 2)

- Paper-backed fusible web –
 two 10cm (4in) square pieces: one for organza and one
 for felt

- Yellow felt –
 10cm (4in) square

- Gold kid leather –
 5cm (2in) square

- 3mm (⅛in) bronze glass beads –
 Mill Hill Size 8º glass beads col. 18221 (x 2)

- 3mm (⅛in) gold hologram sequins (x 6)

- 28-gauge uncovered wire (x 2)

METAL THREADS:

- Gilt Super Pearl Purl – 1m (1yd)

- Gilt No.1 Pearl Purl – 10cm (4in)

- Gilt No.8 Bright Check Purl – 1m (1yd)

- Gilt No.8 Smooth Purl – 1m (1yd)

- Gilt No.6 Smooth Passing Thread – 5m (5½yd)

- Gold T70 Imitation Japanese Thread – 5m (5½yd)

- Dark Gold 3-ply Twist – 5m (5½yd)

SEWING AND EMBROIDERY THREADS:

- Fine gold metallic thread –
 YLI Metallic Yarn 601 col. Gold or
 Kreinik Japan Thread 002J

- Gold silk thread –
 YLI Silk Thread #50 col. 79

- Fine gold silk thread –
 YLI Silk Thread #100 col. 215

- Dark copper stranded thread –
 DMC 355

- Medium copper stranded thread –
 DMC 3830

- Ecru stranded thread –
 DMC Ecru

- Gold polyester sewing thread –
 Gütermann Polyester Thread col. 488

- Clear nylon thread –
 Madeira Monofil No.60 col. 1001

PREPARATION

The Copper Butterfly may be embroidered on a variety of background fabrics. Please refer to page 22 for suggestions and preparation.

TRANSFERRING THE DESIGN

I used method 2 on page 24 to transfer the design, as I found that the kimono silk that I had chosen for this design was not accepting the traced pencil line as produced in method 1. Test your fabric and use method 1 if preferred.

After following steps 1–6 of method 2, I transferred the antennae outlines as follows:

Hold the traced Placement Outline over the fused butterfly shape, lining up the traced and tacked square outlines. Insert a row of fine needles, through the tracing paper and background fabric, along the antennae lines. Carefully remove the tracing paper, leaving the row of needles behind. Using fine silk thread in a fine needle, work a line of tacking/running stitches along the antennae lines, removing the needles as you go. These tacking stitches will be removed when the antennae are worked later.

ORDER OF WORK

HINDWINGS

1 With nylon thread in a size 12 sharps needle, couch a row of Dark Gold 3-ply Twist around the upper and outer edges of the hindwings, covering the edge of the organza shape (if using transfer method 2) and leaving tails of thread on the surface at each end. Sink the tails of thread through to the back at the edge of the abdomen. Secure behind the wing and trim.

2 Using one strand of DMC 3830 medium copper thread in a size 10 crewel needle, couch a double row of Gold T70 Japanese Thread around the upper and outer edges of the hindwings (shown in blue), inside the twist, starting with a fold in the Japanese thread at the upper edge and leaving tails of thread on the surface at the lower end. Sink the lower tails through to the back at the edge of the abdomen, secure behind the wing and trim.

3 With DMC 3830 medium copper thread, couch a double row of Japanese thread around each of the segments of the hindwings, sinking the tails of thread through to the back as required. Couch another double row of Japanese thread inside the previous row, sinking the tails when necessary. Secure the tails behind the wing, then trim.

4 Using one strand of dark copper thread, embroider the teardrop shape inside each segment with padded satin stitch, working the padding stitches across the shape and the longer satin stitches from the edge of the shape towards the abdomen.

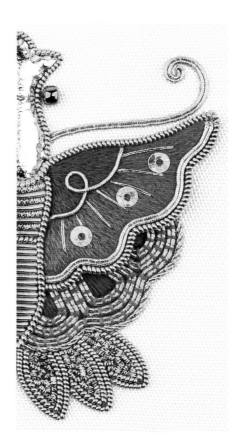

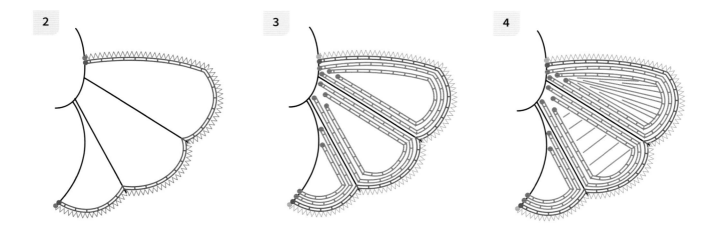

44

LOWER TAIL SEGMENTS

1 Using waxed gold silk thread, couch a row of Gilt Super Pearl Purl around the edge of each tail segment, working the two centre segments first then the remaining segments on either side. It is easier to commence stitching at the lower point of the segment, over a bend in the purl, then couching along each side, trimming the excess purl at the edge of the wing or adjoining segment. Couch a second row of purl inside the first row.

2 Using waxed gold silk thread, fill each segment with short chips of Gilt No.8 Bright Check Purl, sewn on individually and in random directions.

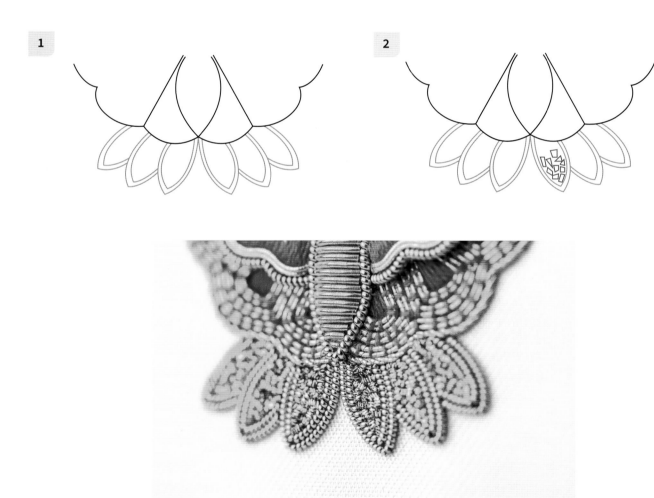

DETACHED FOREWINGS

1. Mount a square of quilter's muslin into a small hoop. Trace the detached wing outlines onto the muslin – a right-side and a left-side wing, aligning the upper edge of each wing with the straight grain of the fabric.

2. *The detached wing is outlined by a length of Gilt Super Purl Pearl with fine wire threaded through it. Before cutting the pearl purl, stretch it very slightly to make it easier to work with.*

 Cut a 6.2cm (2¼in) length of Gilt Super Pearl Purl and a 12cm (4¾in) length of uncovered wire. Thread the wire through the cut length of purl, leaving tails of wire of equal length at each end.

3. *When shaping the wired purl, great care must be taken, as it is not possible to trim the purl once the wire has been threaded through.*

 Using tweezers, shape the wired purl around the detached wing outline, leaving a wire tail at each end of the wing outline. The purl should be slightly shorter than the wing outline (about 1mm shorter at each end).

4. Using waxed, fine gold silk thread in a size 12 sharps needle, stitch the wired purl to the muslin, around the wing outline, with close couching stitches, working a stitch between each coil of the purl. Pull the stitches firmly so that they slip between the coils of the purl. There should be about 1mm of uncovered wire at each end of the wing shape.

5. The wing is embroidered in long-and-short stitch, shading from medium copper at the lower edge to dark copper at the inner corner. Using one strand of medium copper thread in a size 10 crewel needle, work a row of long-and-short stitch along the lower edge of the wing (see illustration below). Work another two rows, the stitch direction being towards the inner corner of the wing. Change to dark copper thread to work the remainder of the wing (this should coincide with the inner curved line on the wing).

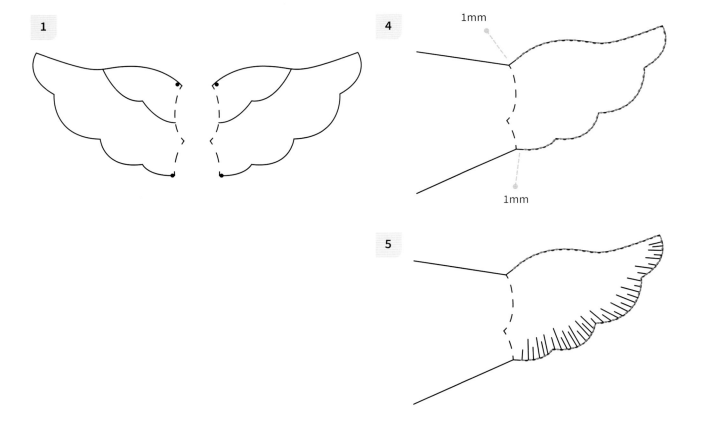

6 Using nylon thread in a size 12 sharps needle, couch a double row of Gilt No. 6 Smooth Passing thread along the lower edge of the wing, next to the purl, sinking the tails of thread through to the back at the corner of the wing and the embroidered side edge. Secure the tails at the back of the wing, retaining the nylon thread. Trim the tails of passing thread.

7 Using nylon thread, couch a row of smooth passing thread along the curved line at the inner corner of the wing, making a loop in the centre of the line. Sink the tails of thread through to the back and secure behind the wing. Trim.

8 Using a double strand of fine gold metallic thread in a size 9 sharps needle, work straight stitches for veins, starting at the edge of the inner couched line of passing thread and finishing just above the lower edge.

9 Using nylon thread, stitch three gold hologram sequins to each wing, working three stitches into each sequin.

6–7

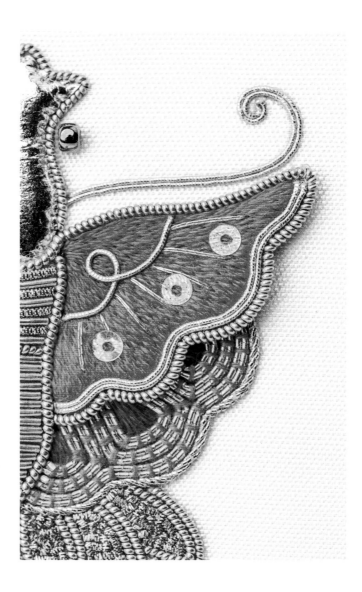

APPLYING THE DETACHED FOREWINGS

1 Carefully cut out the wings, close to the purl on the outer edges and leaving a 2mm (1⁄16 in) margin of muslin at the inner edge (this edge of muslin will be stitched to the background fabric, over the body). Take care not to cut the wire tails.

2 To apply the detached wings to the background fabric, insert the wire tails at the edge of the body at the points as marked, using a large yarn darner. Bend the wire tails behind the wings and secure to the backing with small stitches, worked with ecru thread. Make a U-turn in the wire for extra security.

3 Using gold silk thread, stitch the inner edge of the wings to the background fabric, over the butterfly body, working small straight stitches over the muslin edge left at the edge of the wings. Line up the inner embroidered edge of the wings with the edge of the body.

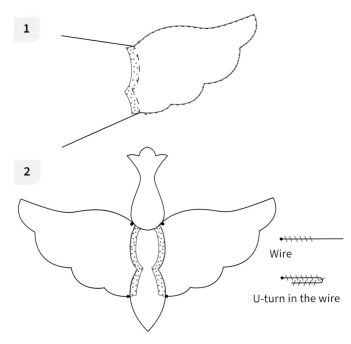

Wire

U-turn in the wire

Author's note
I made some long stitches over the wings with fine gold silk thread to hold the wings temporarily in place while working the head and abdomen.

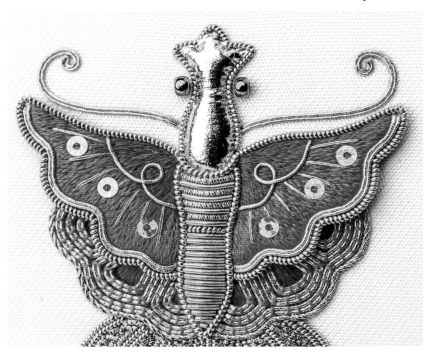

48

HEAD AND BODY PADDING

The body of the butterfly is padded with two layers of yellow felt.

1 Trace the head and body padding outlines onto the paper side of the fusible web then fuse to yellow felt. Carefully cut out both shapes and remove the paper backing.

2 Using gold polyester thread, stitch both layers of felt (web side down) to the background fabric with small stab stitches worked around the outside edge, applying the smaller layer first and stitching over the inner muslin edges of the detached wings. Use the body outline on the organza as a guide to placement.

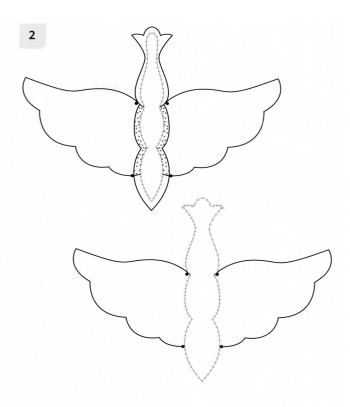

HEAD

1 Trace the Head Leather Outline template onto a sticky note (make sure the tracing is over the sticky end of the sticky note). Carefully cut out the shape. Check for size by placing over the padded head – adjust for size if required. Stick the paper template to the right side of the gold kid leather and cut around the shape with fine sharp scissors. Using nylon thread in a size 12 sharps needle, apply the leather shape over the padded head with small stab stitches. Work a stitch at each upper corner, lower point and each side edge first, then all around the outside edge, working the stitches from the background into the leather shape. Shape the edges with a mellor or nail file.

2 The head is outlined with Gilt Super Pearl Purl, stitched in place with waxed gold silk thread in a size 12 sharps needle. Starting at the upper wire insertion point for one detached wing, couch the purl around the outside edge of the head back to the wire insertion point of the other wing.

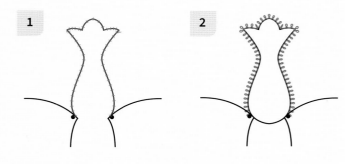

THORAX AND ABDOMEN

The thorax and abdomen are outlined with Gilt No.1 Pearl Purl, stitched in place with waxed silk thread in a size 12 sharps needle.

1 Couch a short length of purl along the lower edge of the head, between the wire insertion points, to form the top edge of the thorax.

2 Starting at an upper corner, couch a length of purl around the remaining edges of the thorax and abdomen padding, finishing at the other upper corner.

3 Using waxed silk thread and starting at the top edge, cover the thorax with lengths of bright check and smooth purl, cut to the appropriate lengths (satin-stitched purl), stitching alternate pieces of Gilt No. 8 Bright Check Purl and Gilt No. 8 Smooth Purl, until the line dividing the thorax and abdomen is reached.

4 Couch a length of Super Pearl Purl across the thorax abdomen dividing line.

5 Cover the abdomen with lengths of smooth purl, cut to the appropriate length (satin-stitched purl).

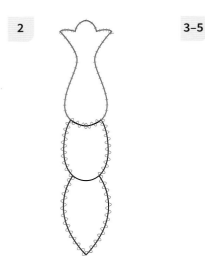

ANTENNAE

Cut a 12cm (4¾in) length of Gilt No.6 Smooth Passing Thread and fold in half. Using nylon thread and starting with the fold in the passing thread at the curved end of the antenna, couch a double length of smooth passing thread along the tacked antenna line, sinking the tails of thread through to the back at the edge of the head. Repeat for the other antenna. Secure the thread tails then trim. Remove the tacking stitches.

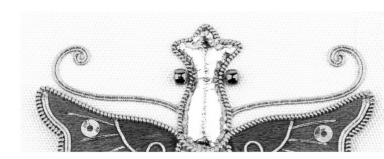

COMPLETING THE BUTTERFLY

1 Using nylon thread, stitch a bronze bead on either side of the head for eyes, at the points as marked on the Placement Outline, working a stitch in one bead and then across to the other and back to pull the beads close to the body.

2 Using tweezers, shape the detached upper wings (first having removed the silk holding threads if used). Using nylon thread in a size 12 sharps needle, work several invisible stitches to hold the upper edge of the detached wings to the surface, if desired.

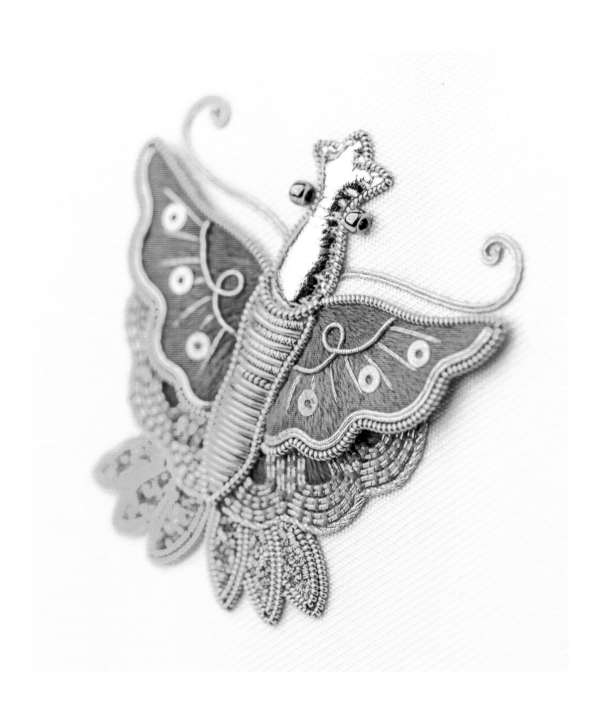

3
AMETHYST BUTTERFLY

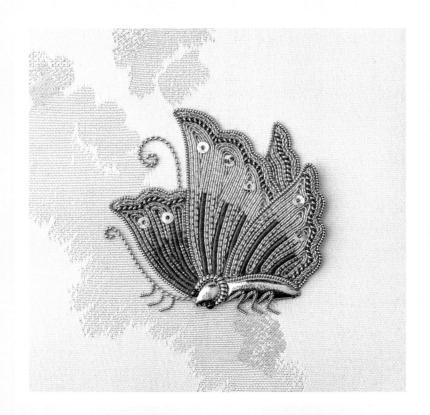

The wings of the Amethyst Butterfly, one raised and one
detached, are worked in *Or Nué*, a goldwork technique in
which the gold threads are couched down decoratively using
coloured threads. As you can see here, colour and tone can
be varied by using different stitch spacings as well as different
shades of thread. The design has been embroidered on a
square of vintage fabric, woven with silk and metal threads.

Butterfly (*cho*)

Among designs based on living creatures, the butterfly motif enjoyed great popularity, especially among Japanese aristocrats, where it appears to have been favoured for its elegance.

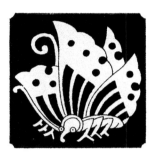

Butterfly *mon*

Japanese design motifs featuring the butterfly

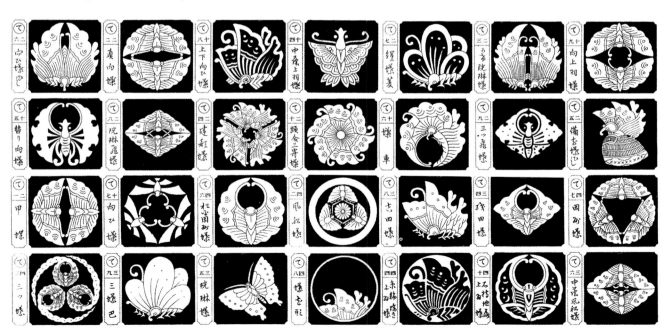

YOU WILL NEED

TEMPLATES:

For full-size, traceable outlines, please see page 172.

EQUIPMENT:

- Embroidery hoop or square frame –
 20cm (8in)
 10cm (4in)

NEEDLES:

- Crewel/embroidery size 10

- Milliners/straw size 9

- Sharps size 12

- Sharp yarn darners sizes 16 or 18

- Embroidery equipment (see page 12)

MATERIALS:

- Background fabric –
 28cm (11in) square of the background fabric of your choice
 (see page 22 for suggestions and preparation)

- Backing fabric –
 28cm (11in) square of firm cotton fabric (calico/muslin)

- Tracing paper –
 15cm (6in) square (I use baking parchment)

- Plain white paper (e.g. photocopy paper) –
 20cm (8in) square

- Non-stick pressing sheet or baking parchment

- Sticky notes

- Quilter's muslin (medium-weight cotton fabric) –
 20cm (8in) square

- White silk organza
 10cm (4in) square (if using transfer method 2)

- Paper-backed fusible web –
 two 10cm (4in) square pieces: one for organza and one
 for felt

- Yellow felt –
 10cm (4in) square

- Gold kid leather –
 5cm (2in) square

- Mill Hill Glass Seed Beads col. 374 (blue-purple) (x 2)

- 3mm (⅛in) gold hologram sequins (x 7)

- 28-gauge uncovered wire (x 3)

METAL THREADS:

- Gilt Very Fine Pearl Purl – 20cm (8in)

- Gilt Super Pearl Purl – 1m (1yd)

- Gilt No.1 Pearl Purl – 25cm (10in)

- Gilt No.3 Pearl Purl – 5cm (2in)

- Gilt No.6 Smooth Passing Thread – 5m (5½yd)

- Dark Gold 3-ply Twist – 1m (1yd)

SEWING THREADS:

- Fine gold metallic thread –
 YLI Metallic Yarn 601 col. Gold or
 Kreinik Japan Thread 002J

- Gold silk thread –
 YLI Silk Thread #50 col. 79

- Fine gold silk thread –
 YLI Silk Thread #100 col. 215

- Dark amethyst stranded thread –
 DMC 3740

- Medium amethyst stranded thread –
 DMC 3041

- Gold polyester sewing thread –
 Gütermann Polyester Thread col. 488

- Clear nylon thread –
 Madeira Monofil No.60 col. 1001

PREPARATION

The Amethyst Butterfly may be embroidered on a variety of background fabrics. Please refer to page 22 for suggestions and preparation.

TRANSFERRING THE DESIGN

I used method 2 on page 24 to transfer the design, as I found that the kimono silk that I had chosen for this design was not accepting the traced pencil line as produced in method 1. Test your fabric and use method 1 if preferred. After following steps 1–6 of method 2, I transferred the antennae outlines as follows:

Hold the traced Placement Outline over the fused butterfly shape, lining up the traced and tacked square outlines. Insert a row of fine needles, through the tracing paper and background fabric, along the antennae lines. Carefully remove the tracing paper, leaving the row of needles behind. Using fine silk thread in a fine needle, work a line of tacking/running stitches along the antennae lines, removing the needles as you go. These tacking stitches will be removed when the antennae are worked later.

ORDER OF WORK

WINGS

BACKGROUND WINGS

Outline the three background wings with a row of Gilt Super Pearl Purl, couched in place with waxed silk thread in a size 12 sharps needle. Work the outline around the larger forewing 1 first, then forewing 2 and the hindwing.

FOREWING 1

1 Using one strand of fine gold metallic thread in a size 9 milliners needle, couch a double row of Dark Gold 3-ply Twist along the scalloped outer edge of the wing, inside the purl. Sink the tails of twist at each edge.

2 Cut a 3.5cm (1⅜in) length of Gilt No.1 Pearl Purl. Expand this to 7cm (2¾in) – insert a fingernail into the coil at each end of the purl and pull apart until it measures 7cm (2¾in). Wrap the expanded purl with three strands of DMC 3740 dark amethyst thread, leaving a tail of thread at each end. Using one strand of dark amethyst thread in a size 10 crewel needle, couch the wrapped purl next to the twist as follows: sink one tail of wrapping thread at the upper corner of the wing, then couch the wrapped purl in place, making one stitch between each coil and working the stitches towards the twist. Before reaching the end, unwrap the thread from the purl, trim the purl to

the required length, then re-wrap the purl, taking the tail of thread through to the back at the lower edge. Complete the couching stitches. Secure the tails of thread at the back then trim.

3 Using the segment lines as a guide, fill each wing segment with couched rows of Gilt No.6 Smooth Passing Thread – mostly used double but single when required. The couching stitches are worked with either one strand of fine gold metallic thread (upper segment) or one strand of dark or medium amethyst thread (lower segment) – the dashed line (see diagram opposite) indicates the upper and lower segments. The couching stitches are worked either spaced or close together as explained in the box opposite (a technique called *Or Nué*).

4 Using nylon thread, stitch three gold sequins in the upper segment as shown in the photograph opposite.

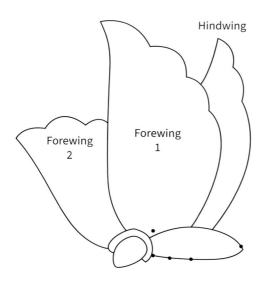

WORKING THE *OR NUÉ*

– Starting at the lower corner of the front segment, couch a double row of passing thread around the edge of the segment – couch the lower fore-edge with medium amethyst thread (the stitches spaced 1.5mm (1⁄16in) apart), the upper wing segment with gold metallic thread (stitches spaced 1.5mm (1⁄16in) apart), and the remaining edge with dark amethyst thread, working the couching stitches side by side (satin stitch) to represent the veins of the wings. Sink the tails of passing thread through to the back.

– Using the diagram and photograph as a guide, fill the remainder of the wing with couched passing thread, either double or single as necessary, and sinking the tails of thread through to the back when required. Use medium amethyst thread for the lower segment of the wing and gold metallic thread for the upper segment. Secure and trim all tails of thread.

– Work the remaining segments the same way, couching the back segment in medium amethyst and gold metallic thread only, as there is no vein in this segment.

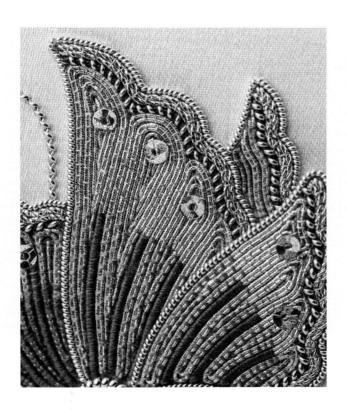

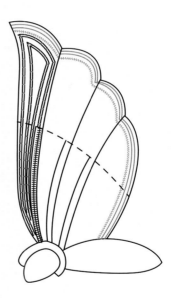

FOREWING 2

1 Using fine gold metallic thread, couch a double row of Dark Gold 3-ply Twist along the upper edge of the wing, inside the purl. Sink the tails of twist at each edge.

2 Cut a 2cm (¾in) length of Gilt No.1 Pearl Purl – expand to 4cm (1½in). Wrap and couch across the top edge of the wing, as for forewing 1.

3 Using the segment lines as a guide, fill each wing segment with couched rows of Gilt No.6 Smooth Passing Thread – mostly used double but single when required (as for forewing 1). The couching stitches are worked with either medium amethyst (for the upper segment) or dark amethyst thread (for the lower segment) – these stitches are worked either spaced, or close together for the veins. Some darker couching stitches may be worked for shading in the upper segment if desired.

4 Using nylon thread, stitch two gold sequins in the upper segments as shown in the photograph, opposite.

HINDWING

1 Using one strand of fine gold metallic thread, couch a double row of Dark Gold 3-ply twist along the scalloped outer edge of the hindwing, inside the purl. Sink the tails of twist at each edge.

2 Cut a 3cm (1¼in) length of Gilt No.1 Pearl Purl – expand to 6cm (2½in). Wrap and couch in place next to the row of twist, as for forewings 1 and 2.

3 Using medium amethyst thread, fill the wing with couched double rows of Gilt No.6 Smooth Passing Thread, working the rows parallel to the scalloped outer edge. Sink the tails of thread at the edges as required. Secure and trim.

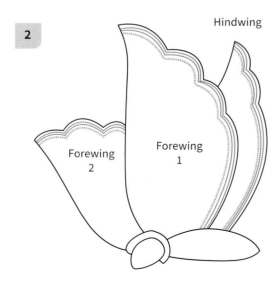

2

Hindwing

Forewing 2

Forewing 1

DETACHED WING

1 Mount a square of quilter's muslin into a small hoop and trace the detached wing outline.

2 The detached wing is outlined by a length of Gilt Super Pearl Purl with fine wire threaded through it. Before cutting the pearl purl, stretch it very slightly to make it easier to work with. Cut a 7cm (2¾in) length of Gilt Super Pearl Purl and an 18cm (7in) length of uncovered wire. Thread the wire through the cut length of purl, leaving tails of wire of equal length.

3 When shaping the wired purl, great care must be taken, as it is not possible to trim the purl once the wire has been threaded through. Using tweezers, shape the wired purl around the detached wing outline, leaving a tail of wire at each end of the wing outline. The purl should be slightly shorter than the wing outline (about 1mm shorter at each end).

4 Using waxed fine gold silk thread in a size 12 sharps needle, stitch the wired purl to the muslin, around the wing outline, with close couching stitches and working a stitch between each coil of the purl. Pull the stitches firmly so that they slip between the coils of the purl. There should be about 1mm of uncovered wire at each end of the wing shape.

5 Fill as for forewing 1. To avoid sinking tails of thread at the lower edge of the wing (which will be cut away), start the double rows of passing thread with a fold in the thread at the lower edge, when possible, or stitch the tails to the back behind the wing.

5

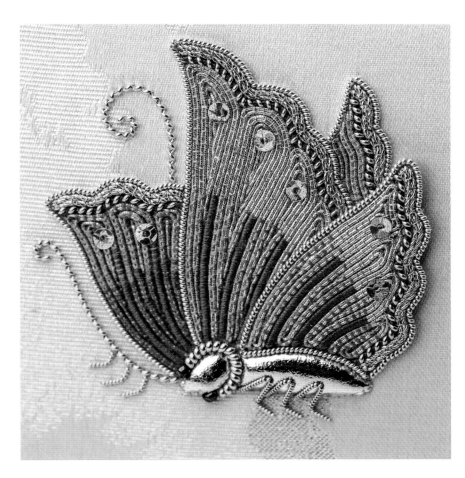

APPLYING THE DETACHED WING

1 Carefully cut out the wing close to the purl edge, leaving a 2–3mm (¹⁄₁₆–¹⁄₈in) margin of muslin at the lower (unwired) edge. Take care not to cut the wire tails.

2 To apply the detached wing to the background fabric, insert the wire tails at the edge of the outline of the abdomen at the points as marked • on the placement outline, using a yarn darner, and hold temporarily at the back with masking tape. Using fine gold silk thread, stitch the muslin edge to the top half of abdomen – lining up the lower edge of the wing with the top edge of the abdomen. Bend the wires behind the abdomen and stitch to the backing. Trim.

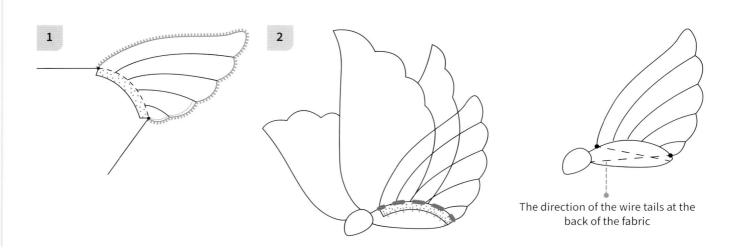

The direction of the wire tails at the back of the fabric

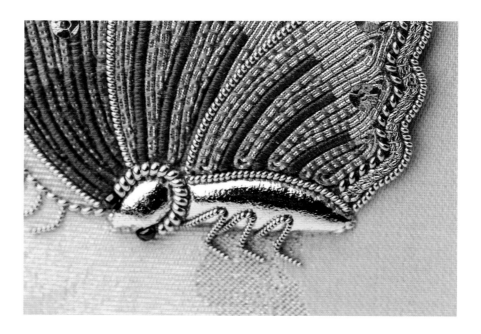

HEAD AND ABDOMEN

1 Trace the head and abdomen padding outlines onto the paper side of the fusible web then fuse to yellow felt. Carefully cut out the shapes and remove the paper backing.

2 **Abdomen padding:** Using gold polyester thread, stitch both layers of felt, web side down, to the background fabric with small stab stitches worked around the outside edge, applying the smaller layer first, and stitching over the muslin edge of the detached wing. Use the abdomen outline on the organza as a guide to placement.

3 **Head padding:** Stitch the padding to the head in the same way as for the abdomen.

4 Trace the Head and Abdomen Leather Outlines onto a sticky note (make sure the tracing is over the sticky end of the sticky note). Carefully cut out the abdomen shape. Check for size by placing over the padded abdomen – adjust for size if required. Stick the paper template to the right side of the gold kid leather and cut around the shape with fine sharp scissors. Using nylon thread in a size 12 sharps needle, apply the leather shape over the padded abdomen with small stab stitches, working the stitches from the silk into the leather shape. Shape the edges with a mellor or nail file, easing the top edge of the kid between the wing and the padding.

5 Stitch the gold kid over the head padding in the same way as for the abdomen. Using nylon thread, stitch a blue-purple bead on either side of the head for eyes.

6 Cut a length of Gilt No.3 Pearl Purl to fit around the head (between the eyes) to form a 'collar'. Stitch in place with waxed silk thread.

7 Using waxed silk thread, couch a length of Super Pearl Purl along the top edge of the abdomen – between the abdomen and detached wing.

5–7

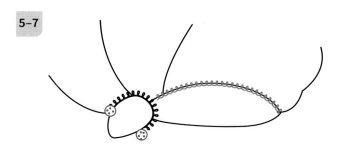

ANTENNAE

The antennae are worked with expanded Gilt No.1 Pearl Purl couched in place with nylon thread. Stretch a 5cm (2in) length of purl to 10cm (4in). Shape the expanded purl around the antennae outlines on the Placement Outline. Starting at the wing edge, couch the shaped purl to the background fabric, along the tacked antennae outlines, removing the silk tacking stitches as you go.

LEGS

DETACHED LEGS

1. Cut three 6cm (2½in) pieces of 28-gauge uncovered wire, one for each leg.
2. Insert 2cm (¾in) wire into the end of a piece of Gilt Very Fine Pearl Purl, leaving a 4cm (1½in) tail of wire protruding.
3. Starting at • bend the wired end of the purl into a leg shape, using the Detached Leg Outlines diagram as a guide. Cut both the wire and purl at the position shown in the illustration right. Shake out the small remaining piece of wire inside the purl. Repeat for the remaining two legs.
4. Using a fine yarn darner, insert the wire tails at the points as marked on the lower edge of the abdomen. Bend the wire tails behind the wings and hold with tape.
5. Adjust the shape of the legs as required, then, using nylon thread, make a stitch over the lower bend in each leg to secure.
6. Using stranded thread, secure the wire tails at the back, making a U-turn in the wire for extra security (see page 48). Trim the excess wire.

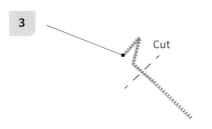

2

Tail

4cm (1½in) 2cm (¾in)

3

Cut

5

Stitch with nylon thread

BACKGROUND LEGS

Cut short lengths of Gilt Very Fine Pearl Purl and bend into leg shapes, using the Placement Outline as a guide. Couch in place with nylon thread.

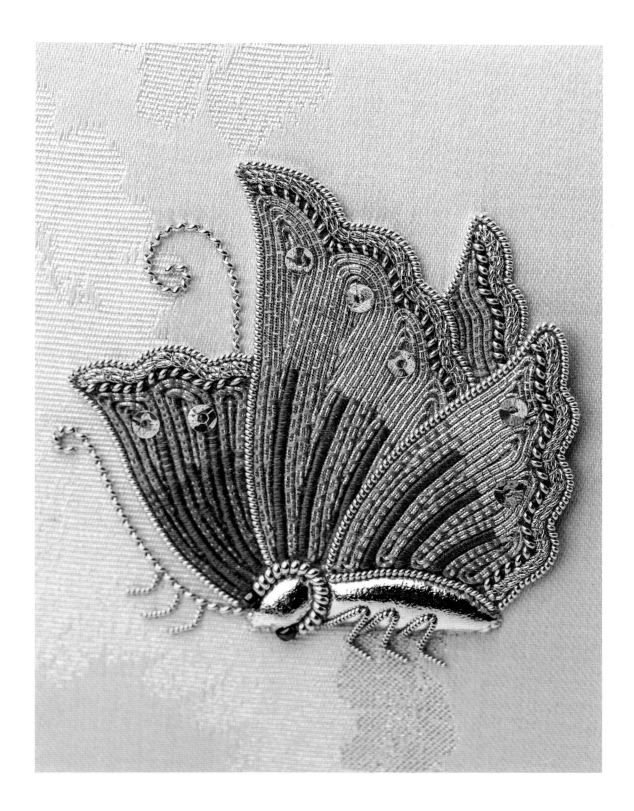

4
GOLD BUTTERFLIES

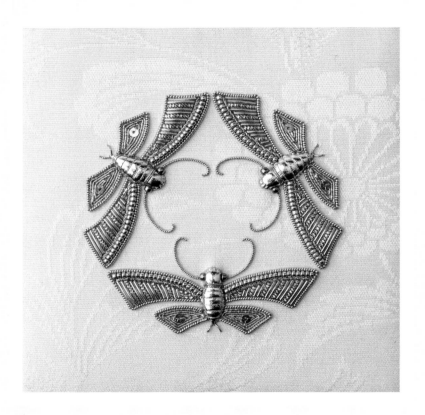

This Japanese family crest, featuring three butterflies, has been worked entirely with gold metallic threads, gold kid and beads, using traditional goldwork techniques. Three is considered to be a lucky number in Japan – it represents mind, body and spirit, as well as past, present and future. The finished piece would look stunning as a brooch, especially if worked on a dark background.

Butterflies (*chocho*)

As well as a symbol of joy and longevity, both the Chinese and Japanese regard the butterfly as a symbol of metamorphosis or transformation. They consider that butterflies (*chocho*) either carry, or are representative of, the souls of the dead.

Butterfly *mon*

YOU WILL NEED

TEMPLATES:

- For full-size, traceable outlines, please see page 173.

EQUIPMENT:

- Embroidery hoop or square frame –
 20cm (8in)

NEEDLES:

- Sharps size 12

- Milliners/straw sizes 5 and 9 or 10

- Chenille size 18

- Embroidery equipment (see page 12)

MATERIALS:

- Background fabric –
 28cm (11in) square of the background fabric of your choice
 (see page 22 for suggestions and preparation)

- Backing fabric –
 28cm (11in) square of firm cotton fabric (calico/muslin)

- Tracing paper –
 15cm (6in) square (I use baking parchment)

- Plain white paper (e.g. photocopy paper) –
 20cm (8in) square

- Sticky notes

- Paper-backed fusible web –
 10cm (4in) square

- Yellow felt –
 10cm (4in) square

- Gold kid leather –
 5cm (2in) square

- Mill Hill Petite Beads col. 40557 (gold) (1 pack)

- Mill Hill Antique Beads col. 3037 (abalone) (x 6)

- 2mm ($\frac{1}{16}$in) gold spangles (x 6)

METAL THREADS:

- Gilt Very Fine Pearl Purl – 20cm (8in)
- Gilt Super Pearl Purl – 1m (1yd)
- Gilt No.8 Bright Check Purl – 1m (1yd)
- Gilt No.8 Smooth Purl – 1.1m (1¼yd)
- Gold T71 Imitation Japanese Thread – 5m (5½yd)
- Dark Gold 3-ply Twist – 2m (2¼yd)
- Dark Gold Couching Thread 371 – 2m (2¼yd)

SEWING THREADS:

- Fine gold metallic thread –
 YLI Metallic Yarn 601 col. Gold or
 Kreinik Japan Thread 002J

- Gold silk thread –
 YLI Silk Thread #50 col. 79

- Fine gold silk thread –
 YLI Silk Thread #100 col. 215

- Clear nylon thread –
 Madeira Monofil #60 col. 1001

Author's note
If embroidering the butterflies on a dark background fabric, you will need a 10cm (4in) square of tracing carbon paper – I used white Clover Tracing Paper 'Chacopy' when I worked this design again on navy silk (see page 73).

PREPARATION

The Gold Butterflies may be embroidered on a variety of background fabrics. Please refer to page 22 for suggestions and preparation.

TRANSFERRING THE DESIGN

I used steps 1–3 of method 1 on page 23 to transfer the design. For step 4, you need to treat a light background fabric or dark background fabric slightly differently:

Step 4: Light background fabric: With the tracing paper right side up, position the tracing over the background fabric, lining up the traced square lines with the tacked square. Temporarily secure the edges of the tracing paper to the background fabric with strips of masking tape or translucent removable adhesive tape. Using a stylus, draw over the design lines to transfer the outlines to the background fabric (it helps to have a board or small book underneath the frame of fabric to provide a firm surface). Do not press too heavily when transferring the antennae outlines as the gold thread that will be covering them is very fine.

Step 4: Dark background fabric: With the tracing paper right side up, position the tracing over the background fabric, lining up the traced square lines with the tacked square. Temporarily secure two adjacent edges of the tracing paper to the background fabric with strips of masking tape or translucent removable adhesive tape. Carefully slip a 10cm (4in) square of white tracing carbon paper, waxy side down, between the tracing paper and the background fabric. Using a stylus, draw over the design lines to transfer white outlines to the background fabric (it helps to have a board or small book underneath the frame of fabric to provide a firm surface). Do not press too heavily when transferring the antennae outlines as the gold thread that will be covering them is very fine.

Author's note
Always use the minimum amount of lead when tracing. If your outlines are too dark, gently press the traced outlines with pieces of masking tape to remove any excess graphite.

ORDER OF WORK

BUTTERFLY BODY PADDING

The body of the butterfly, is padded with two layers of yellow felt.

1 With a fine lead pencil, trace the body padding outlines onto the paper side of the fusible web, then fuse to yellow felt. Carefully cut out both shapes for each butterfly, and remove the paper backing.

2 Using gold silk No. 50 thread in a size 12 sharps needle, apply both layers of felt (web side down) to the background fabric with small stab stitches around the outside edge. Apply the smaller layer of felt – the abdomen padding – first, then the larger body padding on top, using the traced body outline as a guide to placement.

ABDOMEN AND HEAD

The abdomen and the head of the butterfly are covered with gold kid leather, stitched in place with nylon thread in a size 12 sharps needle.

1 Trace the Body (abdomen and head) Leather Outline onto a sticky note, making sure that the traced outline is over the sticky end of the sticky note. Cut out the body shape from the sticky note and place over the padded body to check for size. Adjust if necessary – it should just cover the padding. Stick the sticky body shape to the right side of the gold kid and cut out around the edge of the shape.

2 Using nylon thread, stitch the gold kid over the padded body with small stab stitches, working the stitches from the background into the leather shape. Start by working a stitch at each compass point – the top of the head, tail and each side edge, then continue stitching around the outside edge of both the abdomen and the head – working the stitches 1.5mm (1⁄16in) apart, and alternately from side to side to achieve the best shape (this is optional). Smooth the edges of the kid with a mellor or nail file.

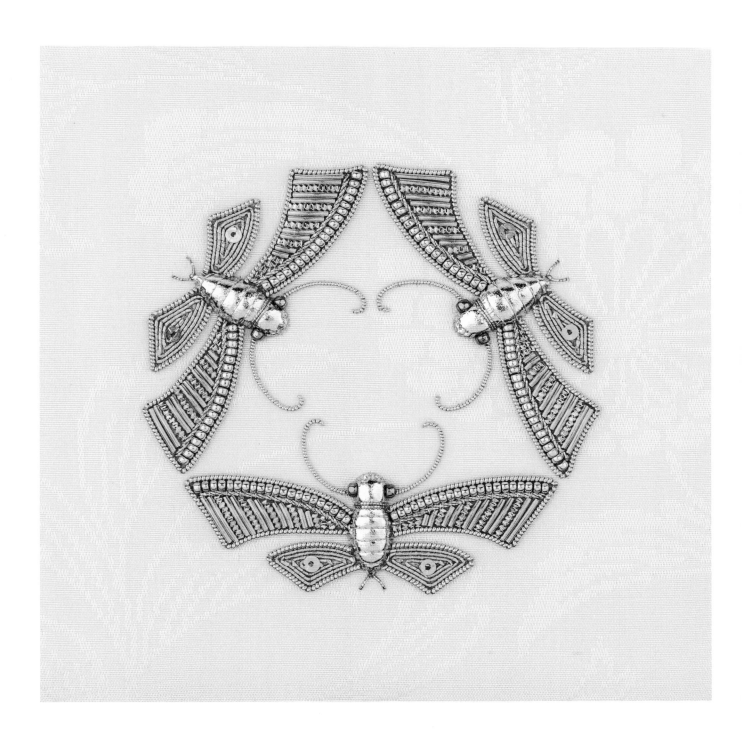

WINGS

WING OUTLINES

With gold silk thread in a size 12 sharps needle, couch a row of Gilt Super Pearl Purl around the outlines of the forewings and the hindwings, using tweezers to carefully bend the purl at the outer corners of the wings, and trimming the purl to the correct length at the inner body edge.

FOREWINGS

1 Couch a row of gold petite beads along the upper edge of the forewing, inside the purl outline as explained here. Bring a sharps needle, threaded with a double strand of gold silk thread, through to the front inside the outer top corner of the wing. Thread on 20–22 petite beads (more than required). With one strand of silk thread in a separate needle, and holding the row of threaded beads under tension, work a couching stitch between each bead, pushing each bead towards the previous couched bead as you go, and working the stitches towards the upper row of purl. Just before you reach the end of the row, remove any excess beads, insert the needle through to the back (next to the edge of the body), then complete the couching. Secure both threads at the back.

2 Couch a row of Dark Gold 3-ply Twist next to the row of beads, working the couching stitches with one strand of fine gold metallic thread in a size 10 milliners needle. Sink the tails of twist through to the back at each end of the row, using a lasso or a chenille needle (see page 25). Secure the tails of twist behind the wing.

3 Trace the forewing padding outlines onto the paper side of the fusible web then fuse to yellow felt. Carefully cut out the shapes and remove the paper backing.

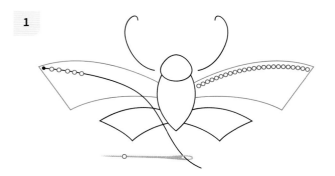

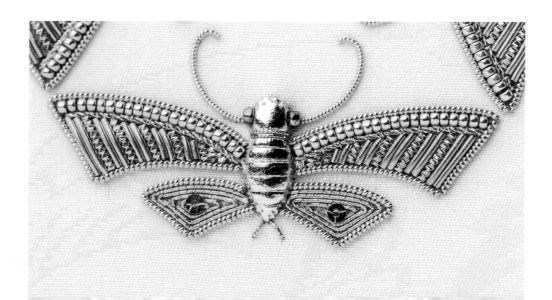

4 Using gold silk thread and small stab stitches, stitch a layer of felt (web side down) in the remaining space in each forewing. The felt may need to be trimmed so that it fits within the edges of the space, leaving a fingernail-width gap all around.

5 The padded area is covered with pieces of Gilt No.8 Bright Check Purl and Gilt No.8 Smooth Purl, cut to the appropriate length and stitched over the padding between the lower purl edge and the row of gold twist (satin-stitched purl). Using waxed gold silk thread in a size 12 sharps needle, and starting at the outer edge of the wing, stitch down, alternately, two lengths of smooth purl, then one length of bright check purl, the stitch direction being from the lower edge towards the upper edge. Work the inner corner of the wing with short lengths of bright check purl.

HINDWINGS

The hindwings are filled with rows of Gold T71 Imitation Japanese Thread, couched with fine (#100) gold silk thread in a size 12 sharps needle.

1 Start by inserting the tail of Japanese thread through to the back at the upper inner corner of the hindwing – hold the tail of thread out of the way with tape. Couch a row of Japanese thread around the inside edge of the wing, working the stitches towards the purl outline. Continue stitching consecutive rounds of Japanese thread, couching in a brick fashion where possible, until the shape is filled, leaving a tiny space in the centre of the wing (this will be covered by a spangle later). Using a chenille needle or lasso, sink the tail of thread through to the back (see page 25). Secure both tails of thread behind the wing.

2 Using nylon thread, stitch a gold spangle in the centre of each hindwing, working three stitches into each spangle.

4

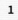

1

COMPLETING THE BUTTERFLIES

1 With Dark Gold Couching Thread 371 in a size 5 milliners needle, make two stitches across the neck to divide the head from the abdomen. It is easier to make each stitch by inserting both tails of thread from the front through to the back at the neck edge, leaving two tails of thread at the back for each stitch. Cross these tails behind the neck, and pull slightly to form a slight indentation between the head and the abdomen. With nylon thread, make a few stitches over the crossed tails of thread to secure. Trim the tails of gold thread. Retain the nylon thread to apply the eyes.

2 Using nylon thread, stitch an antique bead on either side of the head for the eyes, working four or five stitches, alternately, towards the head.

3 With Couching Thread 371, work a fly stitch at the base of the abdomen to form the claspers. Make the stitches 2.5–3mm (scant ⅛in) long, and keep the stitches loose so that they appear slightly raised.

4 With waxed fine gold metallic thread in a size 10 milliners needle, work five evenly spaced stitches across the abdomen to form segment lines. I found it easier to make each stitch individually – inserting the tails of thread for each stitch from the front through to the back, then tying the tails together in a knot to secure. Although more labour intensive, this method is less likely to disturb the threads surrounding the abdomen.

5 The antennae are worked with Gilt Very Fine Pearl Purl couched in place with fine gold silk thread. Cut six 1.6cm (⅝in) lengths of purl and shape around the antennae outlines on the Design Outline. Starting at the eyes, couch the pieces of shaped purl to the background, over the traced antennae outlines.

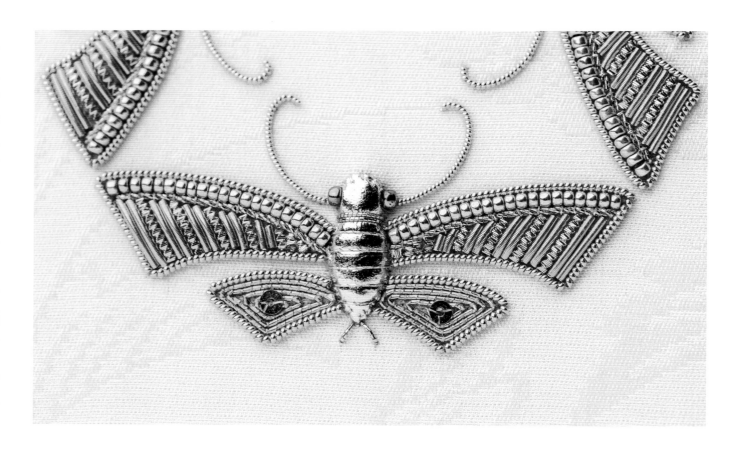

72

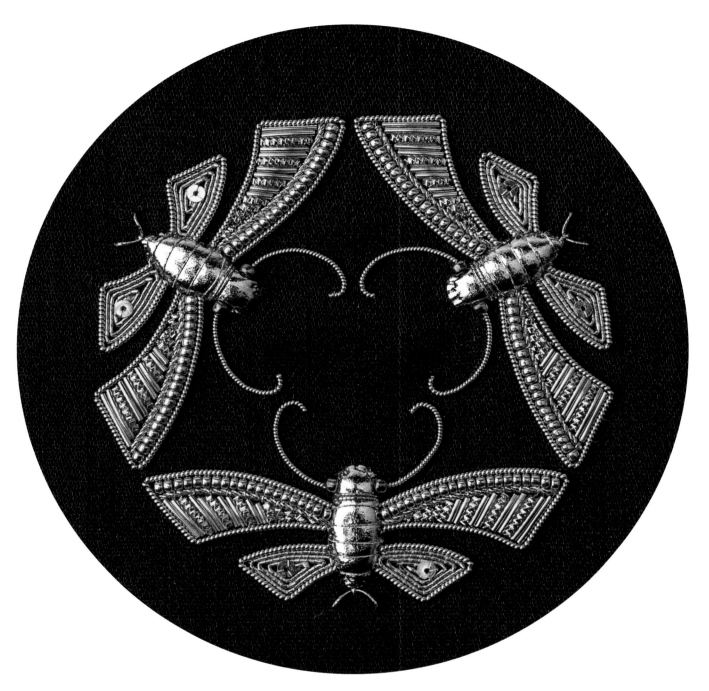

The Gold Butterflies may also be
embroidered on a dark background, such
as the dark navy kimono silk shown here.

5
PINK PLUM BLOSSOM

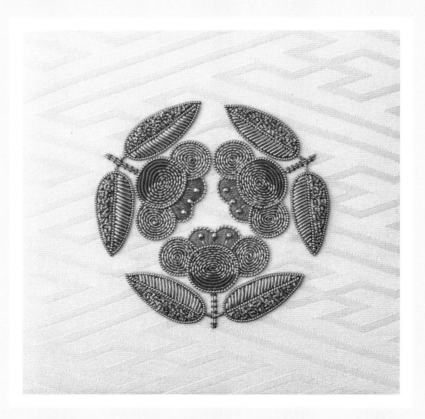

The design for this goldwork plum blossom was inspired by one of many Japanese family crest designs featuring the plum blossom, one of the more popular motifs in Japanese heraldry. Using traditional goldwork techniques, with a variety of gold metallic threads and stranded cotton thread in several shades of pink (or the colour of your choice), this small embroidered medallion may be worked on ivory silk or satin, or the fabric of your choice. I used a scrap of vintage kimono silk. The finished panel may be framed, mounted into the lid of a box, or made into a brooch.

Plum blossom (*ume*)

Introduced from China, the plum was initially the flower most frequently mentioned in Japanese poetry, being celebrated for its delicate blossoms, sweet perfume and custom of flowering during winter's end. Although superseded in popularity by the cherry blossom, the plum continued to be a very popular motif in Japanese art, a favourite subject of early painters being a plum tree with the Japanese bush warbler, *uguisu*, singing in its branches. Frequently appearing as a stylized five-petalled flower motif, the plum-blossom pattern could be found decorating textiles, carriages, furniture and porcelain, and personal items such as the backs of hand mirrors and chests for cosmetics.

With its decorative possibilities, its tradition of endurance, and association with poets and other men of learning, the plum blossom emerged as one of the more popular motifs in Japanese heraldry – there are more than eighty family crests based on the plum blossom.

Although delicate and fragile in appearance, the plum represents more than beauty in Japan. With its habit of blooming in the latter part of winter, it is regarded, along with the pine and bamboo, as a symbol of longevity and resilience. The plum, pine and bamboo are celebrated together as an art motif – 'The Three Friends of Winter'.

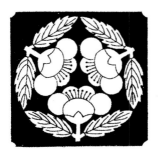

Plum-blossom *mon*

YOU WILL NEED

TEMPLATES:

For full-size, traceable outlines, please see page 174.

EQUIPMENT:

- Embroidery hoop or square frame –
 20cm (8in)

NEEDLES:

- Crewel/embroidery size 10

- Milliners/straw size 9

- Sharps size 12

- Chenille size 22

- Embroidery equipment (see page 12)

MATERIALS:

- Background fabric –
 28cm (11in) square of the background fabric of your choice
 (see page 22 for suggestions and preparation)

- Backing fabric –
 28cm (11in) square of firm cotton fabric (calico/muslin)

- Tracing paper –
 15cm (6in) square (I use baking parchment)

- Plain white paper (e.g. photocopy paper) –
 20cm (8in) square

- Non-stick pressing sheet or baking parchment

- Yellow felt –
 7 x 5cm (3 x 2in)

- Paper-backed fusible web –
 7 x 5cm (3 x 2in)

- Mill Hill Petite Beads col. 40557 (gold) (x 12)

METAL THREADS:

- Gilt No.6 Smooth Passing Thread – 10m (11yd)

- Gilt Super Pearl Purl – 1.2m (1½yd)

- Gilt No.8 Bright Check Purl – 1m (1yd)

- Gilt No.8 Smooth Purl – 1m (1yd)

- Gold T71 Imitation Japanese Thread – 1m (1yd)

SEWING AND EMBROIDERY THREADS:

- Fine gold metallic thread –
 YLI Metallic Yarn 601 col. Gold or
 Kreinik Japan Thread 002J

- Gold silk thread –
 YLI Silk Thread #50 col. 79

- Fine gold silk thread –
 YLI Silk Thread #100 col. 215

- Clear nylon thread –
 Madeira Monofil No.60 col. 1001

- Dark pink stranded thread –
 DMC 3831

- Medium pink stranded thread –
 DMC 3832

PREPARATION

The Pink Plum Blossom may be embroidered on a variety of background fabrics. Please refer to page 22 for suggestions and preparation.

TRANSFERRING THE DESIGN

I used method 1 on page 23 to transfer the design.

Author's note
Always use the minimum amount of lead when tracing. If your outlines are too dark, gently press the traced outlines with pieces of masking tape to remove any excess graphite.

ORDER OF WORK

PETALS

UPPER BACKGROUND PETALS

The upper background petals are worked in padded satin stitch using one strand of medium pink thread in a size 10 crewel needle.

1 Using one strand of thread, work straight stitches to pad the upper background petals, working the stitches parallel to the upper edge.

2 Starting in the centre of the shape, embroider the background petals in satin stitch, working the stitches from the outside edge towards the centre petal.

Author's note
The upper petal edging and beads are applied to the petals *after* the centre and side petals are worked.

PETALS *CONT.*

CENTRE PETAL

The centre petal is filled with concentric rounds of Gilt No.6 Smooth Passing Thread, couched in place with one strand of dark pink thread in a size 10 crewel needle.

1 Starting at the upper left side (leaving the tail of passing thread on the surface), couch a round of smooth passing thread around the edge of the centre petal, placing the passing thread next to the pencil line and working the couching stitches 2mm (1/16in) apart for the blossom and close together (almost satin stitch) at the base of the petal to represent the sepals, using the traced sepal lines as a guide. Continue stitching rounds of passing thread to fill the shape, couching in a brick fashion for the blossom and close together for the sepals, until the centre is reached. Using a fine chenille needle, or a lasso of strong thread, sink both tails of thread through to the back and secure (see page 25).

2 Couch a row of Gilt Super Pearl Purl around the edge of the centre petal, using waxed fine gold silk thread in a size 12 sharps needle.

SIDE PETALS

The side petals are filled with concentric rows of Gilt No.6 Smooth Passing Thread, couched in place with one strand of medium pink thread.

1 Cut a 20cm (8in) length of smooth passing thread. Starting at the lower corner A, sink the tail of the passing thread to the back and hold out of the way with tape, then couch a row of passing thread around the edge of the side petal, placing the passing thread next to the pencil line and working the stitches 2mm (1/16in) apart. Bend the passing thread at the upper corner of the petal at B then couch the thread, in brick fashion, next to the previous row, back to A.

2 To fill the petal, continue to couch the passing thread, in a circular fashion, until the centre is reached (work in an anti-clockwise direction for the left side petal and clockwise direction for the right side petal). Sink the tail of thread through to the back and secure.

3 Couch a row of Gilt Super Pearl Purl around the outer edge of the side petal (from A to B) using waxed fine gold silk thread.

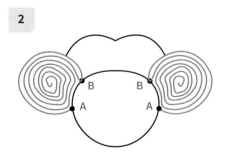

78

COMPLETING THE UPPER BACKGROUND PETALS

1 Cut a 10cm (4in) length of Gilt Super Pearl Purl and expand to 18cm (7in) by holding a coil of purl at each end and pulling apart gently. Using nylon thread in a size 12 sharps needle, couch a row of expanded purl around the top edge of the upper back petals. It is easier to shape a piece of expanded purl against the petal diagram first, then start couching from the middle, trimming the ends of purl as required.

2 Stitch three gold petite beads on top of the satin-stitched petals with nylon thread.

3 Using a double strand of fine gold metallic thread in a size 9 milliners needle, work a straight stitch from each bead to the edge of the centre petal.

STEMS

Using dark pink thread, couch a double row of Gold T71 Imitation Japanese Thread at the base of each blossom to form the stems (five to six stitches). Sink the tails at each end of the line (9mm/⅜in) – secure the top tails behind the blossom and lower tails behind the stem.

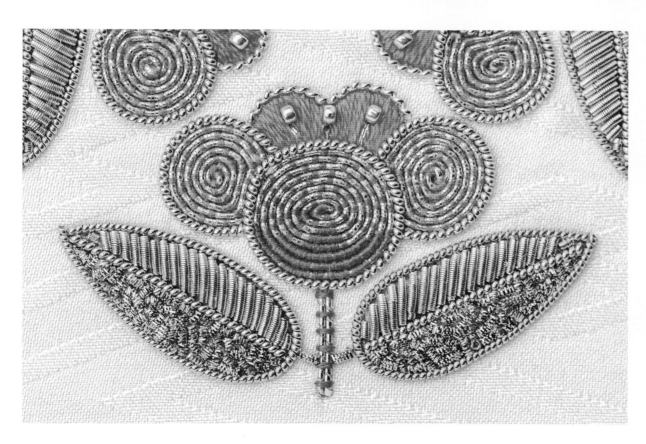

LEAVES

1 Using waxed fine gold silk thread, couch a row of Gilt Super Pearl Purl around the outline of each leaf, starting and ending the couching at the tip of the leaf to form a point.

2 Couch a row of Gilt Super Pearl Purl along the centre vein line as well.

3 Trace the leaf padding outlines onto the paper side of the fusible web then fuse to yellow felt. Carefully cut out the shapes and remove the paper backing.

4 Using gold silk thread, and small stab stitches, stitch a layer of felt (web side up to avoid the felt shredding, see Note on page 25) inside each leaf margin. The felt may need to be trimmed slightly so that it just fits inside the purl edges of the leaf.

5 Cover the upper half of each leaf with lengths of Gilt No.8 Smooth Purl, cut to the appropriate length, and stitched in place with gold silk thread in a size 12 sharps needle (satin-stitched purl). Start at the tip of the leaf with a short piece of purl to fill the tip – 1.5mm (¹⁄₁₆in) length, then apply the cut lengths of purl, over the padding, working the stitches from the vein towards the outer edge.

6 The lower half of each leaf is filled with cut chips of Gilt No.8 Bright Check Purl. Using waxed gold silk thread, fill the lower leaf with bright check purl chips (1.5–2mm (¹⁄₁₆in) in length), sewn on individually and in as many different directions as possible.

7 Stitch a small length of bright check purl at the base of each leaf to form the stem.

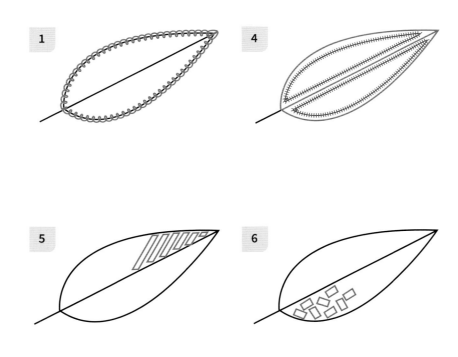

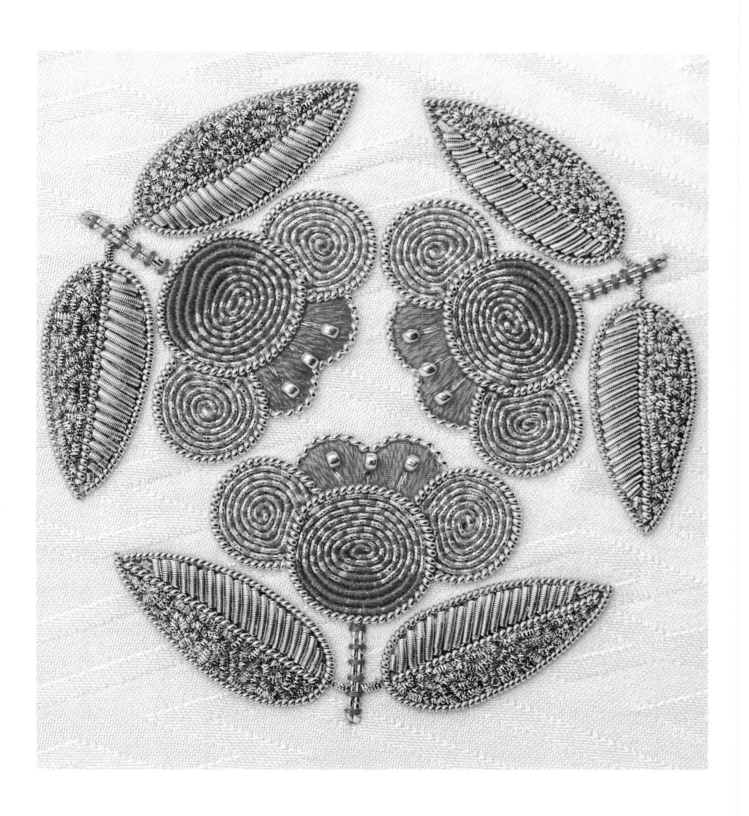

6
GREEN JAPANESE GINGER PLANT

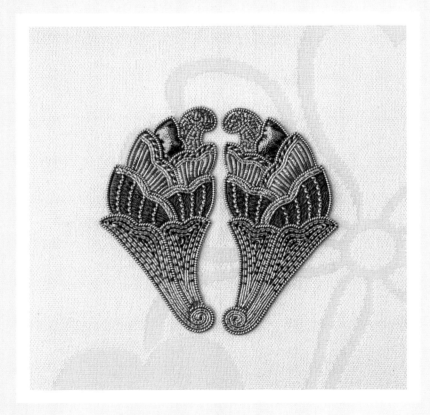

This goldwork design was inspired by one of the many
Japanese family crests featuring the Japanese ginger plant,
myoga ginger – the edible flower buds and flavourful shoots
make it a popular culinary plant. Using traditional goldwork
techniques, I used vintage metal threads, from my collection,
to embroider these small motifs onto a piece of old kimono
silk. The finished panel may be made into a brooch.

Ginger plant (*myoga*)

Japanese ginger, *myoga*, is a perennial herb-like plant native to Japan, China and the Korean peninsula. Used as a flavouring in cooking, the edible flower buds and flavourful shoots of *myoga* may be eaten fresh or pickled. Japanese ginger is in the same genus as ginger but, unlike true ginger, its roots are not edible. One story surrounding Japanese ginger is that if one eats it, all troubles will be forgotten.

With its unusual elegant shape, and auspicious connotations, the ginger plant was a popular motif for family crests and as decoration on military accoutrements. Considered a symbol of good fortune, the favourable associations of *myoga* derive from the fact that its name is homonymic with another Japanese word that means 'divine protection'.

Ginger plant *mon*

YOU WILL NEED

TEMPLATES:

For full-size, traceable outlines, please see page 175.

EQUIPMENT:

- Embroidery hoop or square frame –
 20cm (8in)

NEEDLES:

- Crewel/embroidery size 10

- Sharps size 9 and 12

- Embroidery equipment (see page 12)

MATERIALS:

- Background fabric –
 28cm (11in) square of the background fabric of your choice
 (see page 22 for suggestions and preparation)

- Backing fabric –
 28cm (11in) square of firm cotton fabric (calico/muslin)

- Tracing paper –
 15cm (6in) square (I use baking parchment)

- Plain white paper (e.g. photocopy paper) –
 20cm (8in) square

- Non-stick pressing sheet or baking parchment

- Sticky notes

- White silk organza –
 10cm (4in) square (if using transfer method 2)

- Yellow felt –
 10cm (4in) square

- Paper-backed fusible web –
 two 10cm (4in) square: one for organza and one for felt

- Green/grey (pewter) leather –
 5cm (2in) square

METAL THREADS:

- Dark Gold 3-ply Twist – 1m (1yd)

- Gold T70 Imitation Japanese Thread – 2m (2¼yd)

- Gold T71 Imitation Japanese Thread – 5m (5½yd)

- Gilt Super Pearl Purl – 1m (1yd)

- Gilt No.1 Pearl Purl – 15cm (6in)

- Gilt No.8 Smooth Purl – 1m (1yd)

- Gilt No.8 Rough Purl – 1m (1yd)

- Gilt No.8 Bright Check Purl – 1m (1yd)

SEWING AND EMBROIDERY THREADS:

- Fine gold metallic thread –
 YLI Metallic Yarn 601 col. Gold or
 Kreinik Japan Thread 002J

- Gold silk thread –
 YLI Silk Thread #50 col. 79

- Clear nylon thread –
 Madeira Monofil No.60 col. 1001

- Medium green stranded thread –
 Soie d'Alger 5024 or DMC 501

PREPARATION

The Green Japanese Ginger Plant may be embroidered on a variety of background fabrics. Please refer to page 22 for suggestions and preparation.

TRANSFERRING THE DESIGN

I used method 2 on page 24 to transfer the design, as I found that the kimono silk that I had chosen for this design was not accepting the traced pencil line as produced in method 1. Test your fabric and use method 1 if preferred.

DIAGRAM OF SEGMENTS

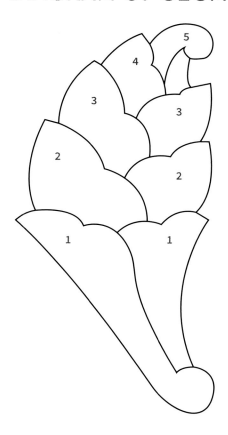

ORDER OF WORK

SEGMENTS 1

The lower segments (segments 1) of the ginger plant are filled with rows of Gold T71 Imitation Japanese Thread couched with one strand of either gold metallic or green thread, inside an outline of Gilt Super Pearl Purl.

1　Using waxed silk thread in a size 12 sharps needle, couch a row of Gilt Super Pearl Purl around the outlines of segments 1. Work the larger outer segment first, starting at A and couching in the direction as shown on the diagram, then the smaller inner segment.

2　The outer segment is filled with couched rows of Gold T71 Imitation Japanese Thread – used mostly double but single in the centre when required, couching with either gold metallic or green thread as directed:

– couch the lower part of each segment with one strand of fine gold metallic thread in a size 9 sharps needle, working the stitches 2mm (¹⁄₁₆in) apart in a brick fashion when possible.

– change to one strand of green thread, in a size 10 crewel needle, to work the upper section of the segment, working the stitches 2mm (¹⁄₁₆in) apart in the central part of the segment reducing to 1.5–1mm (¹⁄₁₆in) apart near the upper edge of the segment (a technique called *Or Nué*). Couch in a brick fashion when possible following the guidance below.

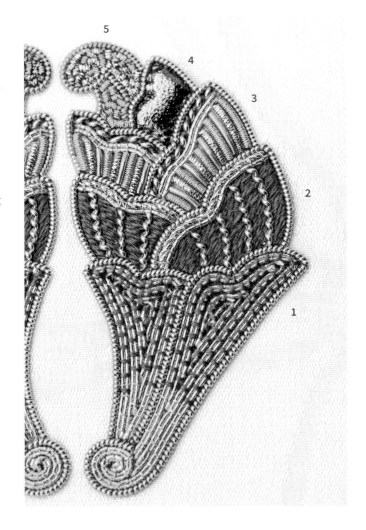

Use the photograph above and diagram below as a guide to stitch placement.

(i)　Starting at point A in the larger outer segment, and leaving the tails of thread on the surface, couch a double row of Japanese thread around the edge of the segment, inside the purl outline. Fill the lower space of the segment with a spiral of couched thread – sinking the tails through to the back in the centre of the spiral. Sink the initial tails of Japanese thread through to the back and hold out of the way with tape.

(ii)　Starting at the edge of the lower couched spiral, fill the remainder of the segment with couched Japanese thread, mostly double but single in the centre when necessary, and sinking the tails of thread through to the back as required. Secure and trim all tails.

3　Fill the smaller inner segment with couched rows of Japanese thread, as for the outer segment, starting and ending the threads at the edge of the lower spiral.

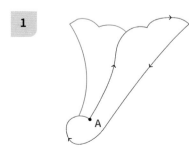

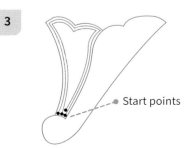

SEGMENTS 2

Segments 2 are filled with satin stitch, worked with one strand of green thread, inside an outline of Gilt Super Pearl Purl.

1 Using one strand of green thread in a size 10 crewel needle, embroider the inside of the segments with long satin stitches, working the stitches parallel to the upper curved edge.

2 Using waxed silk thread in a size 12 sharps needle, couch a row of Gilt Super Pearl Purl around the outlines of segments 2, working the larger outer segment first, then the smaller inner segment.

3 Couch a row of Dark Gold 3-ply Twist and Gold T70 Imitation Japanese Thread, together, to form a border along the top edge of the segments, using one strand of

waxed fine gold metallic thread in a size 9 sharps needle. Sink the tails of thread at each side using a lasso of thread (this method is less likely to disturb the couched purl outline).

4 Stretch a 15cm (6in) length of Gilt No.1 Pearl Purl to 30cm (12in) (insert a fingernail through the final coil at each end of the purl and gently pull apart). Using nylon thread in a size 12 sharps needle, couch cut lengths of stretched purl across the long satin stitches, using the diagram as a guide to placement. Make sure that the couching stitches pierce the satin stitches to avoid gaps in the satin stitch.

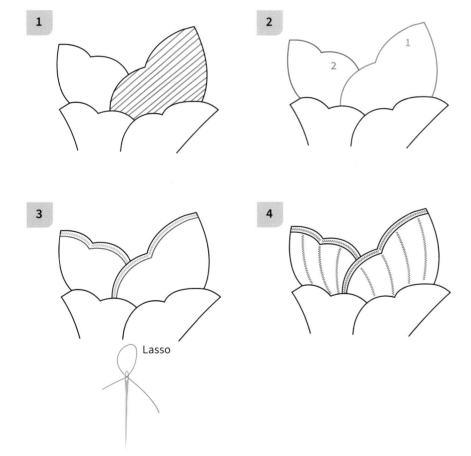

Lasso

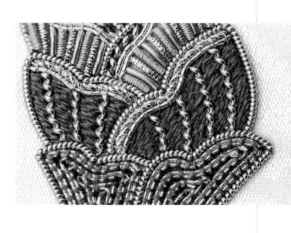

SEGMENTS 3

1. Using waxed gold silk thread in a size 12 sharps needle, couch a row of Gilt Super Pearl Purl around the outlines of segments 3, working the larger outer segment first, then the smaller inner segment.

2. Stretch a 5cm (2in) length of Gilt Super Pearl Purl to 10cm (4in). This stretched purl will be wrapped with green thread then couched along the top edge of the segment, inside the purl outline, as follows:

 i) Shape a piece of stretched purl along the top edge of the segment and cut to length.

 ii) Wrap the shaped purl with three strands of green thread, leaving tails of thread at each end.

 iii) Using one strand of green thread, couch the wrapped purl along the top edge of the segment, inside the purl outline, working one couching stitch across every coil. It is easier to insert the tails of green thread through to the back at each side before you commence couching. Secure the tails of thread at the back.

3. Using one strand of fine metallic thread, couch a double row of Gold T70 Japanese thread next to the wrapped purl to complete the border. Sink the tails of thread at each end using a lasso of thread (see page 25). Secure the tails.

4. Trace the segment padding outlines onto the fusible web then fuse to yellow felt. Cut out shapes to pad the remaining space inside each segment (trim the felt until it fits, leaving a fingernail of space all around the inside edge). Apply the padding, fusible web side down, with small stab stitches using one strand of gold silk thread.

5. Using one strand of waxed silk thread in a size 12 sharps needle, cover the padding with pieces of purl, cut to size (satin-stitched purl), working the stitches from the lower edge towards the upper edge. Use, alternately, the following purls – Gilt No.8 Rough Purl, Gilt No.8 Bright Check Purl, Gilt No.8 Smooth Purl.

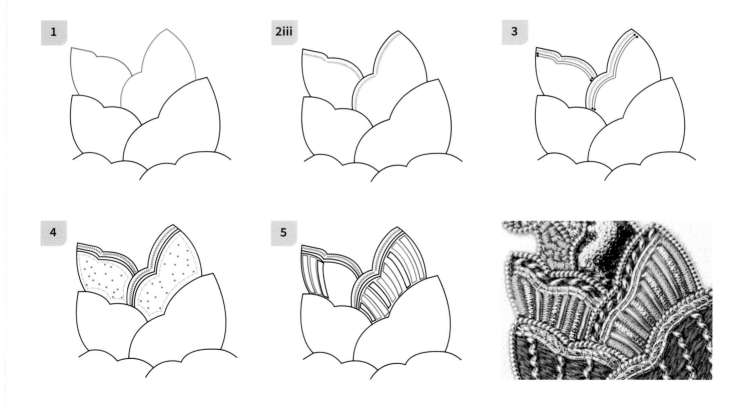

88

SEGMENT 4

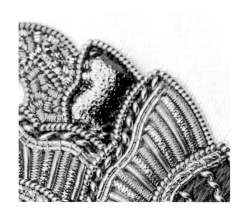

1 Trace a padding outline for segment 4 onto the fusible web then fuse to yellow felt. Cut the padding shape a scant 1mm inside the outline. With one strand of silk thread, stitch the padding inside the outline with small stab stitches, fusible web side down.

2 Trace the Segment 4 Leather Outline onto a sticky note (over the sticky end). Cut out this shape and hold over the padded segment to check for size (it should be the same size as the padded space – the traced line on the upper edges, the lower line next to the purl edge of segment 3). Stick the sticky note template to the right side of the pewter leather and cut out the shape. Carefully bevel the back edges of the leather if necessary.

3 Using nylon thread in a size 12 sharps needle, apply the leather over the padding with small stab stitches. Start by working a stitch at each corner, then around the edges, easing the lower edge of the leather under the purl.

4 Using waxed gold silk thread, couch a row of Gilt Super Pearl Purl around the upper edges of the segment.

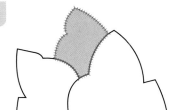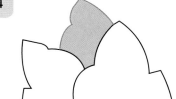

SEGMENT 5

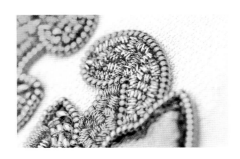

1 Using waxed gold silk thread, couch a row of Gilt Super Pearl Purl around the outlines of segment 5, working the larger outer segment lines first, then the smaller inner line.

2 Fill the larger section of the segment with small chips of Gilt No. 8 Bright Check Purl, stitched in all directions with waxed silk thread in a size 12 sharps needle.

3 Fill the smaller section of the segment with small chips of Gilt No.8 Rough Purl.

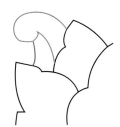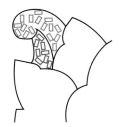

7
ORANGE CHRYSANTHEMUMS

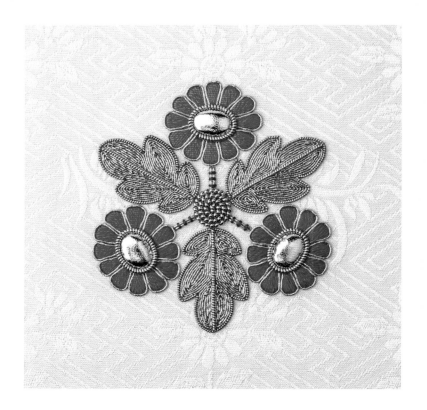

Once a symbol of the Japanese imperial family, the chrysanthemum features in more than ninety family crest designs. This small medallion is worked with gold and silk threads and gold kid leather, employing traditional goldwork techniques. It has been embroidered on a background of cream chrysanthemum-patterned kimono silk.

Chrysanthemum (*kiku*)

The chrysanthemum had its origins in China where the flower was esteemed for its therapeutic properties, being widely used to help treat nervous conditions and general debility. According to legend, it was believed that drinking water into which chrysanthemum blossoms had fallen would ensure a long life. The chrysanthemum came to be regarded as an auspicious symbol of longevity and endurance.

From as early as the eighth century, the elegant chrysanthemum pattern, with its intrinsic beauty and decorative symmetry, was used extensively on formal court attire by Japanese courtiers and, with the adoption of the sixteen-petalled chrysanthemum as the crest of Japan's imperial family in the thirteenth century, the chrysanthemum motif came to be regarded as one of the most prestigious of emblems. In later centuries, with the granting of permission to use the imperial chrysanthemum, the motif came to be appropriated at will, often appearing as trademarks and patterns on commercial goods. Many used the flower as a family crest, with a catalogue from 1913 displaying ninety-five crest designs based on the chrysanthemum.

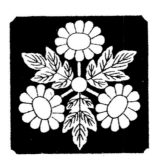

Chrysanthemums *mon*

YOU WILL NEED

TEMPLATES:

For full-size, traceable outlines, please see page 176.

EQUIPMENT:

- Embroidery hoop or square frame –
 20cm (8in)

NEEDLES:

- Crewel/embroidery sizes 3 and 10

- Milliners/straw size 9

- Sharps size 12

- Chenille sizes 18 and 22

- Embroidery equipment (see page 12)

MATERIALS:

- Background fabric –
 28cm (11in) square of the background fabric of your choice
 (see page 22 for suggestions and preparation)

- Backing fabric –
 28cm (11in) square of firm cotton fabric (calico/muslin)

- Tracing paper –
 15cm (6in) square (I use baking parchment)

- Plain white paper (e.g. photocopy paper) –
 20cm (8in) square

- Non-stick pressing sheet or baking parchment

- Sticky notes

- Yellow felt –
 7 x 5cm (3 x 2in)

- Paper-backed fusible web –
 7 x 5cm (3 x 2in)

- Gold kid leather –
 5cm (2in) square

METAL THREADS:

- Gilt No.6 Smooth Passing Thread – 5m (5½yd)

- Dark Gold Couching Thread 371 – 5m (5½yd)

- Gilt Very Fine Pearl Purl – 1m (1yd)

- Gilt Super Pearl Purl – 15cm (6in)

- Gilt No.1 Pearl Purl – 15cm (6in)

- Gilt No.2 Pearl Purl – 10cm (4in)

- Gold T71 Imitation Japanese Thread – 1m (1yd)

SEWING AND EMBROIDERY THREADS:

- **Fine gold metallic thread –**
 YLI Metallic Yarn 601 col. Gold or
 Kreinik Japan Thread 002J

- **Gold silk thread –**
 YLI Silk Thread #50 col. 79

- **Fine gold silk thread –**
 YLI Silk Thread #100 col. 215

- **Light orange stranded thread –**
 Soie d'Alger 645 or DMC 947

- **Medium orange stranded thread –**
 Soie d'Alger 635 or DMC 946

- **Dark orange stranded thread –**
 Soie d'Alger 636 or DMC 900

- **Russet stranded thread –**
 Soie d'Alger 2626 or DMC 918

- **Gold polyester sewing thread –**
 Gütermann Polyester Thread col. 488

- **Clear nylon thread –**
 Madeira Monofil No.60 col. 1001

PREPARATION

The Orange Chrysanthemums may be embroidered on a variety of background fabrics. Please refer to page 22 for suggestions and preparation.

TRANSFERRING THE DESIGN

I used method 1 on page 23 to transfer the design.

Author's note
Always use the minimum amount of lead when tracing. If your outlines are too dark, gently press the traced outlines with pieces of masking tape to remove any excess graphite.

ORDER OF WORK

PETALS

The flower petals are worked in padded satin stitch, inside a gilt outline, using one strand of orange thread in a size 10 crewel needle. I worked one flower in dark orange, one flower in medium orange, and the remaining flower in light orange thread. You may prefer to use all shades of orange thread within each flower.

Author's note
I found it easier to work the couching stitches around each petal in the order shown in the diagram opposite, fine-tuning the shape of each petal after stitch 4, before completing the couching. Use tweezers to gently squeeze the edges of the loops together at the inner edge of the petal.

1 Using nylon thread in a size 12 sharps needle, couch a row of Gilt No.6 Smooth Passing Thread around the edge of each petal, making a loop in the gold thread at the inner edge, next to the flower-centre outline, and leaving both tails of thread on the surface. Using a size 3 crewel needle or a fine chenille needle, sink the tails of thread through to the back and secure.

2 Using one strand of dark orange thread, work straight padding stitches across the petals, inside the gilt outline. Embroider each petal in satin stitch, working the stitches from the centre outline towards the outer edge, commencing the satin stitching in the centre of a petal and working about seven to eight stitches (I aimed to work the same number of satin stitches in each petal so that they would be a similar size).

3 Work the petals of the remaining flowers the same way, using medium orange thread for one flower, and light orange for the other. You may prefer to use all the shades of orange in each flower.

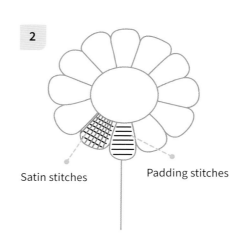

Satin stitches Padding stitches

FLOWER CENTRES

The centre of each flower is covered with gold kid leather, applied over yellow-felt padding, then outlined with Gilt No.1 Pearl Purl.

1 Trace the flower centre padding outlines onto the paper side of the fusible web, then fuse to the yellow felt. Carefully cut out the shapes and remove the paper backing.

2 Using polyester thread in a size 10 crewel needle, apply both layers of felt (web side down) to the background fabric, inside the centre outline, with small stab stitches around the outside edge, applying the smaller layer first.

3 Trace the Flower Centre Leather Outline onto a sticky note, making sure that the traced outline is over the sticky end of the sticky note. Cut out the shape – just at the edge of the traced line, and place it over the padded centre to

check for size. Adjust if necessary – it should just cover the padding. Stick the centre shape to the right side of the gold leather and cut out around the edge of the shape.

4 Using nylon thread, stitch the leather over the padded centre with small stab stitches. Start by working a stitch at the 'north, south, east and west' positions, then continue stitching all around the outside edge, working the stitches towards the leather shape. Smooth the edges of the leather with a mellor or nail file.

5 Using waxed gold silk thread, couch a row of Gilt No.1 Pearl Purl around the edge of the gold kid centre, butting the cut ends of the purl together.

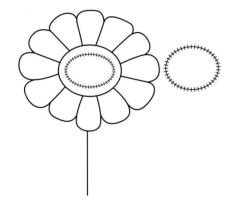

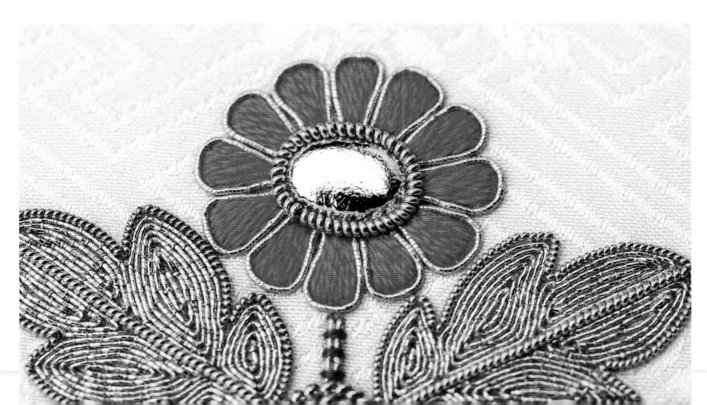

LEAVES

The leaves are outlined with Gilt Very Fine Pearl Purl then filled with rows of couched Dark Gold Couching Thread 371.

1 Couch a row of Gilt Very Fine Pearl Purl around the outer edge of the leaf, starting and ending at the lower stem end, and using tweezers to bend the purl gently at the points and indentations as required. Use one strand of fine gold silk thread, waxed, in a size 12 sharps needle for the couching – a thicker silk thread may show across this very fine purl.

2 Using waxed gold silk thread, couch a row of Gilt Super Pearl Purl along the central vein of the leaf, inside the purl edge.

3 Starting at a lower inner corner of the leaf (and sinking the tail of couching thread through to the back with a size 3 crewel needle), couch a row of Dark Gold Couching Thread 371 around the perimeter of the lower segments of the leaf, working the right segment in an anti-clockwise direction, and the left segment in a clockwise direction. Use one strand of fine gold metallic thread (waxed), in a size 9 milliners needle to work the couching stitches. Continue couching concentric rounds of couching thread, stitching in a brick fashion when possible, until the segment is filled. Sink the tail of couching thread through to the back, then secure.

4 Work both the lower leaf segments first, then the middle segments, and finally the upper segments, sinking the tails and working the rounds of thread in the same direction as for the lower segments.

2

4

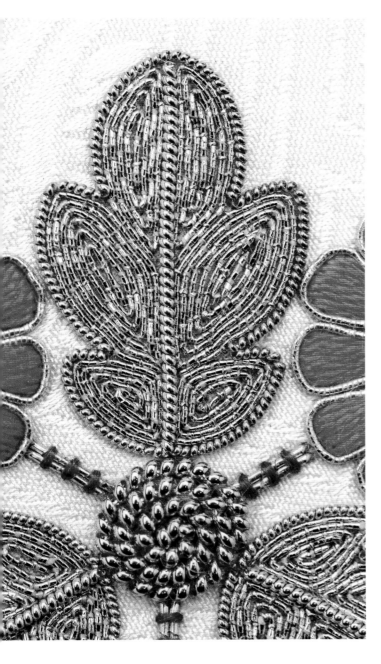

CENTRE CIRCLE

1 Trace the centre circle padding outline onto the paper side of the fusible web, then fuse to yellow felt. Carefully cut out the shape and remove the paper backing.

2 Using polyester thread, apply the felt padding (web side down) to the background fabric, inside the centre circle outline, with small stab stitches around the outside edge.

3 The centre circle is filled with a coil of Gilt No.2 Pearl Purl, couched in place with waxed gold silk thread. Use fine tweezers to shape the coil of purl thread before couching in place, starting the shaping in the centre by bending the first loop of the purl quite sharply before shaping the length of purl around the centre to form a circular shape. Start couching in the centre of the shape, then work around the coil to the outside edge. Trim the purl.

STEMS

Using one strand of russet thread, couch a double row of Gold T71 Japanese Thread, between the base of each flower and the centre circle, to form the stems (using three stitches), sinking the tails of Japanese thread at each end of the stem line. Secure the tails at the outer ends behind the flower and the other tails behind the centre.

8
CHERRY BLOSSOM AND LADYBIRD

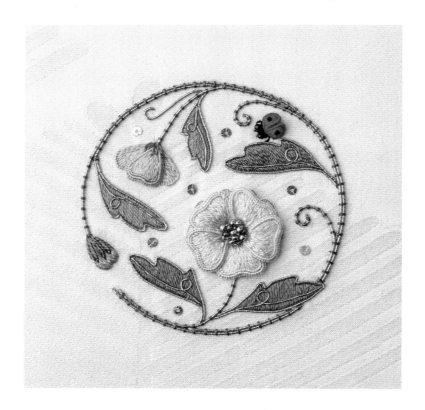

Stumpwork and goldwork combine in this pretty design of pale pink cherry blossom, with detached petals, and a tiny ladybird with raised detached wings. Inspired by a family crest of a stylized cherry blossom flower, buds and leaves, this embroidery is worked with silk and metal threads, beads and spangles on an ivory silk background.

Cherry blossom (*sakura*)

The flowering cherry, *sakura*, originally found growing wild in the mountains in Japan, has been cultivated and hybridized over many centuries, assuming pride of place as the flower most beloved by the Japanese. So anticipated is the brief blooming period of these flowers, that, from the eighth century through to the present day, blossom viewing celebrations, *hanami*, featuring food, drink, poetry and music, are held to admire the flowers and to socialize.

While the flowering of the cherry blossom signifies spring and the rebirth of the year, the ephemeral nature of these pale blossoms also brings to mind the precarious nature of life and the certainty of its passing. The blooming and scattering of cherry-blossom petals became strongly tied to the samurai aesthetic, the flower becoming the symbol of the 'way of the warrior' – the samurai ideal was to fall, like the blossom, at the height of his glory – an approach to death much revered in Japanese chivalry.

The Japanese term, *setsugekka*, refers to the Three Beauties of Nature – snow, moon and flowers – each of which are said to be a reminder of the transience of life. The Three Beauties – a snow-covered landscape, a moonlit scene, and the flowering of the cherry blossom – have inspired countless artists in Japan.

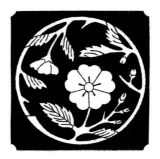

Cherry-blossom *mon*

YOU WILL NEED

TEMPLATES:

For full-size, traceable outlines, please see page 177.

EQUIPMENT:

- Embroidery hoop or square frame –
 25cm (10in)
 12cm (4¾in)
 10cm (4in)

NEEDLES:

- Crewel/embroidery size 10

- Sharps size 12

- Chenille sizes 18 and 22

- Sharp yarn darners sizes 14 and 16

- Embroidery equipment (see page 12)

MATERIALS:

- Background fabric –
 30cm (12in) square of the background fabric of your choice
 (see page 22 for suggestions and preparation)

- Backing fabric –
 30cm (12in) square of quilter's muslin (medium-weight
 cotton fabric)

- Tracing paper –
 15cm (6in) square (I use baking parchment)

- Plain white paper (e.g. photocopy paper) –
 20cm (8in) square

- 2mm (1/16in) gold spangles (x 10)

CHERRY BLOSSOM

- 33-gauge white wire (or flower wire) –
 six 9cm (3½in) lengths

- Quilter's muslin (medium-weight cotton fabric) –
 20cm (8in) square

- Mill Hill Petite Beads col. 40557 (gold) (x 15)

- Mill Hill Petite Beads col. 42012 (cherry) (x 6)

LADYBIRD

- Mill Hill Petite Beads col. 42014 (black) (x 2)

- 33-gauge white wire (or flower wire) –
 12cm (4¾in) length coloured red (Copic R17
 Lipstick Orange)

- Red medium-weight cotton fabric –
 15cm (6in) square

METAL THREADS:

- Gold T70 Imitation Japanese Thread – 3m (3¼yd)

- Gold T71 Imitation Japanese Thread – 2m (2¼yd)

- Dark Gold Couching Thread 371 – 2m (2¼yd)

SEWING AND EMBROIDERY THREADS:

CHERRY BLOSSOM

I used Soie d'Alger silks to work the cherry blossom. The suggested DMC substitutes are close, but not the exact colour.

- Dark green stranded thread –
 Soie d'Alger 2145 or DMC 730

- Medium green stranded thread –
 Soie d'Alger 2144 or DMC 732

- Light green stranded thread –
 Soie d'Alger 2143 or DMC 733

- Dark pink stranded thread –
 Soie d'Alger 3012 or DMC 603

- Medium pink stranded thread –
 Soie d'Alger 3011 or DMC 604

- Light pink stranded thread –
 Soie d'Alger 1021 or DMC 605

- Fine gold silk thread –
 YLI Silk Thread #100 col. 215

- Clear nylon thread –
 Madeira Monofil No.60 col. 1001

LADYBIRD

- Red stranded thread –
 DMC 349

- Black stranded thread –
 DMC 310

PREPARATION

The Cherry Blossom and Ladybird may be embroidered on a variety of background fabrics. Please refer to page 22 for suggestions and preparation.

TRANSFERRING THE DESIGN

I used method 1 on page 23 to transfer the design.

Author's note

Always use the minimum amount of lead when tracing. If your outlines are too dark, gently press the traced outlines with pieces of masking tape to remove any excess graphite.

ORDER OF WORK

CHERRY BLOSSOM

STEMS

The stems are worked with Gold T70 Japanese Thread, couched in place with one strand of dark green thread in a size 10 crewel needle, working the stitches 2–3mm (1/16–1/8in) apart.

The main circular stem line is worked with a double row of Japanese gold thread, while the flower stem, open-bud stem, two inner scroll lines and closed-bud stem are worked with one row of gold thread, using the diagram as a guide. Start with the tails of gold thread at the front, sinking them through to the back, either with a chenille needle or a lasso, when appropriate.

1. Insert two lengths of gold thread at the lower end of the stem line, staggering the insertion points to give a neat start to the line (hold the tails out of the way with masking tape). Couch a double row of Japanese gold thread along the main stem line until the flower stem is reached. Couch the inner row of gold thread along the flower-stem line, sinking the tail of thread through to the back at the edge of the flower.

2. Returning to the main stem, sink the tail of another length of gold thread in the corner and continue couching a double row of gold thread until a scroll line or bud stem is

reached, couching a single row of gold along these lines and returning to work the main stem as before. Note: when the edge of the lower leaf is reached, leave tails of gold thread parked on the surface until the leaf is worked – this makes for a neater finish. Do not work the scroll line beside the open bud (shown in black) yet.

3. Sink all remaining tails of gold thread through to the back. Trim and secure all thread tails to the backing fabric.

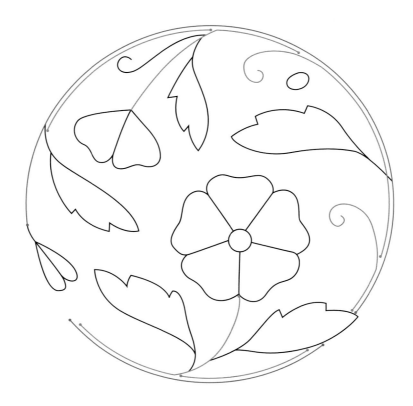

LEAVES

The leaves are worked with one strand of green thread – medium green for the three larger leaves (1, 2 and 3) and light green thread for the two smaller leaves (4 and 5).

1 Starting at the lower corner, embroider each leaf in satin stitch, worked at an angle over the leaf surface.

2 Using nylon thread in a size 12 sharps needle, couch a row of Gold T71 Japanese Thread around the edge of the leaf, leaving 5cm (2in) tails of gold thread at the lower end to form the leaf stem. Couch these threads together along the stem line, sinking the tails at the main stem. Secure at the back and trim.

3 Couch a short length of Dark Gold Couching Thread 371 across the surface of the leaf, twisting it into a loop at the lower end and sinking the tails at each end of the leaf. Secure the tails behind the leaf.

4 Couch a length of Gold T71 Japanese Thread along the scroll line next to the open-bud stem, using nylon thread, and sinking the tails of gold thread through to the back at each end of the scroll line. Secure the tails and trim.

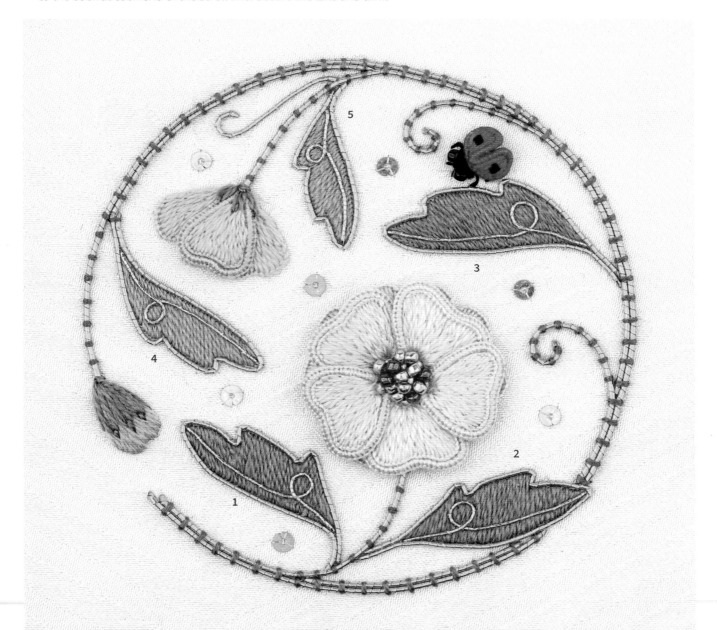

BACKGROUND FLOWER PETALS

1 Using one strand of light pink thread in a size 10 crewel needle, work a row of long-and-short buttonhole stitch along the outer edge of each petal.

2 Fill each petal with long-and-short stitch, angling all the stitches towards the centre of the flower.

Author's note

As the petals are worked in light pink thread, press masking tape or translucent removable adhesive tape over the traced pencil outlines of both the background and detached petals to remove as much graphite as possible and reduce the risk of a grubby edge to the petals.

DETACHED FLOWER PETALS

Mount a square of quilter's muslin into a 12cm (4¾in) hoop. Trace five detached flower petal outlines, and one detached bud petal outline onto the muslin.

1 Using one strand of light pink thread, couch a 9cm (3½in) length of white wire around the petal outline, shaping as you go with tweezers, and leaving two tails of wire, slightly separated, at the base of the petal. Buttonhole stitch the wire to the muslin.

2 Work a row of long-and-short buttonhole stitch along the outer edge of the petal with light pink thread, angling all the stitches towards the base of the petal, then fill each petal with long-and-short stitch.

DETACHED BUD PETAL

1 Using one strand of medium pink thread, couch a 9cm (3½in) length of white wire around the petal outline, shaping as you go with tweezers, and leaving two tails of wire, touching but not crossing at the base of the petal. Buttonhole stitch the wire to the muslin.

2 Work a row of long-and-short buttonhole stitch inside the wire with medium pink thread, then fill each petal with long-and-short stitch.

COMPLETING THE CHERRY-BLOSSOM FLOWER

1 Carefully cut out the petals. Take care to separate the bud petal from the flower petals.

2 Using a yarn darner, apply the five detached flower petals over the background petals, inserting the wire tails through the holes, in the positions as shown – two holes for each petal. Bend the wire tails behind the background petals and secure with small stitches. Carefully shape the petals with tweezers.

3 Using nylon thread, stitch gold and cherry petite beads into the centre to form a small mound.

OPEN BUD

1 Using one strand of medium pink thread, work a row of long-and-short buttonhole stitch along the outer edge of the background petals.

2 Fill each petal with long-and-short stitch, working the stitches towards the base of the petal.

3 Using a fine yarn darner, apply the detached bud petal over the background petals, inserting the wire tails at the end of the stem. Bend the wire tails behind the embroidered background petals and secure with small stitches. Carefully shape the petal with tweezers.

4 With one strand of medium green thread, work three detached chain stitches over the base of the petals, through to the back, to form the sepals.

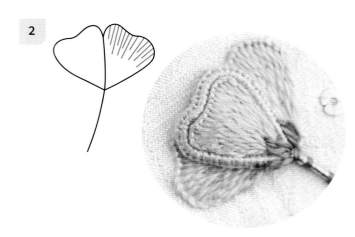

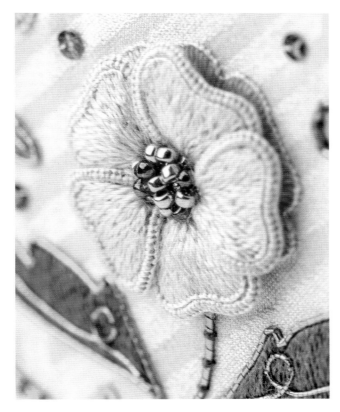

CLOSED BUD

1 Using one strand of dark pink thread, work a row of small backstitches around the outside edge of the closed-bud petals.

2 Embroider the petals with padded satin stitch, working the satin stitches from the outer edge of the petals towards the stem, enclosing the outline.

3 Using one strand of medium green thread, work three detached chain stitches to cover two thirds of the bud, for sepals.

LADYBIRD

ABDOMEN

With one strand of black thread, outline the abdomen with small backstitches, then embroider with padded satin stitch, working the stitches across the shape, enclosing the outline.

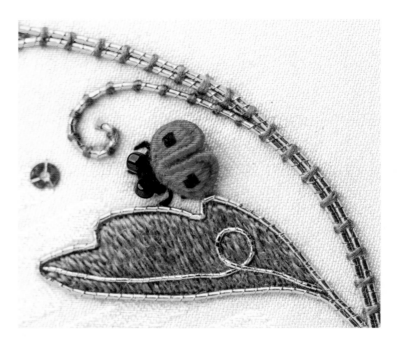

DETACHED WINGS

1 Mount the red cotton fabric into the small hoop and trace the wing-cases outline, placing the straight inner edges of the wings on the straight grains of the fabric.

2 Fold the 12cm (4¾in) wire in half to form a ∧ shape. With one strand of red thread, couch the wire around the wing outlines, making the first stitch at the top of the ∧ inside the wings, and leaving two tails of wire at the top that touch but do not cross. Overcast stitch the wire to the fabric around the wing outlines, then work a row of split stitch inside the wire.

3 Embroider the wings in padded satin stitch, working the satin stitches parallel to the straight inner edge of the wings.

4 With one strand of black thread, embroider a spot on each wing in satin stitch, working two to three stitches *across* the red satin stitches.

COMPLETING THE LADYBIRD

1 Cut out the wings and shape with tweezers, pushing the straight inner edges together and curving the wings into a rounded shape. Using a yarn darner, insert the wire tails through • at the top edge of the abdomen (see diagram below). Bend the wires towards the tail of the ladybird and secure at the back of the abdomen with a few stitches. For extra security (especially for tiny ladybirds), bend the wires back towards the head and stitch again. Trim the wire.

2 With one strand of black thread in a sharps needle, work wide satin stitches over the wire insertion point to form the head of the ladybird. Apply two petite black beads for eyes.

3 Using one strand of black thread, work two straight stitches for each leg. Work two stitches for the antennae. Gently shape the wings with tweezers.

Start

SPANGLES

Using nylon clear thread in a sharps needle, stitch gold spangles to the background, making three stitches into each spangle (secure the thread behind each spangle before moving on to the next one). Position the spangles as desired.

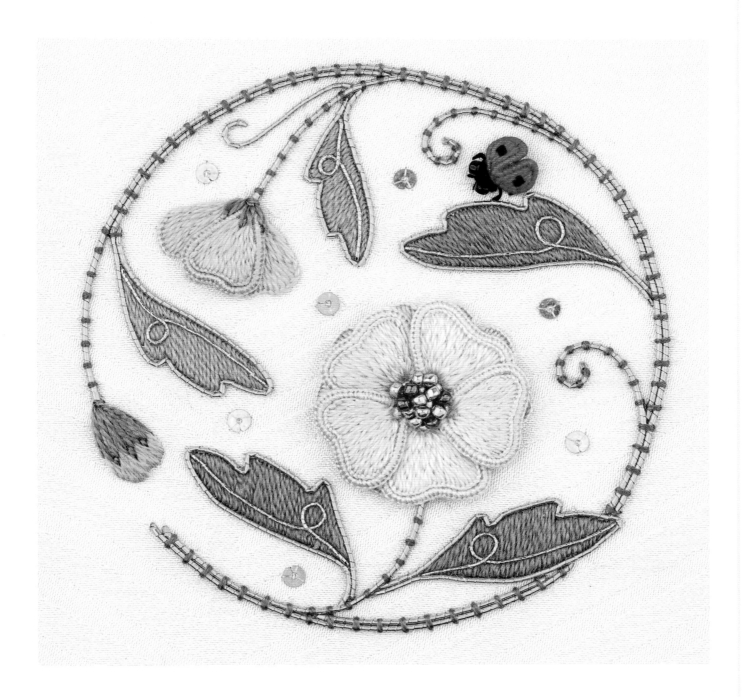

9
IRIS AND MAYFLY

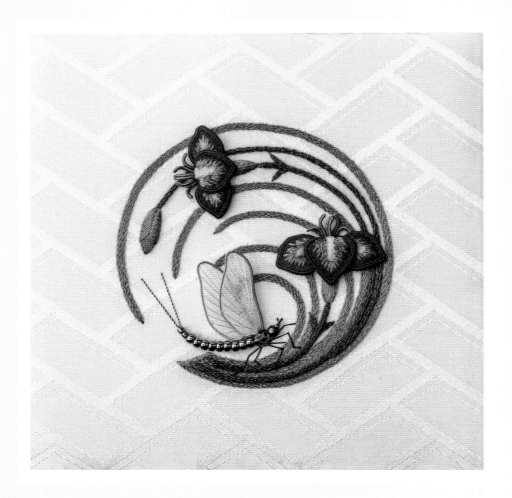

Using a combination of stumpwork and surface embroidery techniques, this small circular panel has been worked on ivory kimono silk, with a variety of silk threads, organza and beads. Inspired by a Japanese family crest of a stylized iris plant, this design features purple bearded iris flowers, with wired detached petals, and a mayfly (*Cloeon dipterum*), with detached gauzy wings and a beaded abdomen.

Iris (*kakitsubata*)

This tall, eye-catching flower, named after the Greek goddess of the rainbow, Iris, comes in many beautiful colours – purple, blue, yellow, white, pink or a mixture of shades. Of the more than 300 species in the genus *Iris*, the most familiar are the bearded iris with their distinctive narrow strip of soft hairs along the centre ridge of the three larger outer petals.

Celebrated in Japanese art and poetry since early times, the iris was also a popular motif for family crests in both court and warrior circles, being selected not only for its decorative beauty but also as a protection against evil spirits. From as early as 600AD, a festival celebrating the iris was held on the fifth day of the fifth lunar month, as it was believed that at this time of the year in particular, the use of the disease-fighting properties of iris and mugwort would help drive off evil spirits.

Iris *mon*

YOU WILL NEED

TEMPLATES:

For full-size, traceable outlines, please see page 178.

EQUIPMENT:

- Embroidery hoop or square frame –
 25cm (10in)
 15cm (6in)
 10cm (4in)

NEEDLES:

- Crewel/embroidery size 10

- Milliners/straw size 9

- Sharps sizes 10 and 12

- Tapestry size 28

- Chenille size 20

- Sharp yarn darners sizes 14–18

- Embroidery equipment (see page 12)

MATERIALS:

- Background fabric –
 30cm (12in) square of the background fabric of your choice
 (see page 22 for suggestions and preparation)

- Backing fabric –
 30cm (12in) square of quilter's muslin (medium-weight cotton fabric)

- Tracing paper –
 15cm (6in) square (I use baking parchment)

- Plain white paper (e.g. photocopy paper) –
 20cm (8in) square

- Quilter's muslin (medium-weight cotton fabric) –
 two 20cm (8in) squares: one for each detached petal

- Honey-coloured nylon organza –
 15cm (6in) square

- Pearl metal organdie –
 15cm (6in) square

- Paper-backed fusible web –
 15cm (6in) square

- Light brown snakeskin –
 2.5cm (1in) square

BEARDED IRIS

- 33-gauge white wire –
 sixteen 12cm (4¾in) lengths coloured purple (Copic BV08 Blue Violet)

MAYFLY

- Mill Hill Size 8° Glass Beads col. 18221 (bronze) (x 9)

- Mill Hill Seed Beads col. 221 (bronze) (x 2)

- 3mm (⅛in) glass bead –
 SBXL-449 (blue/bronze)

- Mill Hill Petite Bead col. 40374 (blue/bronze)

- 28-gauge uncovered wire –
 two 15cm (6in) lengths

THREADS:

BEARDED IRIS

- Dark green stranded thread –
 Soie d'Alger 2135 or DMC 3345

- Medium green stranded thread –
 Soie d'Alger 2134 or DMC 3346

- Dark purple stranded thread –
 Soie d'Alger 1344 or DMC 791 (not an exact match)

- Medium purple stranded thread –
 Soie d'Alger 1343 or DMC 333 (not an exact match)

- Yellow stranded thread –
 DMC 725

MAYFLY

- Medium gold rayon thread –
 Madeira Rayon No.40 col. 1126

- Light gold rayon thread –
 Madeira Rayon No.40 col. 1055

- Light gold metallic thread –
 Madeira Metallic No.40 col. Gold-3

- Brown/black metallic thread –
 Kreinik Cord 201c (brown/black)

- Bronze/black metallic thread –
 Madeira Metallic No.40 col. 425

- Clear nylon thread –
 Madeira Monofil No. 60 col. 1001

- Ecru stranded thread –
 DMC Ecru

PREPARATION

The Iris and Mayfly may be embroidered on a variety of background fabrics. Please refer to page 22 for suggestions and preparation.

TRANSFERRING THE DESIGN

I used method 1 on page 23 to transfer the design.

Author's note
Always use the minimum amount of lead when tracing. If your outlines are too dark, gently press the traced outlines with pieces of masking tape to remove any excess graphite.

ORDER OF WORK

BEARDED IRIS

LEAVES (1–5)

The spear-like iris leaves are worked in stem stitch with one strand of medium green thread in a size 10 crewel needle.

1. Starting at the base, work a row of stem stitch along the outer leaf line (1), working the stem stitches approximately 2.5mm (⅛in) in length.

2. Starting at the base (just to the right of the starting point of the previous row), work a second row of stem stitch, next to and inside the first row, finishing the row of stitching slightly shorter than the previous row at the tip of the leaf.

3. Starting at the base, work two more rows of stem stitch, as in step 2, ending each row slightly shorter than the preceding row to form a smooth point at the tip of the leaf.

The remaining leaves are worked the same way, with four rows of stem stitch, starting the rows at the base and finishing in a smooth point at the tip. Work the leaves along the leaf outlines in the order 1, 2, 4 and 5, *then* work leaf 3, starting, in staggered rows, between leaves 2 and 4.

Author's note
Start all the rows of stem stitch so that they form a sloping lower edge line for the leaves.

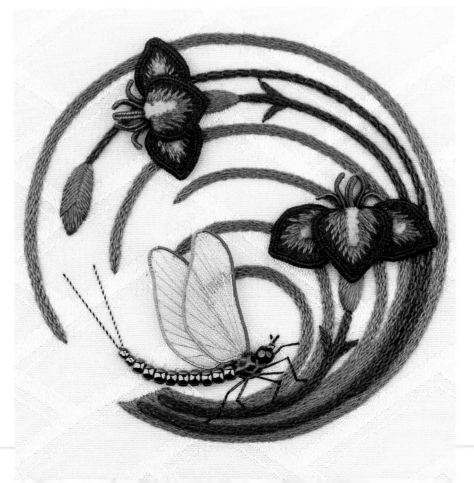

UPPER IRIS STEM (6)

The iris stems are worked in raised stem stitch with one strand of dark green thread, over a padding of seven strands of dark green thread.

1 Thread seven strands of dark green thread into a size 20 chenille needle – this will be used for padding the iris stems. Bring the padding thread out at the base of the upper iris flower (a) – hold the tail of thread out of the way at the back with tape. Using one strand of dark green thread in a size 10 crewel needle, couch the padding thread along the upper iris stem line, working the stitches 2.5mm (⅛in) apart and holding the padding thread under tension while couching. Make the entry and exit points of the couching stitches very close together along the line (almost through the same hole), so that the stems will be raised and narrow. Also, as raised stem stitch will be worked over these couching stitches, make sure that they are not too tight – just snug. Insert the padding thread at the end of the stem (b), and hold the tail of thread out of the way at the back.

2 Starting at b, work a row of raised stem stitch along stem line 6, using one strand of thread in a size 28 tapestry needle. Take the needle through to the back at a. Secure.

3 To complete the stem, work three more rows of raised stem stitch, as before. Trim the padding thread tails.

LOWER IRIS STEM (7)

1 Bring the padding thread out at the base of the lower iris flower (c). Using one strand of dark green thread, couch the padding thread along the lower iris stem line. Insert the padding thread at the end of the stem (d).

2 Starting at d, work a row of raised stem stitch along stem line 7, using one strand of thread. Take the needle through to the back at c. Secure.

3 To complete the stem, work three more rows of raised stem stitch as for the upper iris stem. Trim the padding thread tails.

IRIS-BUD STEM (8)

1 Bring the padding thread out at the base of the iris bud (e). Using one strand of thread, couch the padding thread along the iris-bud stem line, inserting the padding thread at the edge of the upper iris stem (f).

2 Starting at f, work a row of raised stem stitch along stem line 8, using one strand of thread. Take the needle through to the back at e. Secure.

3 Work *two* more rows of raised stem stitch to complete the stem (the bud stem is slightly narrower).

IRIS BUD

1 Using one strand of medium purple thread in a size 10 crewel needle, work a row of small backstitches around the iris-bud outline.

2 Using a double strand of thread, work five long straight stitches inside the bud outline for the first layer of padding then work five stitches across this layer, also inside the outline.

3 Embroider the bud with long satin stitches, worked from the tip to the base, enclosing the bud outline.

4 Using one strand of medium green thread, work fishbone stitch over the satin stitches to form the bud spathe (base), starting the stitches a third of the way down from the tip of the bud.

FLOWER SPATHE

1 Using one strand of medium green thread, work a row of small backstitches around the spathe (base) outline.

2 Using a double strand of thread, work five straight stitches inside the spathe outline for the first layer of padding then work five stitches across this layer, also inside the outline.

3 Embroider the spathe in satin stitch, worked at an angle across the shape, enclosing the spathe outline.

LOWER PETALS ('FALLS')

The iris flower has three lower petals called 'falls', often with soft 'hairs' along the centre of the petals (bearded irises).

Mount a square of quilter's muslin into a 15cm (6in) hoop. Trace the detached iris petal outlines onto the muslin – one centre petal and two side petals for each iris flower. Check that you have the right petals for the two different iris flowers, that there is a right and left petal for each one, and that they are marked. Use a 12cm (4¾in) length of purple wire for each petal.

Upper petals

Lower petals

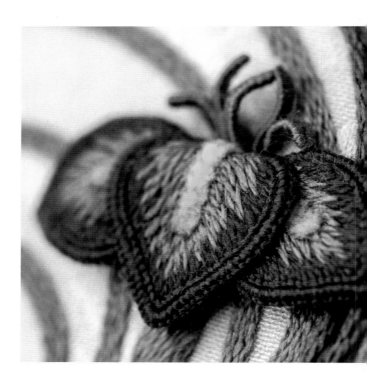

CENTRE PETAL

1 Shape a length of purple wire around the detached centre petal outline, leaving two tails of wire, of equal length, at the base of the petal. Using one strand of dark purple thread, couch the wire to the muslin around the centre petal outline, leaving the space between wires at the base. Stitch the wire to the muslin with close buttonhole stitches.

2 Using dark purple thread, work a row of long-and-short buttonhole stitch around the inside edge of the buttonholed wire, angling all the stitches towards the base of the petal.

3 To mark the centre line of the petal, make a straight stitch along the marked line with one strand of yellow thread – use a waste knot and hold the tail of thread out of the way with tape at the back.

4 With one strand of medium purple thread, embroider the remainder of the petal in long-and-short stitch, working all the stitches towards the base of the petal and leaving the yellow stitch free (work up to the straight stitch – leaving a 1mm centre space).

5 The centre 'beard' of the petal is worked with Turkey knots using one strand of yellow thread in a size 10 crewel needle. Work two rows of Turkey knots (nine knots each row) along the marked line – working a row of knots on either side of the centre line with the rows touching each other. Make sure that the Turkey-knot securing stitches are tiny and that the securing stitch is pierced with the second tail of the Turkey knot.

6 Cut the loops between the Turkey knots and comb upwards. Holding the tails of thread firmly, cut to 1–1.5mm (a scant ¹⁄₁₆in) in length. Fluff the knots with a needle to form the 'hairy' centre strip of the petal.

SIDE PETALS

Check that the detached right- and left-side petals are marked as such.

1 Shape a length of purple wire around the left-side petal outline, leaving two tails of wire at the base of the petal that touch but do not cross. Work as for the centre detached petal, working eight Turkey knots down the centre line of the petal.

2 Work the right-side petal in the same way.

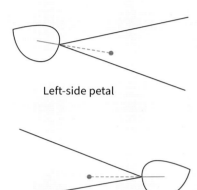

Left-side petal

Right-side petal

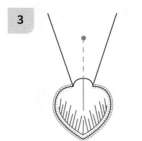

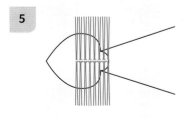

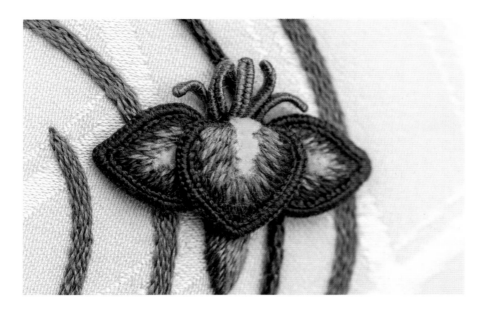

UPPER PETALS ('STANDARDS')

The iris flower has inner upright petals called 'standards'. These upper petals are worked in needle-weaving over purple wire, using one strand of medium purple thread. Use a 12cm (4¾in) length of purple wire for each upper petal.

1 Using one strand of medium purple thread in a size 28 tapestry needle, wrap the centre 2mm (1⁄16in) of the wire, leaving a short tail of thread at one end and the longer tail of thread in the needle.

2 Holding both tails of thread, bend the wire in the centre of the wrapping and squeeze together (this ensures that the end of the petal is covered). Adjust the tails of thread, if required, so that just the tip of the wire is wrapped.

3 Holding on to the shorter tail of thread, work needle-weaving over both wire tails, bringing the needle *up* between the wires, and enclosing the shorter tail of thread with the weaving (trim this tail whenever suits). Weave to a length of about 1cm (⅜in) then secure the thread with a knot, leaving the tail of thread intact. Work ten upper petals.

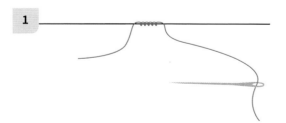

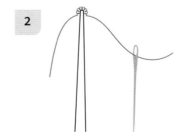

COMPLETING THE IRIS FLOWER

1 Carefully cut out the lower petals, leaving a small turning of fabric between the wire tails of the centre petal.

2 Using a yarn darner, insert the wire tails of the side petals through the two lower dots – make sure the petals are the right way around – the less curved edge is at the top (see the illustration below). Fold the wire tails out to the side behind the side petals. Hold with tape.

3 Using the two smallest yarn darners, insert the wire tails of the centre petal through the two upper dots, easing the raw edge underneath the petal. Shape and adjust the centre petal, then bend the wire tails to the side, next to the side-petal wires (do not cross the centre wires). When happy with the position of all three petals, stitch the wire tails to the muslin behind the side petals (use medium green thread). Do not cut the wire tails yet – you will trim them when the iris is complete.

4 Using a yarn darner, insert one of the upper petals above the centre of the centre petal, taking both wire tails and thread tail through to the back. Leave about 7mm (¼in) of wrapped wire protruding. Cut off one of the wire tails near the wrapping, leaving one wire tail and the thread tail – hold both behind the iris stem with tape. Insert the remaining upper petals, two on either side of the centre petal, through separate holes. Trim one wire from each petal and hold the remaining wire and thread tail with tape. Shape the upper petals with tweezers then stitch the wire tails to the back of the stem with one of the thread tails.

5 With one strand of dark green thread, work leaves on either side of the stem, below the flower, with stem stitch (about three 'rows', worked to a point).

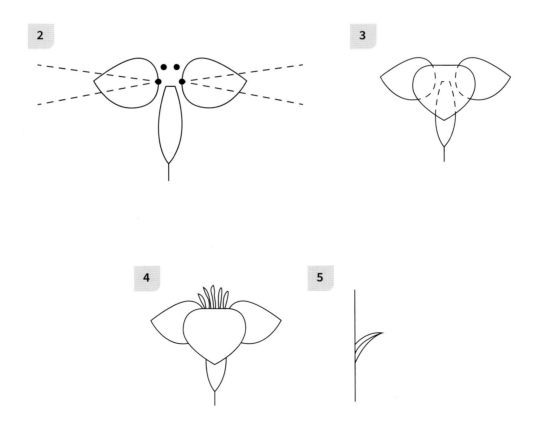

117

MAYFLY

DETACHED WINGS

1 Using fusible web, fuse the honey-coloured organza to the pearl organdie, rotating one of the squares to be on the bias, and protecting the iron and ironing board with baking parchment. Mount into a 10cm (4in) hoop, honey organza side uppermost, and pull as tight as a drum.

2 Shape a 15cm (6in) length of uncovered wire around the detached wing outline, leaving two tails of wire at the base of the wing that touch but do not cross. Attach to the surface of the fabric 'sandwich' with tape, making sure that the wire is the right way around.

3 With one strand of medium gold rayon thread in a size 12 sharps needle, work two stitches over both wires at the base of the wing, then, starting at the straighter front edge of the wing, overcast the wire to the wing fabric with close, firm overcast stitches. At the tip of the wing, change to light gold rayon thread for the remainder of the wing, catching both tails of thread at the back in the subsequent overcasting (2–3mm/¹⁄₁₆–¹⁄₈in). Work two stitches over both wires at the base of the wing, secure at the back then trim. Repeat for the second wing, checking that it faces the same way.

4 Using one strand of light gold metallic thread in a size 10 sharps needle, work the veins in the wings with a combination of fly and single-feather stitches. It is easier to start by making a small stitch from a to b – leaving tails of thread of equal length on the upper surface. Use each tail of thread to work the veins with a combination of fly and single feather stitches as shown, leaving the thread tails at the base of the wing.

1 • Gold organza

Pearl organdie

2

3 Medium gold

Light gold

4 a b

Author's note
Take the thread tails through to the back at the base of the wing *after* the wing has been cut out to reduce the chance of cutting these threads. Retain the tails to take through to the back of the work when the wing wires are inserted.

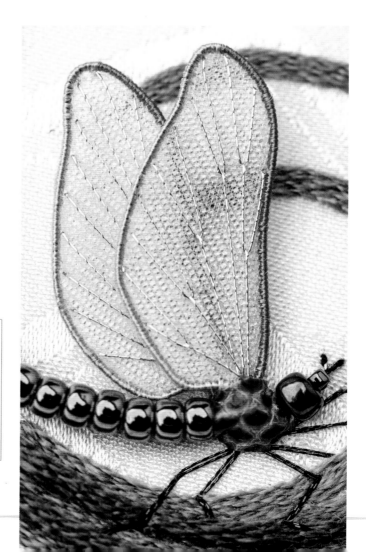

ABDOMEN

The abdomen is formed from beads, stitched in place with nylon thread in a size 12 sharps needle.

1 Secure the nylon thread at the back then bring through to the front at 1. Thread on the nine large bronze beads, then the two bronze seed beads. Take the thread down near 2, making a stitch slightly longer than the combined length of the beads to allow for the curve of the abdomen. Bring the needle out at 3 and work a couching stitch between each bead back to the tail. Come out again at 2 and take the needle back through all beads one more time, going through to the back of the fabric at 1. Secure.

2 The long tails of the mayfly are worked with a fly stitch using bronze/black Madeira Metallic No. 40 thread in a size 10 sharps needle. Using the photograph overleaf as a guide, work the fly stitch towards the base of the abdomen, then take the thread back through all of the beads then through to the back of the fabric at 1. Secure the thread.

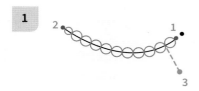

ATTACHING THE WINGS

1 Carefully cut out the wings, then take the thread tails from the veins through to the back at the corner of the wings. Retain the thread tails.

2 Using a large yarn darner, insert the wing wire and thread tails through the background fabric, close to the top of the abdomen. Adjust the position of the wings then bend the wire tails back behind the wings. Hold with tape. Gently pull the vein thread tails, to adjust the tension of the stitches in the wings, then secure the tails.

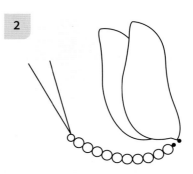

THORAX

The thorax is worked with snakeskin, applied over a padding of thread.

1 Using a double strand of ecru thread, work padding stitches over the wing entry point.

2 Cut a small piece of brown snakeskin, approximately 6 x 5mm (¼ x ³⁄₁₆in). Trim off the corners and check for size – it will be applied close to the abdomen, over the padding and base of the wings. Using nylon thread in a size 12 sharps needle, apply the snakeskin over the padding with about four stab stitches.

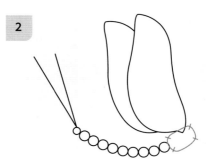

HEAD AND EYE

1 Using nylon thread, stitch a 3mm (⅛in) blue/bronze bead next to the thorax for the head, working the stitches towards the thorax, then stitch a petite blue/bronze bead through the hole of the larger bead for the eye.

2 To form the antennae, work a small fly stitch with bronze/black Madeira Metallic No. 40 thread near the eye.

LEGS

Using two strands of brown/black metallic Kreinik Cord 201c in a size 9 milliners needle, work the legs, below the thorax, with backstitches. Using the photograph below as a guide, work three complete legs (three backstitches for each leg) and sections of legs falling behind the leaf, if desired.

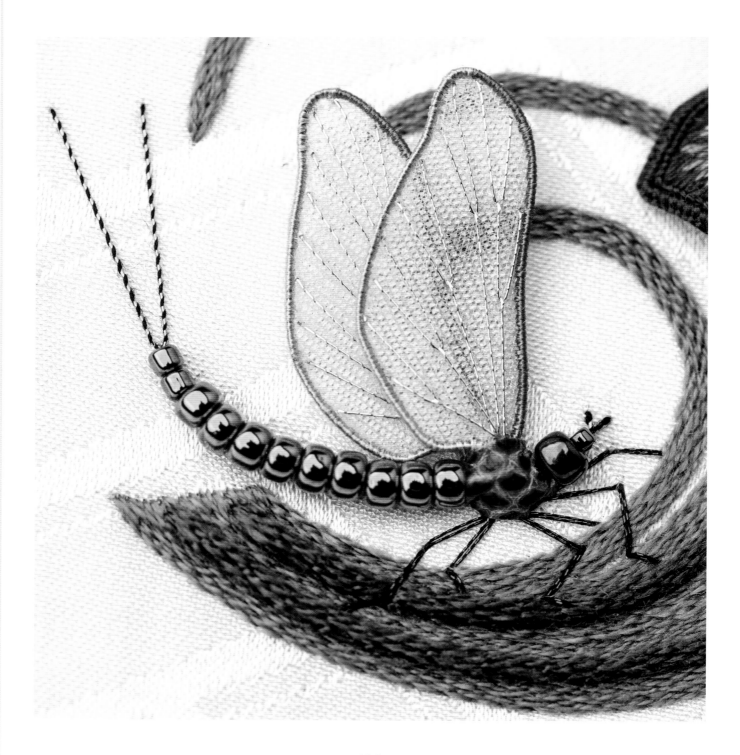

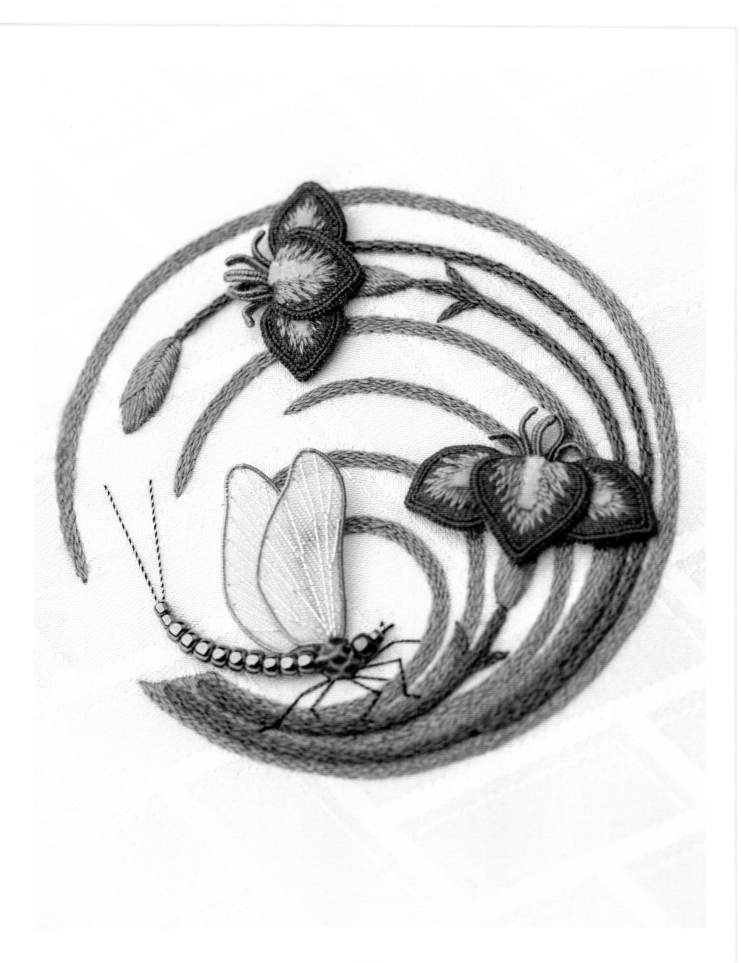

10
PEONY AND BUMBLE BEE

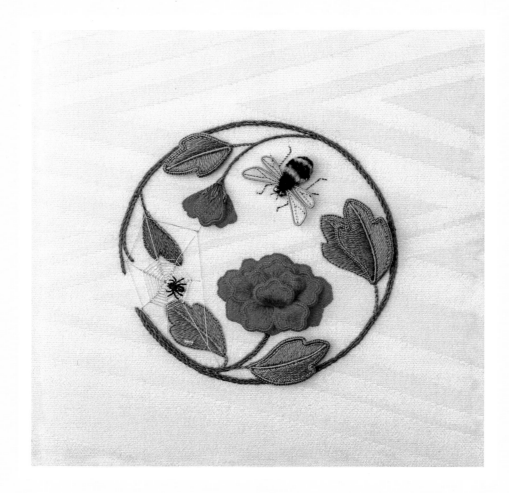

Three shades of crimson have been used to embroider the detached petals of the peony flower and bud. This design also features a bumble bee, with detached gauzy wings and velvety striped abdomen, and a tiny spider in a glistening web – all worked with a variety of silk and metallic threads, organza and beads, and using stumpwork and surface embroidery techniques.

Peony (*botan*)

The peony, a symbol of good fortune, nobility and the season of spring, was a popular choice for family crests of both the court aristocracy and warrior classes in early Japanese culture. Originally from China, where it was regarded as the 'king of flowers', the tree peony was introduced to Japan around the eighth century AD, where it was valued not only for its beauty but also for its use as a traditional medicine.

Adored for its decorative qualities, and for its association with female beauty and sensuality, the peony features prominently in the areas of both fine and applied arts in Japan. Exquisite renderings may be found in paintings, screens and textiles – such as woven silk brocades and embroidered panels for kimono.

Peony *mon*

YOU WILL NEED

TEMPLATES:

For full-size, traceable outlines, please see page 179.

EQUIPMENT:

- Embroidery hoop or square frame –
 25cm (10in)
 15cm (6in)
 two 10cm (4in)

NEEDLES:

- Crewel/embroidery sizes 8 or 9, and 10

- Milliners/straw size 9

- Sharps size 11 and 12

- Sharp yarn darners sizes 14–18

- Embroidery equipment (see page 12)

MATERIALS:

- Background fabric –
 30cm (12in) square of the background fabric of your choice
 (see page 22 for suggestions and preparation)

- Backing fabric –
 30cm (12in) square of quilter's muslin
 (medium-weight cotton fabric)

- Tracing paper –
 15cm (6in) square (I use baking parchment)

- Plain white paper (e.g. photocopy paper) –
 20cm (8in) square

- Quilter's muslin (medium-weight cotton fabric) –
 two 20cm (8in) squares

CRIMSON PEONY

- 33-gauge white wire –
 nine 9cm (3½in) lengths coloured fuchsia
 (Copic RV09 Fuchsia)

- 33-gauge white wire –
 two 12cm (4¾in) lengths coloured olive (Copic G99 Olive)

BUMBLE BEE

- Gold nylon organza
 15cm (6in) square

- Pearl metal organdie
 15cm (6in) square

- Paper-backed fusible web
 15cm (6in) square

- 28-gauge uncovered wire
 four 11cm (4⅜in) lengths

- Mill Hill Seed Beads col. 374 (blue-bronze) (x 2)

SPIDER AND WEB

- Mill Hill Petite Beads col. 40161 (crystal) (optional)

THREADS:

CRIMSON PEONY

I used Soie d'Alger silks for the peony. The suggested DMC substitutes are close, but not the exact colour.

- Dark green stranded thread –
 Soie d'Alger 2126 or DMC 3346

- Medium green stranded thread –
 Soie d'Alger 2125 or DMC 3347

- Light green stranded thread –
 Soie d'Alger 2124 or DMC 470

- Dark crimson stranded thread –
 Soie d'Alger 945 or DMC 304

- Medium crimson stranded thread –
 Soie d'Alger 1025 or DMC 326

- Dark pink stranded thread –
 Soie d'Alger 1034 or (no match in DMC)

BUMBLE BEE

- Old gold stranded thread –
 DMC 783

- Black stranded thread –
 DMC 310

- Gold/black metallic thread –
 Kreinik Cord 205c

- Gold rayon machine thread –
 Madeira Rayon 1055

- Ecru stranded thread –
 DMC Ecru

SPIDER AND WEB

- Silver metallic thread –
 Madeira Metallic No.40 Silver

- Black rayon thread –
 Raj Mahal Art Silk col.29 Charcoal

- Peacock-green metallic thread –
 Kreinik Blending Filament 085 (optional)

PREPARATION

The Peony and Bumble Bee may be embroidered on a variety of background fabrics. Please refer to page 22 for suggestions and preparation.

TRANSFERRING THE DESIGN

I used method 1 on page 23 to transfer the design.

Author's note

Always use the minimum amount of lead when tracing. If your outlines are too dark, gently press the traced outlines with pieces of masking tape to remove any excess graphite.

ORDER OF WORK

PEONY

STEMS

The peony stems are worked in stem stitch with two strands of dark green thread in a size 8 or 9 crewel needle.

1 Work a row of dark green stem stitch around the circular outside stem line (1), starting at the lower end of the stem line and working the stem stitches approximately 2–2.5mm (⅛in) in length.

2 Starting at the lower end of the stem line (just to the right of the starting point of the first row), work a second row of stem stitch (2), next to and inside the first row, veering to the left at the junction of the main stem and bud stem to work the bud stem line, finishing the row of stitching at the base of the bud.

 Starting at the junction of the bud and main stem line, continue the second row of stem stitch along the remaining stem line, veering to the left at the end of the line where the line splits.

3 Starting at the lower end of the stem line, work a third row of stem stitch (3), as for the previous row, veering to the left along the flower stem line, ending at the edge of the peony flower. To complete the flower stem, work a second row of stem stitch to the right of the previous row, starting at the junction of the flower stem and the main stem line, and ending at the edge of the flower.

> **Author's note**
> Start all the rows for the stem as in step 2, to form a sloping lower end line for the stem.

> **Author's note**
> The leaf stems are worked at a later stage.

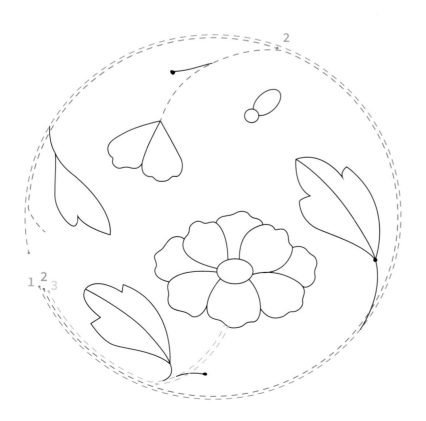

BACKGROUND LEAVES

Work the two whole background leaves (1 and 2) as follows:

1 Work the central vein in split stitch with one strand of light green thread in a size 10 crewel needle.

2 Using one strand of medium green thread, and starting at the stem end of the leaf, embroider each side of the leaf with long buttonhole stitches, worked at an angle over the leaf surface, inserting the needle underneath the stitched central vein.

3 Work the leaf stem, and the detached leaf stems, in chain stitch with one strand of medium green thread.

Work the single-sided leaf (3) as follows:

1 Work the central vein in split stitch with one strand of medium green thread.

2 Using dark green thread, work the side of the leaf with long buttonhole stitches.

3 Work the leaf stem in chain stitch with dark green thread.

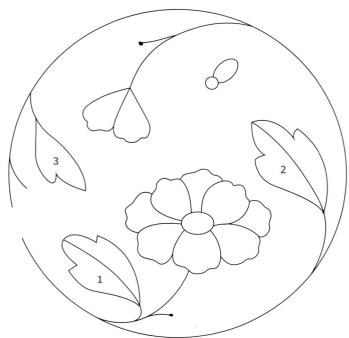

DETACHED LEAVES

1. Mount a square of quilter's muslin into a small hoop then trace the upper, lower and right detached leaf outlines (make sure the leaves are facing the correct way).

2. Cut a 12cm (4¾in) length of olive-coloured wire for each leaf. Using one strand of light green thread, couch, then overcast the wire along the central vein line, starting with one end of the wire at the tip of the leaf, and keeping the remaining wire free to work the outside leaf edge.

3. Shape the remaining wire around the outside edge of the leaf. Using one strand of medium green thread, couch then buttonhole stitch the wire to the muslin, leaving a short tail of wire at the lower end of the leaf. Work a row of split stitch on either side of the wired central vein.

4. Embroider the leaf surface, inside the wire, with slanted buttonhole stitch, inserting the needle next to the central vein and enclosing the split stitch.

5. Carefully cut out the detached leaves and, using a fine yarn darner, insert the wire tails at the end of the embroidered leaf stems at the dots as marked. Secure the wire tails behind the stems with small stitches. Trim the wire tails. Shape the leaves.

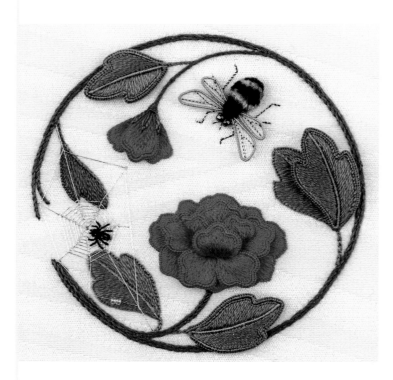

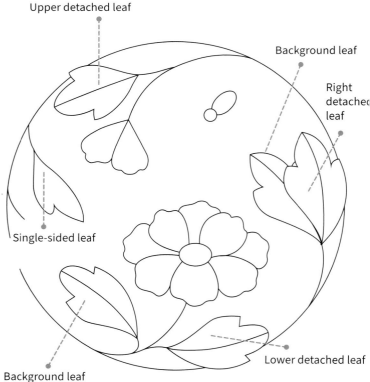

Upper detached leaf

Background leaf

Right detached leaf

Single-sided leaf

Lower detached leaf

Background leaf

BACKGROUND FLOWER PETALS

Work the background petals as follows:

1 Using one strand of dark pink thread in a size 10 crewel needle, work a row of long-and-short buttonhole stitch along the outer edge of each petal.

2 Using medium crimson thread, fill each petal with long-and-short stitch, angling all the stitches towards the base of each petal.

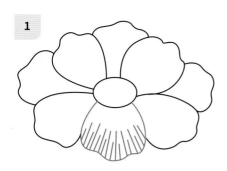

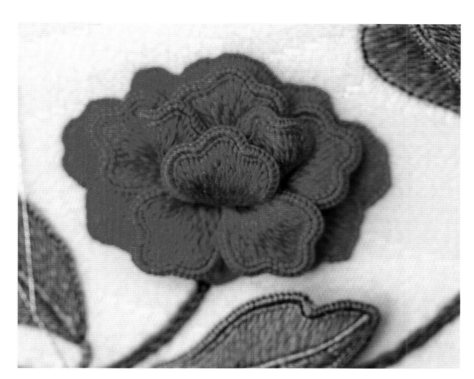

BACKGROUND BUD PETALS

1 Using one strand of medium crimson thread, work a row of long-and-short buttonhole stitch along the outer edge of each petal.

2 Fill each petal with long-and-short stitch using dark crimson thread.

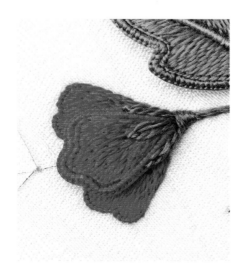

DETACHED FLOWER PETALS

Mount a square of quilter's muslin into a 15cm (6in) hoop. Trace nine detached petal outlines onto the muslin as follows:

- five outer petals
- one centre petal
- two centre-side petals
- one bud petal

They will all be worked the same way, each using a 9cm (3½in) length of fuchsia-coloured wire, with the colour combinations as follows:

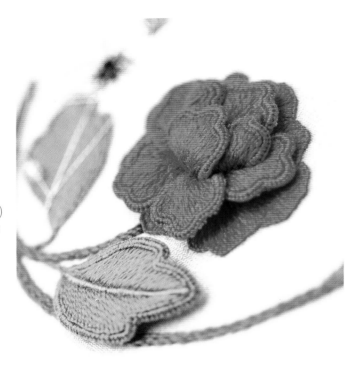

OUTER PETALS (WORK FIVE)

1 Using one strand of dark pink thread, couch a length of wire around the petal outline, shaping as you go with tweezers, and leaving two tails of wire at the base of the petal. Buttonhole stitch the wire to the muslin.

2 Work a row of long-and-short buttonhole stitch inside the wire with dark pink thread, angling all the stitches towards the base of the petal.

3 Using medium crimson thread, fill each petal with long-and-short stitch.

CENTRE PETAL (WORK ONE) AND CENTRE-SIDE PETALS (WORK TWO)

1 Using one strand of dark pink thread, couch then buttonhole stitch the wire to the muslin.

2 Work a row of long-and-short buttonhole stitch inside the wire with medium crimson thread, angling all the stitches towards the base of the petal.

3 Using dark crimson thread, fill each petal with long-and-short stitch.

DETACHED BUD PETAL (WORK ONE)

1 Using one strand of medium crimson thread, couch then buttonhole stitch the wire to the muslin.

2 Work a row of long-and-short buttonhole stitch inside the wire with medium crimson thread, angling all the stitches towards the base of the petal.

3 Using dark crimson thread, fill each petal with long-and-short stitch. Make sure you keep the bud petal separate to avoid confusion.

COMPLETING THE FLOWER

1. Carefully cut out the petals.
2. Using a yarn darner, apply the five outer petals first, inserting the wire tails through the holes as shown – two holes for each petal. Note: the position of the wires for the outer side petals may need to be adjusted. They may, or may not, share holes with the upper and lower outer petals. Bend the wire tails behind the detached petals – hold with tape until the centre petals are inserted.

3. Shape the centre petal before applying. Insert the wires for the centre petal – the wire tails will lie under the upper back petals (they are not bent back under centre petal). This petal needs to be cupped.
4. Shape the centre-side petals before they are inserted behind the centre petal (further shaping can be made after they are applied). Allow the wire tails to lie behind the centre of the flower – do not bend them back. Adjust all of these petals, and the back petals of the outer row, to 'enclose' the centre – the centre space should not be able to be seen. When satisfied with the placement, secure the wires with small stitches behind the flower. Trim the tails.

COMPLETING THE BUD

1. Using a yarn darner, insert the wire tails of the detached bud petal at the end of the bud stem, over the background petals. Bend the wire tails back behind the detached petal – separate like a V for stability. Secure with small stitches, then trim.
2. With one strand of dark green thread in a size 11 or 12 sharps needle, work three detached chain stitches into the detached petal to form sepals. Using the same thread, work some satin stitches across the stem and the petal insertion point to form the flower base.

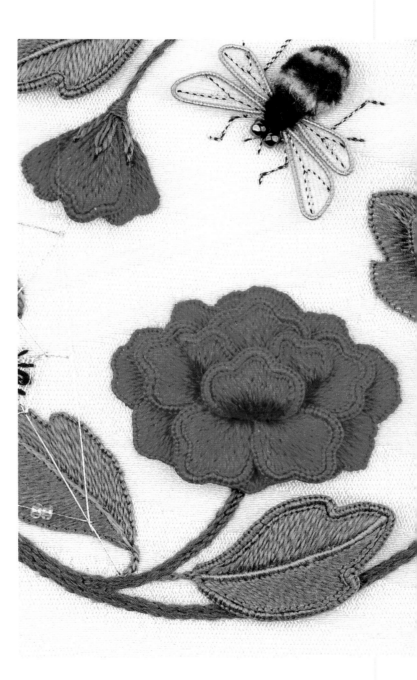

BUMBLE BEE

THORAX AND ABDOMEN

1 Outline the abdomen and the small circle next to it (the thorax) with small backstitches using one strand of black thread.

2 The abdomen is filled with consecutive rows of Turkey knots, worked with two strands of either old gold or black thread in a size 9 crewel needle. Starting at the thorax end of the abdomen, work two rows of Turkey knots in black, then two rows in old gold thread. Work two more rows in black, two rows in old gold, then two rows in black at the tail (adjust the number of rows for each stripe, if necessary, to end up with a black tail). *The Turkey knots should pierce the backstitches but not protrude outside them.*

3 Cut the loops between the Turkey knots and comb the threads upwards. Carefully cut and comb the threads to form a velvety mound for the abdomen.

WINGS

1 Using fusible web, fuse the gold organza to the pearl organdie, rotating one of the squares 45 degrees to be on the bias, and protecting the iron and ironing board with baking parchment. Mount into a 10cm (4in) hoop, gold organza side uppermost, and pull as tight as a drum.

2 Bend the uncovered wire around the wing outline templates – two forewings and two hindwings – leaving two tails of wire at the base of each wing that touch but do not cross. Make sure that you have a right and a left forewing and a right and a left hindwing. Place the wire shapes on the fabric in the hoop, holding the wire tails in place with masking tape.

3 Using one strand of gold rayon machine thread in a sharps needle, stitch the wire to the wing fabric with small, close overcast stitches, working several stitches over both wires at the base of the wing, to begin and end the stitching.

4 With one strand of gold/black metallic thread in a size 9 milliners needle, work a fly stitch in each wing for veins, retaining the tails of thread at the inner ends of the wings. Carefully cut out the wings, taking care not to cut the tails of metallic thread.

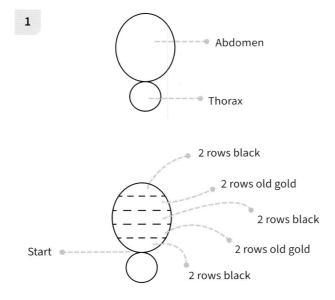

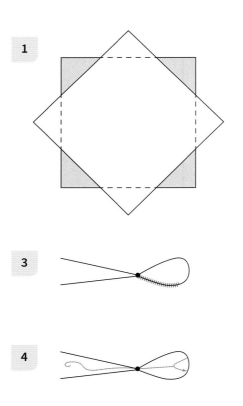

COMPLETING THE BEE

1. Using a large yarn darner, insert the wings through two separate holes, inside the stitched thorax outline – the right fore- and hindwings together through one hole and the left fore- and hindwings through the other (they will be very close together). Bend the wires to the sides (under the wings) and stitch to the backing with tiny stitches using ecru thread. The tails of metallic thread are taken through to the back at the same time, and through the same holes, as the wing wires. Do not trim the wire tails until the bee is finished.

2. Using two strands of black thread, work Turkey knots between the wings to fill the thorax (approximately eight knots). Cut the Turkey knots to form a velvety mound.

3. To form the head/eyes, stitch two blue-bronze seed beads (side by side with one stitch), very close to the thorax, using one strand of black thread. Work another stitch through both beads then a stitch between the beads (across the previous stitches towards the thorax). Push the beads together with tweezers.

4. With two strands of gold/black metallic thread in a milliners needle, stitch six legs, working three backstitches for each leg. Work a fly stitch for the antennae with one strand of metallic thread. Trim the wire tails.

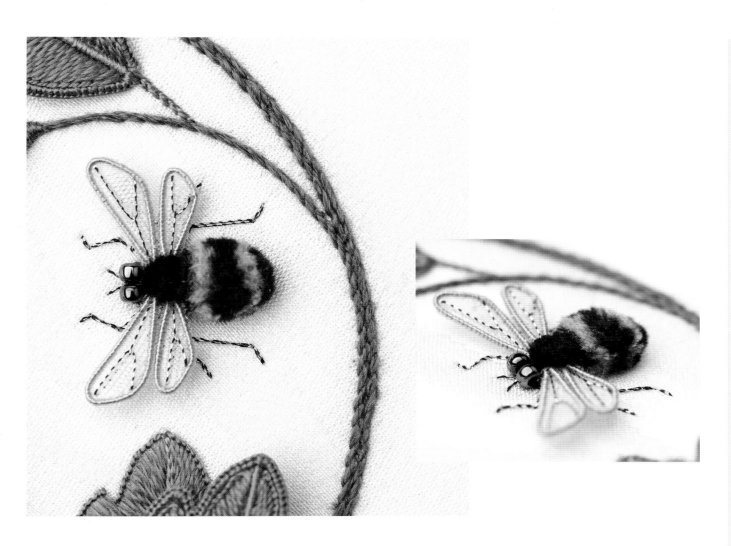

SPIDER'S WEB

1. To establish the centre-point of the web, place the original tracing over the web diagram and draw in the centre point. Position this tracing over the embroidery, lining up the traced lines with the embroidered lines, and insert a fine needle through the centre point of the web into the background fabric. Carefully remove the tracing paper, leaving the needle temporarily placed through the centre point.

2. The spider's web is worked with one strand of silver metallic thread in a size 9 milliners needle. Using the web diagram as a guide, work each spoke from the outside of the web in to the centre point.

3. Work the perimeter of the web with straight stitches, each time taking the needle over the spoke and bringing it up on the other side (taking a tiny stitch at the back of the work). Thread one or two crystal petite beads on one or two of these lines to represent dew drops, if desired.

4. Starting from the centre, work concentric rows of web with straight stitches, taking a tiny stitch through to the back of the work around each spoke, as for the perimeter. Make sure that the rows are fairly close and parallel to each other for the best effect.

2 **WEB DIAGRAM**

KEY

Perimeter

Spokes

3

Stitch guide for web perimeter

SPIDER

1 With one strand of black rayon thread in a size 12 sharps needle, work two padded satin-stitch spots, over rows of the web, for the spider's thorax and abdomen. Work two small French knots to represent eyes. Work two tiny straight stitches between the eyes for mouthparts. If desired, work several straight stitches over the abdomen with metallic thread to form a stripe.

2 Work the legs with straight stitches – two stitches for each leg, worked towards the thorax (eight legs).

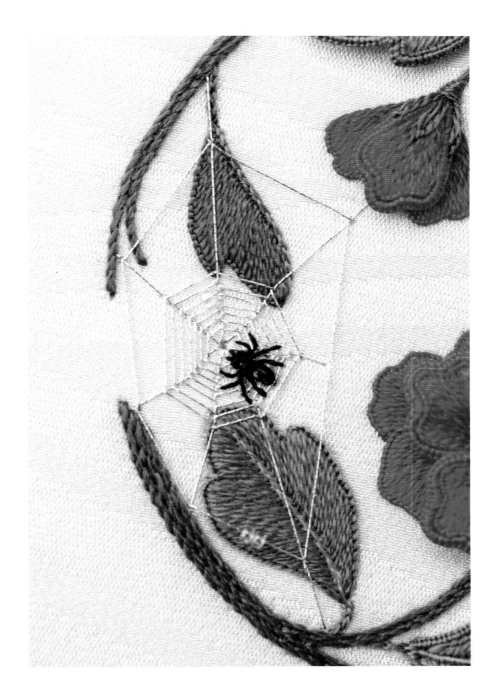

11
LOTUS AND PRAYING MANTIS

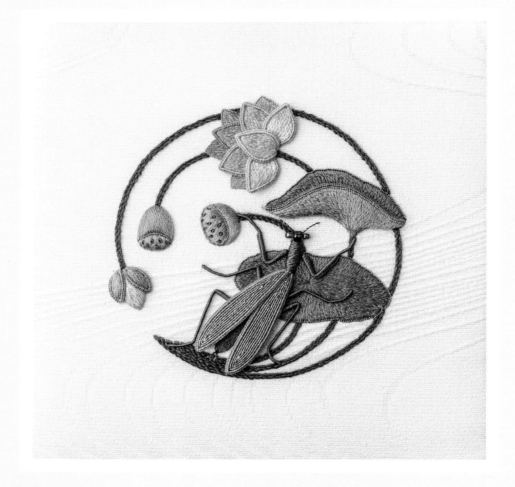

A praying mantis, with detached metallic wings and wrapped-wire legs is the star of this small embroidered panel. Inspired by a Japanese family crest of a stylized lotus plant – this design also features a lotus flower and bud, with wired detached petals, and padded seed pods, all worked with silks and metallic threads on a piece of antique kimono silk.

Lotus (*hasu*)

The lotus, one of the earliest stylized Chinese floral motifs to be adopted into the lexicon of traditional Japanese design, was beloved by early Japanese artisans; the lotus motif could be found carved, painted, embroidered, woven, worked in metal or embellishing lacquerware. It was also favoured by Japanese courtiers to decorate formal court attire.

As well as playing an important role in Japanese art, medicine and cuisine, the lotus also has religious significance; Buddhist traditions believe that the lotus is a sacred flower, a symbol of purity emerging from impurity – even when its roots are in muddy waters, the lotus produces the most exquisite flower. Traditional family crests featuring the lotus may depict one or all parts of the plant in the design – leaves, flower, bud, seed pod, stem and root.

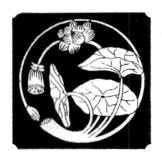

Lotus *mon*

YOU WILL NEED

TEMPLATES:

For full-size, traceable outlines, please see page 180.

EQUIPMENT:

- Embroidery hoop or square frame –
 25cm (10in)
 10 or 13cm (4 or 5in)
 15cm (6in)

NEEDLES:

- Crewel/embroidery sizes 9 and 10

- Milliners/straw size 9

- Sharps size 10 and 12

- Chenille size 20

- Sharp yarn darners sizes 14–18

- Embroidery equipment (see page 12)

MATERIALS:

- Background fabric –
 30cm (12in) square of the background fabric of your choice
 (see page 22 for suggestions and preparation)

- Backing fabric –
 30cm (12in) square of quilter's muslin
 (medium-weight cotton fabric)

- Tracing paper –
 15cm (6in) square (I use baking parchment)

- Plain white paper (e.g. photocopy paper) –
 20cm (8in) square

- Quilter's muslin (medium-weight cotton fabric) –
 three 20cm (8in) squares

- Grey felt –
 8 x 5cm (3 x 2in)

- Cream felt –
 8 x 5cm (3 x 2in)

- Paper-backed fusible web –
 8 x 10cm (3 x 4in)

- Sticky notes

LOTUS

- 33-gauge white wire coloured green (Copic YG63 Pea Green) –
 two 9cm (3½in) lengths and one 12cm (4¾in) length

- 33-gauge white wire –
 six 9cm (3½in) lengths

PRAYING MANTIS

- Mill Hill Antique Beads col. 3038 (ginger) (x 2)

- 3mm (⅛in) glass bead –
 SBXL-449 (blue/bronze)

- 33-gauge white wire –
 two 15cm (6in) lengths

- 30-gauge green wire –
 six 12cm (4¾in) lengths

THREADS:

LOTUS

- Very dark green stranded thread –
 Soie d'Alger 2126 or DMC 3345

- Dark green stranded thread –
 Soie d'Alger 2125 or DMC 3346

- Medium green stranded thread –
 Soie d'Alger 2124 or DMC 3347

- Light green stranded thread –
 Soie d'Alger 2123 or DMC 3348

- Medium purple stranded thread –
 Soie d'Alger 5114 or DMC 3888

- Dark pink stranded thread –
 Soie d'Alger 3013 or DMC 961

- Medium pink stranded thread –
 Soie d'Alger 3012 or DMC 962

- Light pink stranded thread –
 Soie d'Alger 3011 or DMC 3716

- Very pale pink stranded thread –
 Soie d'Alger 1012 or DMC 3713

- Light yellow stranded thread –
 Soie d'Alger 2511 or DMC 745

PRAYING MANTIS

- Dark gold stranded thread –
 Soie d'Alger 2225 or DMC 732

- Medium gold stranded thread –
 Soie d'Alger 2224 or DMC 733

- Iridescent metallic thread –
 Benton & Johnson Couching Thread 371 – col. Red Opal

- Old gold rayon thread –
 Madeira Rayon No.40 col. 1190

- Bronze/copper metallic thread –
 Madeira Metallic No.40 col. 482

- Clear nylon thread –
 Madeira Monofil No. 60 col. 1001

PREPARATION

The Lotus and Praying Mantis may be embroidered on a variety of background fabrics. Please refer to page 22 for suggestions and preparation.

TRANSFERRING THE DESIGN

I used method 1 on page 23 to transfer the design.

Author's note

Always use the minimum amount of lead when tracing. If your outlines are too dark, gently press the traced outlines with pieces of masking tape to remove any excess graphite.

ORDER OF WORK

LOTUS

STEMS

The stems are worked in stem stitch with two strands of very dark green thread in a size 9 crewel needle. Work the stem stitches approximately 2.5mm (⅛in) in length.

1. Starting at the base, work a row of stem stitch along the outside bud stem line, carrying the thread underneath the leaves and petals and finishing at the edge of the bud. Work a second row of stem stitch inside the first row, starting the row of stitching slightly to the right of the starting point of the first row.

2. Work the remaining two lotus-pod stems in the same way – carrying the thread under the petals and leaves, and starting all the rows of stem stitch slightly to the right of the previous row to form a sloping lower edge line for the stems.

LOWER LEAF

The lotus leaves are worked with one strand of thread in a size 10 crewel needle.

1. Using one strand of dark green thread, work a row of long-and-short buttonhole stitch around the outside edge of the leaf, working the stitch direction towards the centre point of the leaf.

2. Fill the leaf surface with long-and-short stitch, continuing to work the stitches towards the centre point of the leaf.

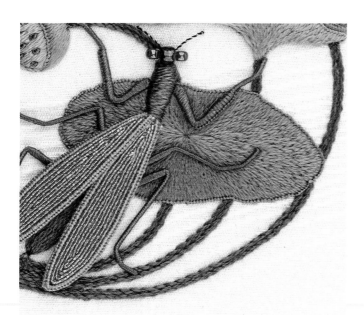

UPPER LEAF

The upper leaf consists of an embroidered background leaf partially covered by a detached lower segment.

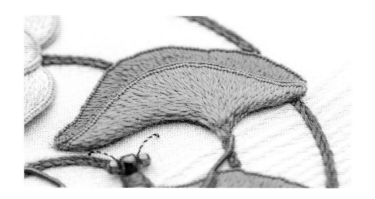

BACKGROUND LEAF

1 Using one strand of medium green thread, work a row of split stitch along the lower edges of the leaf.

2 With one strand of dark green thread, work a row of long-and-short buttonhole stitch across the upper edge of the leaf, working the stitch direction towards the centre point (stem) of the leaf.

3 Fill the leaf surface with long-and-short stitch, continuing to work the stitches towards the stem.

DETACHED LEAF SEGMENT

1 Mount a 20cm (8in) square of muslin into a small hoop and trace the detached leaf outline.

2 Using one strand of dark green thread, couch then buttonhole stitch a 12cm (4¾in) length of green-coloured wire to the muslin across the top edge of the leaf, leaving two tails of wire, of equal length, at each side of the leaf edge. Hold the tails of wire with tape.

3 Changing to medium green thread, work a row of long-and-short buttonhole stitch across the top edge of the leaf, inside the wire, angling all the stitches towards the centre point (stem) of the leaf. Work a row of split stitch along the lower edges of the leaf.

4 Fill the leaf surface with long-and-short stitch, continuing to work the stitches towards the stem and covering the row of split stitch.

141

APPLYING THE DETACHED LEAF SHAPE OVER THE EMBROIDERED BACKGROUND LEAF

1 Carefully cut out the detached leaf shape, cutting very close to the upper buttonholed edge and leaving a 2.5–3mm (⅛in) turning of muslin along the lower edges. Take care not to cut off the wire tails. Finger-press the turning behind the detached leaf shape (it helps to snip the lower curves of the turning allowance).

2 Using a yarn darner, insert the wire tails on either side of the background leaf at the points as marked – see the illustration bottom right. Bend the wires behind the leaf and hold in place temporarily with tape. Using medium green thread, slip stitch the lower edge of the detached leaf in place along the lower edge of the background leaf, tucking in the turning with the point of your needle as you go. Work some stitches from the stem into the base of the leaf to neaten the lower point.

3 Stitch the wire tails to the back of the leaf, then trim.

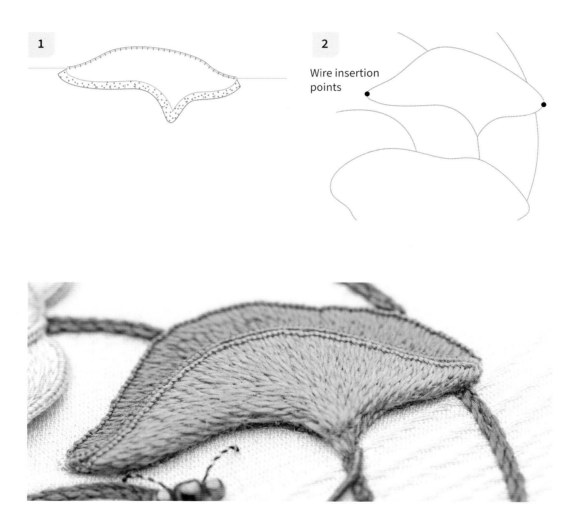

LOTUS-FLOWER BUD

1 Using a lead pencil, trace the bud padding shape onto the paper side of paper-backed fusible web. Fuse to cream felt, cut out the shape then remove the paper backing.

2 Using one strand of very pale pink thread, apply the bud padding shape, fusible web side up, over the bud outline on the background fabric, with a few stab stitches. Work a row of spaced buttonhole stitch around the edge of the padding, working the stitches 2mm (1⁄16in) apart.

3 Embroider the bud in satin stitch, enclosing the buttonhole stitched outline.

DETACHED BUD SEPALS

1 Mount a 20cm (8in) square of muslin into a small hoop and trace the two detached bud sepal outlines.

2 Shape a 9cm (3½in) length of green wire around the detached bud sepal outline, leaving two tails of wire at the base that touch but do not cross. Using one strand of light green thread, couch then buttonhole stitch the wire to the muslin around the edge of each sepal.

3 Embroider the sepal, inside the wire, in long-and-short stitch. Repeat for the second sepal.

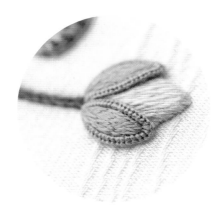

COMPLETING THE BUD

1 Carefully cut out the detached bud sepals and shape slightly before applying.

2 Using a yarn darner, insert both bud sepals at the end of the stem, over the satin-stitched bud, checking that the sepals are placed correctly (the straighter edges are in the centre of the bud).

3 Bend the wire tails behind the bud and stitch to the back with small stitches. Trim the wires. Shape the detached sepals.

SEED PODS

Cut the seed-pod padding shapes from grey felt using paper-backed fusible web to obtain an accurate outline. Both seed pods are worked the same way.

1 Using one strand of medium green thread, apply the seed-pod padding, fusible web side up, over each seed-pod outline, with a few stab stitches. Work a row of spaced buttonhole stitch around the lower edge of the padding (the seed-pod base) working the stitches 2mm (1⁄16in) apart. Do not cut the thread.

2 Using light green thread, work a row of spaced buttonhole stitch across the top edge of the seed pod, then work a line of backstitch along the curved inner line of the seed pod.

3 Embroider the top section of the seed pod with satin stitch, working the stitches across the oval shape, enclosing the buttonholed edge and the row of backstitch.

4 Using the retained medium green thread, cover the base of the seed pod with long, close buttonhole stitches, working the ridge of the buttonhole next to the light green satin stitch, and enclosing the lower padding outline. Work a row of stem stitch around the top edge of the satin stitch.

5 Using one strand of medium purple thread in a size 9 milliners needle, work French knots into the satin-stitched top of the seed pod to represent the seeds of the lotus pod. Take care to pierce the satin stitches when working the knots to avoid gaps between the satin stitches.

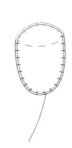

LOTUS-FLOWER PETALS

The lotus flower is made up of four embroidered background petals and six detached petals, all worked in shades of pink thread – one strand in a size 10 crewel needle.

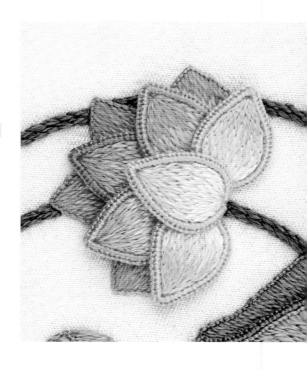

BACKGROUND PETALS

1 Using dark pink thread, work a row of long-and-short buttonhole stitch across the upper edge of one background petal 1 to form the outer petal outline.

2 Use medium pink thread to fill the rest of the petal with long-and-short stitch. Repeat for the remaining petal 1.

3 Using medium pink thread, work a row of long-and-short buttonhole stitch across the upper edge of one background petal 2 to form the petal outline.

4 Use light pink thread to fill the rest of the petal with long-and-short stitch. Repeat for the remaining petal 2.

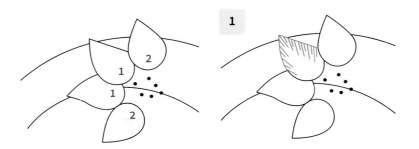

DETACHED PETALS

Mount a 20cm (8in) square of muslin into a 15cm (6in hoop) and trace six detached petal outlines. Take a 9cm (3½in) length of 33-gauge white-covered wire for each petal and embroider with various shades of pink thread, as follows:

Detached petal 1

Work one petal with this colour combination.

1 Shape a length of wire around a detached petal outline, leaving two tails of wire at the base that touch but do not cross. Using one strand of dark pink thread, couch then buttonhole stitch the wire to the muslin around the edge of the petal.

2 Continuing with dark pink thread, work a row of long-and-short stitch across the top edge of the petal, inside the wire.

3 Using medium pink thread, work the remaining petal surface with long-and-short stitch, changing to light pink thread at the base of the petal.

Detached petals 2

Work two petals with this colour combination.

1 Shape a length of wire around the detached-petal outline, leaving two tails of wire at the base that touch but do not cross. Using one strand of medium pink thread, couch then buttonhole stitch the wire to the muslin around the edge of the petal.

2 Continuing with medium pink thread, work a row of long-and-short stitch across the top edge of the petal, inside the wire.

3 Using light pink thread, work the remaining petal surface with long-and-short stitch, blending in very pale pink thread at the base of the petal.

Detached petals 3

Work three petals with this colour combination.

1 Shape a length of wire around the detached petal outline, leaving two tails of wire at the base that touch but do not cross. Using one strand of light pink thread, couch then buttonhole stitch the wire to the muslin around the edge of the petal.

2 Continuing with light pink thread, work a row of long-and-short stitch across the top edge of the petal, inside the wire.

3 Using very pale pink thread, work the remaining petal surface with long-and-short stitch, blending in light yellow thread at the base of the petal.

COMPLETING THE LOTUS FLOWER

1 Carefully cut out the detached lotus-flower petals and shape slightly before applying.

2 Using a yarn darner, insert petal 1 through the upper dot, bending the wire tails behind the embroidered upper petals. Temporarily hold the wire tails with tape.

3 Using a yarn darner, insert petals 2 through the two upper side dots, and two petals 3 through the two lower side dots. Insert the remaining petal 3 through the remaining dot at the end of the stem.

4 Bend all the wire tails behind the flower and stitch to the back with small stitches. Trim the wires. Shape the detached petals.

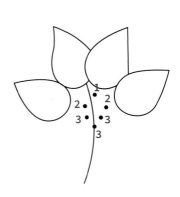

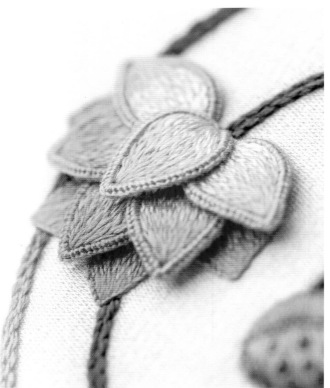

PRAYING MANTIS

ABDOMEN

1 Trace the Praying Mantis Placement Outline, including the square outline, onto tracing paper. This will be used to position the abdomen and legs of the praying mantis.

2 Trace the abdomen outline, and internal segment lines, onto the sticky end of a sticky note. Cut out this shape to use as an abdomen template. Position the abdomen template, sticky side down, over the background stems and leaf, using the Placement Outline as a guide. If required, temporarily hold the template in position with two needles piercing the paper and the background.

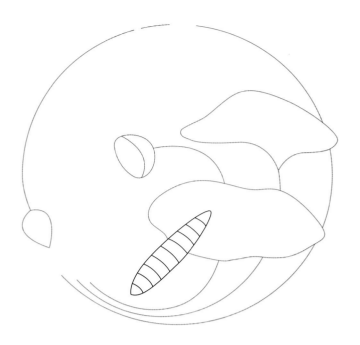

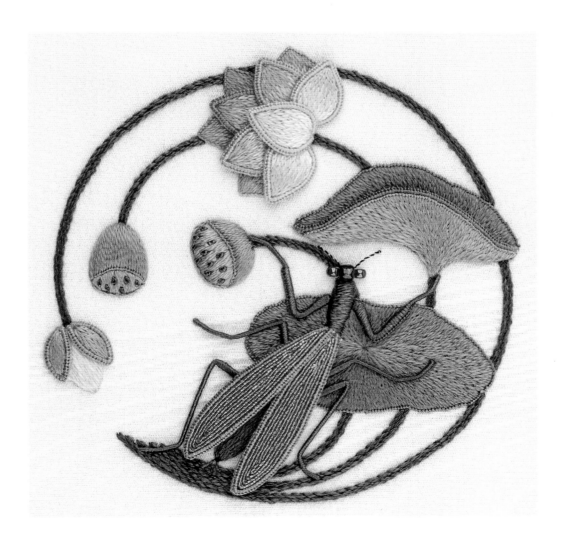

3 Using one strand of dark gold thread, work a row of backstitch around the abdomen template, making one backstitch for each segment (ten backstitches along each side). Hold the thread to one side to use later. Remove the paper template.

4 Thread seven strands of dark gold thread into a chenille needle. To pad the abdomen, work five long straight stitches, inside the abdomen outline (laid satin stitch), holding the tails of thread out of the way at the back with tape.

5 Retrieve the retained single strand of dark gold thread and use to work nine straight stitches across the padded abdomen, using the backstitches as a guide to placement – these stitches need to be reasonably firm as the abdomen is quite wide.

6 Using one strand of dark gold thread in a size 28 tapestry needle, work rows of raised stem stitch over the couching stitches to cover the abdomen. Start all rows at the thorax end of the abdomen (working all rows towards the tail), working some short rows when required (about 15 rows altogether).

7 Work a fly stitch at the end of the abdomen to complete.

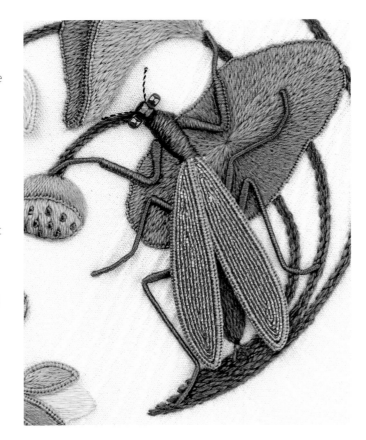

WINGS

The wings of the praying mantis are wide and sheer when opened. When closed, the sheer wings are folded under the thicker section of the wing, near the centre back, which acts as a wing cover to protect the wings. We are working a representation of the wings when closed.

1 Mount a square of muslin into a 10 or 13cm (4 or 5in) hoop and trace the detached wing outlines – a right-side and left-side wing. Cut two 15cm (6in) lengths of 33-gauge white covered wire if you have not already done so.

2 Shape a length of wire around a wing outline, leaving two tails of equal length that touch but do not cross. Using one strand of medium gold thread, couch, then buttonhole stitch the wire to the muslin around the wing outline. Repeat for the remaining wing.

The wings are filled with consecutive rows of Red Opal Couching Thread – couched in place with old gold rayon machine thread in a size 12 sharps needle.

3 Cut a 40cm (16in) length of red opal couching thread. Insert a tail of couching thread through to the back at the wire-tail end of the wing – hold out of the way with tape. Couch red opal thread around the inside edge of the wing, working the couching stitches 2mm (1⁄16in) apart. Continue couching consecutive rounds of thread until the wing is filled, couching in a brick fashion when possible. If the space in the centre of the wing gets too narrow to fold the couching thread back, thread it into a needle and take it through to the back, bringing it out to the front again as required to fill the space. Secure the tails of couching thread to the back of the wing with small stitches. Trim. Work the remaining wing in the same way, couching the red opal couching thread in the opposite direction so that the wings are a mirror-image of each other. Carefully cut out the wings, taking care to avoid the wire tails.

4 Using a large yarn darner, insert the wire tails for each wing through two separate holes – one thread-width apart – at the top of the abdomen, bending the wire tails behind the abdomen (one wing slightly overlaps the other). Stitch the wire tails to the back of the abdomen with small stitches (start trimming the wire tails – grading – about halfway down the abdomen, making sure no wire tails protrude past the tail of the abdomen).

THORAX

1 Trace a thorax shape onto the paper side of fusible web, then fuse to the grey felt. Carefully cut out the shape and remove the paper backing. Using one strand of dark gold thread, apply the padding, web side up, with a few stab stitches, then work a row of spaced buttonhole stitch around the edge of the padding.

2 Cover the padding with satin stitches, worked across the shape and enclosing the buttonhole-stitch outline, working several stitches on top of each other to cover the wire insertion points for the wings.

Author's note
Check the diagram for the thorax placement – the mantis bends at the junction of the thorax and the abdomen.

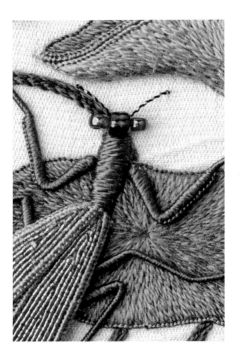

HEAD AND EYES

Using clear nylon thread, stitch a 3mm (⅛in) blue/bronze bead at the top of the thorax for the head, the hole in the bead being parallel to the thorax. Stitch a ginger bead on either side of this bead for the eyes, taking the thread through the large bead in a figure-of-eight motion, so that the ginger beads are suspended on either side of the head. Secure the thread at the back.

ANTENNAE

Using the bronze/copper metallic thread, work two loose straight stitches for the antennae. The thread can be taken through the large head bead when making these stitches – this gives a more realistic look to the antennae.

LEGS

The legs are formed by wrapping 30-gauge green paper-wrapped wire with one strand of dark gold thread. The leg outlines on the Praying Mantis Placement Outline are used to shape the wrapped legs before applying to the background fabric.

PREPARATION

1 Cut six 12cm (4¾in) lengths of green wire, one piece for each leg. Thread a 45cm (17¾in) length of dark gold thread into a size 28 tapestry needle (the needle is optional – I find it easier to wrap with the thread in a needle).

2 To determine the insertion points for the legs, hold the traced Praying Mantis Placement Outline over the back of the embroidery (right side down) – lining up the square outline and the abdomen – and insert size 12 needles at the leg ends (insertion points) and abdomen attachment points.

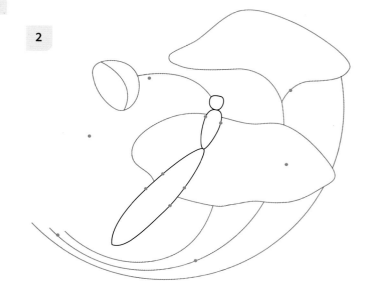

I worked and applied the legs in the following order: leg 3, leg 4, leg 5, leg 6, then leg 1 and leg 2.

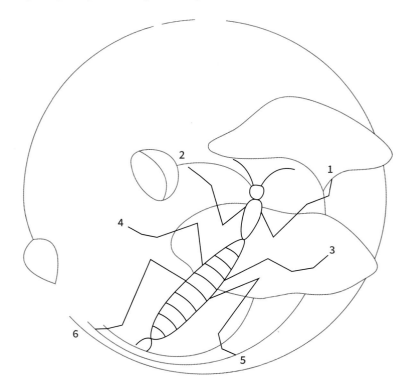

LEG 3

1 Attach a length of thread to a piece of wire with a single knot, 4cm (1½in) from one end, leaving a short tail of thread (about 6cm/2⅜in) and a longer 'wrapping' tail (threaded into a size 28 tapestry needle if desired).

2 Bend the wire at the knot and squeeze, then cut the short wire tail to 9mm (⅜in).

3 Keeping the short thread tail out of the way, wrap the doubled wire, from the knot, with the 'wrapping' tail, then continue wrapping the single wire until the total wrapped length is 3cm (1³⁄₁₆ in). Secure the thread tail with a single knot, leaving the tail in place (it will be used to stitch with later).

4 Using the Praying Mantis Placement Outline as a guide, shape the wrapped wire into a leg shape along leg line 3, the doubled wire closest to the abdomen. Bend the tail of excess wrapped single wire at the end of the leg at right angles, down towards where the background fabric will be (it will be inserted through the background fabric when the leg is applied). This will be the 'foot' end of the wrapped leg.

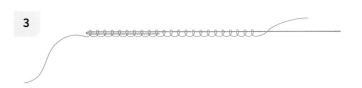

Author's note

To apply the legs, use the marked insertion points and work steps 5 and 6 at the same time, making small adjustments as required.

5 Insert the 'foot' end of the wrapped leg through to the back at the marked insertion point with a small yarn darner – take the end of the wrapped wire and thread tail through too. Bend the wire tail back under the 'foot' and stitch in place (to the backing fabric) with the thread tail. Trim the wire.

6 Thread the retained short tail of thread (at the bend in the wire) into a size 12 sharps needle, then take it through to the back at the marked point at the edge of the abdomen. Secure the thread tail at the back. Make another stitch into the bend of the wire, and across, if the leg requires more stability.

Repeat this process for legs 4, 5 and 6, using the measurements as indicated – and applying the legs in the following order:

LEG 4

1 Attach a length of thread to a piece of wire with a single knot, 4cm (1½in) from one end, leaving a short tail of thread and a longer 'wrapping' tail. Bend the wire at the knot and squeeze, then cut the short wire tail to 8mm (¼in).

2 Keeping the short thread tail out of the way, wrap the doubled wire, from the knot, with the 'wrapping' tail, then continue wrapping the single wire until the *total* wrapped length is 3cm (1¾₁₆in). Secure the thread tail with a half hitch knot, leaving the tail intact.

3 Using the Praying Mantis Placement Outline as a guide, shape the wrapped wire into a leg shape along leg line 4, the doubled wire closest to the abdomen. Bend the tail of excess wrapped single wire at the end of the leg.

4 Apply the leg as above, using the marked insertion points and making small adjustments as required.

LEG 5

1 Attach a length of thread to a piece of wire with a knot, 4cm (1½in) from one end, leaving a short tail of thread and a longer 'wrapping' tail. Bend the wire at the knot and squeeze, then cut the short wire tail to 1cm (⅜in).

2 Keeping the short thread tail out of the way, wrap the doubled wire, from the knot, with the 'wrapping' tail, then continue wrapping the single wire until the total wrapped length is 4cm (1½in). Secure the thread tail with a half hitch knot, leaving the tail intact.

3 Using the Praying Mantis Placement Outline as a guide, shape the wrapped wire into a leg shape along leg line 5, the doubled wire closest to the abdomen. Bend the tail of excess wrapped single wire at the end of the leg.

4 Apply the leg as above, using the marked insertion points and making small adjustments as required.

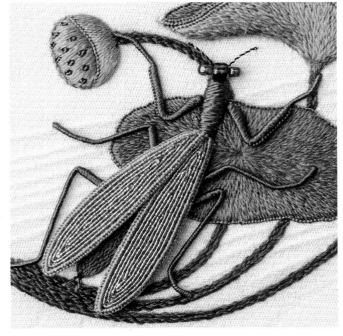

LEG 6

1 Attach a length of thread to a piece of wire with a knot, 4cm (1½in) from one end, leaving a short tail of thread and a longer 'wrapping' tail. Bend the wire at the knot and squeeze, then cut the short wire tail to 8mm (¼in).

2 Keeping the short thread tail out of the way, wrap the doubled wire, from the knot, with the 'wrapping' tail, then continue wrapping the single wire until the total wrapped length is 4cm (1½in). Secure the thread tail with a half hitch knot, leaving the tail intact.

3 Using the Praying Mantis Placement Outline as a guide, shape the wrapped wire into a leg shape along leg line 6, the doubled wire closest to the abdomen. Bend the tail of excess wrapped single wire at the end of the leg.

4 Apply the leg as above, using the marked insertion points and making small adjustments as required.

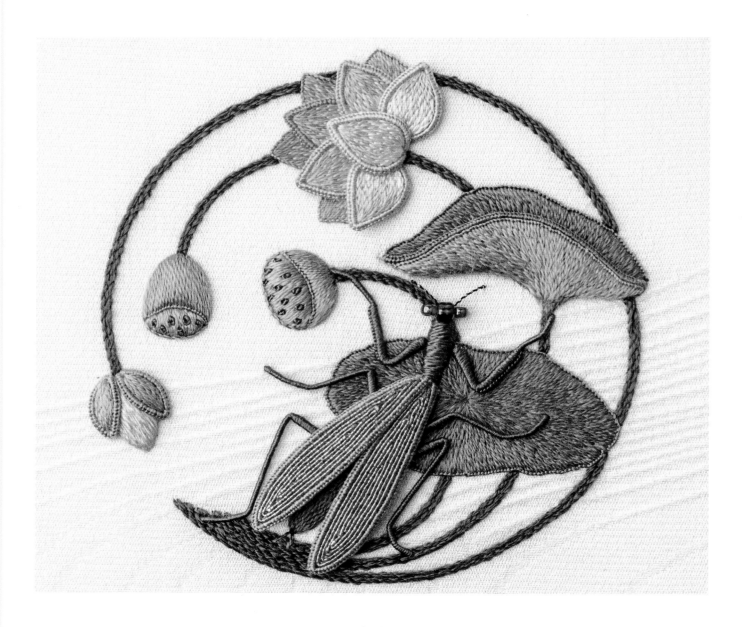

154

LEGS 1 AND 2

The front legs, 1 and 2, are worked in a similar way except that they have two segments of covered 'double' wire to represent the predatory front legs of the praying mantis.

1 Attach a length of thread to a piece of wire with a knot, 4cm (1½in) from one end, leaving a short tail of thread and a longer 'wrapping' tail. Bend the wire at the knot and squeeze, then cut the shorter wire tail to 1.5cm (⅝in).

2 With the longer tail of thread in a size 28 tapestry needle, and keeping the short thread tail out of the way, wrap the doubled wire (from the knot) for 6mm (¼in), then change to buttonhole stitch for 1cm (⅜in) (1.6cm/⅝in covered altogether). Continue wrapping the single wire until the total wrapped length is just over 3cm (1³⁄₁₆in). Secure the thread tail with a half hitch knot, leaving the tail intact. Wrap and buttonhole stitch the other leg in the opposite direction.

3 Using the Praying Mantis Placement Outline as a guide, shape the wrapped wires along leg line 1, and leg line 2, making sure the buttonholed edge of the second segment is on the lower side of each leg (see photo opposite). Bend the tail of excess wrapped single wire at the end of the leg.

4 Apply the legs as before, using the marked insertion points and making small adjustments as required. Make another stitch into the bend of the wire, and across, if the leg requires more stability.

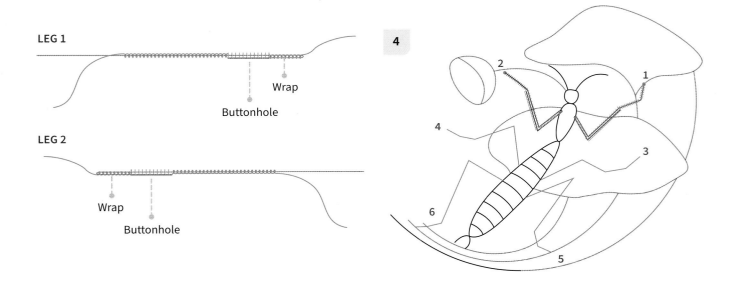

155

12
MORNING GLORY
AND GRASSHOPPER

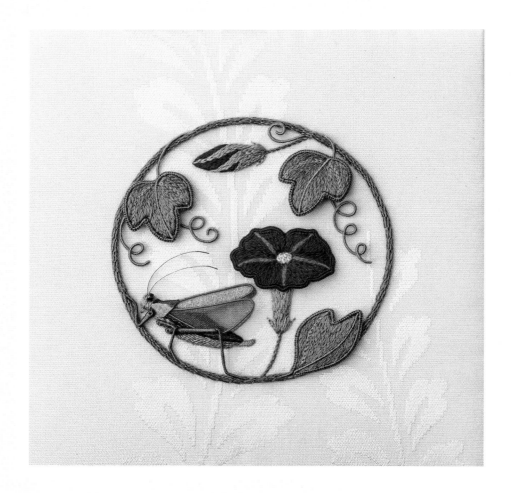

A family crest showing a stylized morning glory plant was the
inspiration for this small circular panel. The design features a
trumpet-shaped purple flower with wired detached petals, a
padded embroidered bud, detached leaves and wrapped-wire
tendrils; and a grasshopper, with gauzy detached wings
and wrapped-wire legs, worked on a background of vintage
Japanese silk.

Morning glory (*asagao*)

The morning glory is a summer-flowering climbing plant with slender stems, heart-shaped leaves and trumpet-shaped flowers of pink, blue, purple, magenta or white. As the name implies, the flowers bloom in the morning and close around noon.

The morning glory, *asagao* ('morning face'), is said to have been brought to Japan by diplomats from China, mainly for medicinal purposes, but it rapidly became one of the most sought-after garden plants in Japan, with people breeding them in vast quantities; at their height of popularity, gardeners created some 1000 varieties of morning glory through deliberate cross-pollination. With its beautifully shaped blooms and decorative twining tendrils, the morning glory was also a popular motif in both the fine and decorative arts, embellishing textiles, screens, paintings, porcelain and several family crests.

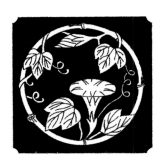

Morning glory *mon*

YOU WILL NEED

TEMPLATES:

For full-size, traceable outlines, please see page 181.

EQUIPMENT:

- Embroidery hoop or square frame –
 25cm (10in)
 two 10 or 13cm (4 or 5in)

NEEDLES:

- Crewel/embroidery size 10

- Milliners/straw size 9

- Sharps size 12

- Tapestry size 28

- Chenille sizes 18 and 20

- Sharp yarn darners sizes 14–18

- Embroidery equipment (see page 12)

MATERIALS:

- Background fabric –
 30cm (12in) square of the background fabric of your choice
 (see page 22 for suggestions and preparation)

- Backing fabric –
 30cm (12in) square of quilter's muslin (medium-weight
 cotton fabric)

- Tracing paper –
 15cm (6in) square (I use baking parchment)

- Plain white paper (e.g. photocopy paper) –
 20cm (8in) square

- Quilter's muslin (medium-weight cotton fabric) –
 two 20cm (8in) squares

- Orange silk organza –
 15cm (6in) square

- Gold metal organdie –
 8 x 5cm (3 x 2in)

- Cream felt –
 8 x 5cm (3 x 2in)

- Paper-backed fusible web –
 two 8 x 5cm (3 x 2in) pieces

- Bronze snakeskin/leather –
 2.5cm (1in) square

- PVA glue

MORNING GLORY

- 33-gauge white wire coloured purple (Copic V09 Violet) –
 15cm (6in) length

- 33-gauge white wire coloured green (Copic YG63 Pea Green) –
 seven 12cm (4¾in) lengths

GRASSHOPPER

- Mill Hill Seed Bead col. 374 (blue-bronze)

- 28-gauge uncovered wire –
 two 10cm (4in) lengths

- 30-gauge green wire –
 three 12cm (4¾in) lengths

- 32/34-gauge brass wire –
 10cm (4in) length

THREADS:

MORNING GLORY

- **Green soft cotton tapestry thread –**
 DMC Soft Cotton col. 2470

- **Dark green stranded thread –**
 Soie d'Alger 2125 or DMC 3346

- **Medium green stranded thread –**
 Soie d'Alger 2124 or DMC 3347

- **Pale green stranded thread –**
 Soie d'Alger 241 or DMC 772

- **Dark purple stranded thread –**
 Soie d'Alger 1326 or DMC 550 (not an exact match)

- **Light purple stranded thread –**
 Soie d'Alger 1313 or DMC 3835

- **Cerise pink stranded thread –**
 Soie d'Alger 1043 or DMC 3886 (not an exact match)

- **Yellow stranded thread –**
 Soie d'Alger 622 or DMC 3855

- **Smoke nylon thread –**
 Madeira Monofil No.60 col. 1000

GRASSHOPPER

- **Dark olive stranded thread –**
 Soie d'Alger 2146 or DMC 934

- **Medium olive stranded thread –**
 Soie d'Alger 2145 or DMC 730

- **Light olive stranded thread –**
 Soie d'Alger 2143 or DMC 733

- **Orange rayon thread –**
 Madeira Rayon No.40 col. 1021

PREPARATION

The Morning Glory and Grasshopper may be embroidered on a variety of background fabrics. Please refer to page 22 for suggestions and preparation.

TRANSFERRING THE DESIGN

I used method 1 on page 23 to transfer the design.

Author's note

Always use the minimum amount of lead when tracing. If your outlines are too dark, gently press the traced outlines with pieces of masking tape to remove any excess graphite.

ORDER OF WORK

MORNING GLORY

STEMS

The circular main stem is worked in raised stem stitch over a padding of soft cotton thread.

1 Thread a length of the green soft cotton thread into a size 18 chenille needle. Bring the needle out at A, leaving a tail of thread at the back (held out of the way with tape). With one strand of dark green stranded thread in a size 10 crewel needle, couch the length of soft cotton over the circular stem outline, working the stitches approximately 2.5mm (⅛in) apart and making sure that they are not too tight – just snug over the soft cotton. Take the padding thread through to the back again at A, and, keeping both tails out of the way, work a couching stitch over this insertion point, again, not pulling the stitch too tight. Secure the stranded thread at the back. (The tails of soft cotton thread will remain until the rows of raised stem stitch have been worked.)

2 Using one strand of dark green thread in a size 28 tapestry needle, work four rows of raised stem stitch, over the couching stitches, to cover the stem padding, working the first row on the outside edge of the circle, and starting and finishing each row at A, as invisibly as possible (insertion point A will be covered by a detached leaf). Trim the soft cotton tails.

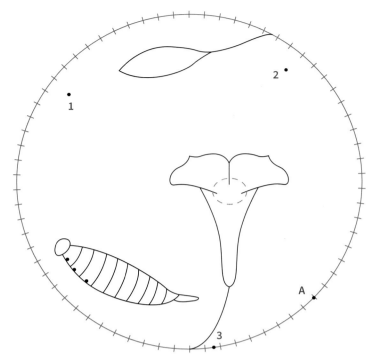

Author's note
The flower and bud stems will be worked at a later stage.

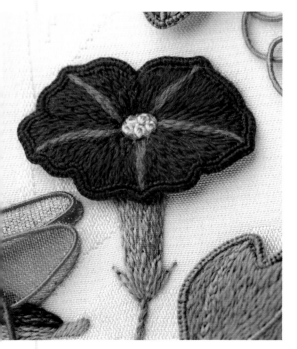

FLOWER

The tube of the morning glory flower is worked on the background fabric with one strand of light purple thread in a size 10 crewel needle.

1 Outline the tube of the flower with small backstitches, then fill with long-and-short stitch, quite densely worked, finishing at the lower edge of the dotted centre circle (this edge will not be seen as it is underneath the detached flower petals).

2 Work the stem of the flower in stem stitch with two strands of dark green thread.

3 With one strand of medium green thread, work five chain stitches over the base of the tube to form the sepals.

DETACHED FLOWER PETALS

1 Mount a 20cm (8in) square of muslin into a small hoop and trace the detached flower petals outline (the five petals of the morning glory flower are fused at the edges). Cut a 15cm (6in) length of 33-gauge purple-coloured wire if you have not already done so.

2 Insert one wire tail at the upper edge of the petals outline at • – hold out of the way with tape. Using one strand of dark purple thread, couch the wire to the muslin around the outside edges of the flower petals, shaping the wire with fine tweezers as you go. Before couching around the final petal, insert the remaining wire tail through to the back at •. Keeping both tails of wire beneath the detached petal, stitch the couched wire to the muslin with close, firm buttonhole stitches, avoiding the wire tails. Trim the wire tails to 2mm (1⁄16in) and secure with subsequent embroidery.

3 Using one strand of dark purple thread, work a row of long-and-short buttonhole stitch around the outside edges of the flower petals, inside the wire, angling all stitches towards the centre circle of the flower. Take care with the stitch direction – draw in lines to help if needed.

4 Continuing with dark purple thread, embroider each flower petal with long-and-short stitch, continuing to work the stitches towards the centre circle of the flower.

5 With one strand of cerise pink thread, work a row of long stem stitches along the centre ray of each petal, starting at the edge of the centre circle and inserting the needle very close to the inner edge of the buttonholed wire at end of the line (three or four stem stitches). Starting at the edge of the centre, work a second row of stem stitch close to the first, ending the row slightly shorter than the previous row to form a form a pointed end to the centre ray.

6 Carefully cut out the petals shape, close to the buttonholed edge. Run your fingernail along the edges to loosen any stray threads, and trim. Using a stiletto, make a hole in the centre of the detached petals, working the stiletto to make a hole the size of the centre of the flower (this is like making an eyelet). With one strand of dark purple thread, work two or three stitches at the base of each petal, taking the needle from the petal through the hole then to the back of the petal, to neaten the edge of the hole and hide any muslin that may be showing.

Author's note

Do not make the stitches too dense around the centre circle as there will be more stitches added here when the detached petals are applied.

APPLYING THE DETACHED FLOWER PETALS

1 Outline the upper background petals with a row of small backstitches using one strand of dark purple thread.

2 With one strand of pale green thread, work a patch of vertical satin stitches in the centre area of the background petals.

3 Using smoke-coloured nylon thread in a size 12 sharps needle, apply the detached petals shape over the upper background petals outline as follows:

 – Secure the nylon thread well at the back then bring the needle through the background petals outline at 1. Make a small stitch into the detached petal shape at the equivalent position 1 – take the needle from the back over the wire and through to the back again at point 1 of the shape (this stitch should be invisible). Then take the needle through the background fabric again at 1, resulting in the shape overlapping the petal outlines on the background fabric. Repeat for points 2 and 3. Work several securing stitches at the back to prevent these stitches from loosening. Repeat this process for the outer points – 4 and 5 – of the petals. It doesn't matter in what order you work these five securing stitches.

 – When you are happy with the position of the detached petals shape, work some invisible stitches around the edge of the centre hole through to the back to secure the edge.

 – Finally, make a few invisible stitches along the lines of the petal edges (centre back and two sides) to further secure and help with the shaping. Secure the thread and carefully shape the petals with tweezers.

4 With two strands of yellow thread in a size 9 milliners needle, work five French knots, with one wrap each, inside the centre of the flower, to represent the stamens.

Author's note

When the detached petals shape is applied over this area, the satin stitches will be visible through the centre hole, so check to see that the satin-stitched patch is larger than the centre hole.

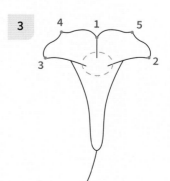

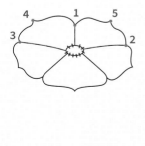

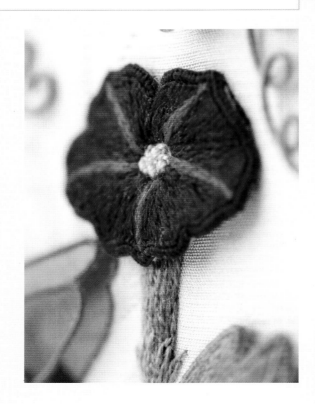

MORNING-GLORY BUD

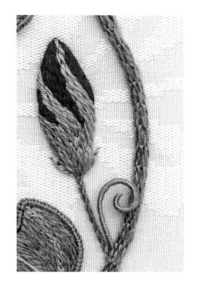

1 Using a lead pencil, trace the bud padding shape onto the paper side of paper-backed fusible web. Fuse to cream felt, cut out the shape then remove the paper backing.

2 Using one strand of light purple thread, apply the bud padding shape, fusible web side up, over the bud outline on the background fabric, with a few stab stitches. Work a row of spaced buttonhole stitch around the edge of the padding, working the stitches 2mm (1⁄16in) apart and using light purple thread for the lower half of the bud (closest to the stem) and dark purple thread for the upper half.

3 Embroider the upper half of the bud in long-and-short stitch with dark purple thread, enclosing the buttonholed edge.

4 Using light mauve thread, work rows of stem stitch over the bud to represent the twisted nature of the unopened bud. Work from the stem end of the bud with consecutive rows of stem stitch, using the diagram as a guide.

5 Work the stem of the bud in stem stitch with two strands of dark green thread.

6 With one strand of medium green thread, work five chain stitches over the base of the bud to form the sepals.

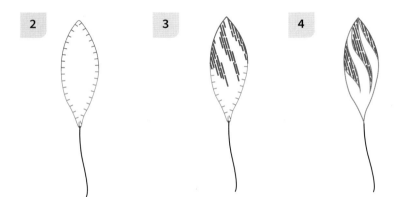

163

DETACHED LEAVES

1 Mount a square of quilter's muslin into a small hoop then trace the three detached leaf outlines (make sure the leaves are facing the correct way). Number the leaves.

2 Use a 12cm (4¾in) length of green-coloured 33-gauge wire for each leaf. Using one strand of medium green thread, couch, then overcast the wire along the central vein line, starting with one end of the wire at the tip of the leaf, and keeping the remaining wire free to work the outside leaf edge. Work the two side veins in chain stitch.

3 Shape the remaining tail of wire around the outside edge of the leaf, couching in place as you go with one strand of dark green thread. Buttonhole stitch the wire to the muslin, leaving a short tail of wire at the lower end of the leaf.

4 Using dark green thread, embroider the leaf surface with long-and-short stitch.

5 Carefully cut out the detached leaves and, using a fine yarn darner, insert the wire tails at the points as marked. Secure the wire tails behind the leaves with small stitches. Trim the wire tails. Shape the leaves.

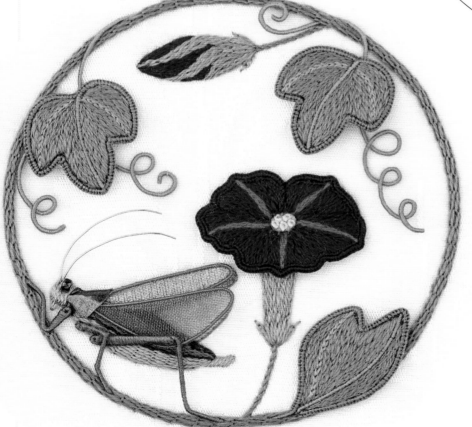

TENDRILS

Apply the detached leaves before inserting the tendrils. The morning glory tendrils are formed by wrapping 12cm (4¾in) lengths of 33-gauge green-coloured wire with one strand of medium green thread.

1 Using a minute amount of PVA glue, attach a short tail of thread to the wire, 1cm (⅜in) from one end, leaving a long tail of thread for wrapping. Keeping the 1cm (⅜in) tail of wire at one end, wrap about 5cm (2in) (7cm/2¾in for the longer tendril) of wire, enclosing the short tail of glued thread. Secure the wrapping thread with a knot, retaining the tails of wire and thread.

2 Holding on to the 1cm (⅜in) 'unwrapped' end of wire, twist the wrapped wire into a tendril shape, using fine tweezers and the diagram as a guide. Do not cut the short end of wire until the tendril is in place and secured (this prevents the thread from unravelling at the end of the tendril). Make the four tendrils.

3 Using a fine yarn darner, insert the retained wire and thread tails through to the back of the work, using the diagram as a placement guide. Note: Two of the insertion points for the tendrils are on the outer edge of the stem circle (as shown), and one insertion point is under a detached leaf. The remaining shorter tendril appears to be slightly overlapping the outside circle at the top – but its insertion point is under the line – near where the bud stem joins the main circle. Adjust the position of the tendrils and secure to the back. Trim the wire. Carefully cut off the 'unwrapped' 1cm (⅜in) of wire, close to the tip of each tendril.

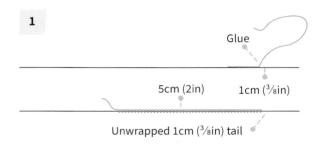

Glue

5cm (2in) 1cm (⅜in)

Unwrapped 1cm (⅜in) tail

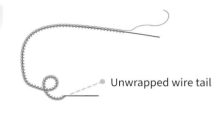

Unwrapped wire tail

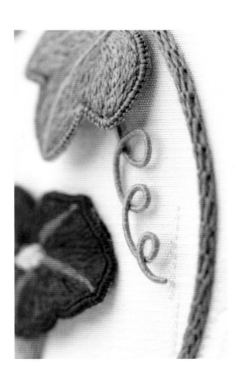

GRASSHOPPER

DETACHED WINGS

1 Using paper-backed fusible web, fuse the gold metal organdie to the orange silk organza, placing one long edge of the gold fabric along the 'centre line' of the organza (use baking parchment to protect the iron and the ironing board). Mount into a small hoop, organza side uppermost.

2 Bend uncovered wire around the Detached Wing Outlines templates – one forewing and one larger hindwing, leaving two tails of wire at the base of the wing that touch but do not cross. Attach the wire tails to the organza with masking tape, positioning the smaller forewing over the 'gold backed' section of the organza, and the larger hindwing over the single layer of organza. Check that the wings are the right way up. Using orange rayon thread in a size 12 sharps needle, overcast stitch the wire to the wing fabric, working several stitches over both wires, at the base of the wing, to begin and end the stitching. Carefully cut out the wings, saving the remaining wing fabric for the surface wings.

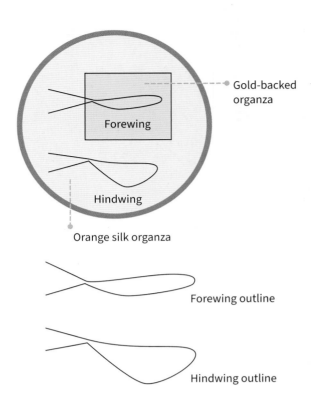

Gold-backed organza

Forewing

Hindwing

Orange silk organza

Forewing outline

Hindwing outline

SURFACE WINGS

1 Place a piece of paper-backed fusible web over the 'surface wing outlines' diagram (below), paper side up, and trace around both wing outlines. Fuse the traced outlines to the back of the saved pieces of wing fabric, fusing the forewing outline to the gold side of the fused wing fabric, and the hindwing outline to the single layer of organza (use baking parchment to protect the iron and the ironing board). Cut out the wings and remove the paper backing.

2 Using the wing outlines on the diagram below as a guide to placement, position the surface wings (web side down) over the traced abdomen outline on the background fabric, hindwing first, then the slightly overlapping forewing. With a board under the hoop for support and baking parchment over the wings for protection from the iron, carefully fuse the wings to the background fabric.

3 Using orange rayon thread in a sharps needle, work an outline around the wings with small stem stitches (next to the edge of the fabric), stitching over the organza for the lower edge of the forewing.

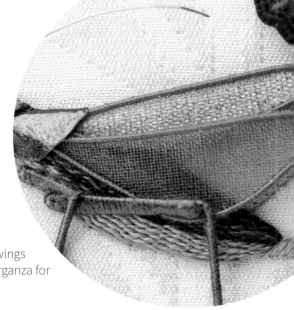

1 SURFACE WINGS OUTLINE

Forewing

Hindwing

2

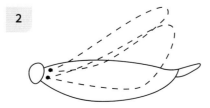

ABDOMEN

The abdomen is worked in raised stem stitch over a layer of padding stitches.

1. Using one strand of light olive thread in a size 10 crewel needle, outline the head, abdomen and ovipositor (narrow pointed tail) in split stitch, working the stitches over the fused organza wing (this portion of wing will be covered by the stitched abdomen). The head and ovipositor will be worked later.

2. With six strands of light olive thread in a chenille needle, pad the abdomen, inside the outline, with five or six long straight stitches.

3. With one strand of light olive thread, work nine couching stitches over the padding, enclosing the split-stitched outline. Secure the thread.

4. Cover the abdomen with rows of raised stem stitch, worked over the couching stitches with one strand of thread in a size 28 tapestry needle. Work some short rows to allow for the width of the abdomen:
 - starting at the lower edge, work four to five rows in light olive thread;
 - work one row in dark olive;
 - continue working with medium olive then finish with two to three rows of dark olive thread.

5. With one strand of light olive thread, work the ovipositor in slanted satin stitch, enclosing the outline.

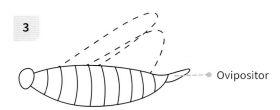

Ovipositor

HEAD AND WING ATTACHMENTS

1. Work the head in padded satin stitch with one strand of light olive thread. Make a 'hole' in the satin stitch, for the eye, with a yarn darner then stitch a blue-bronze seed bead in the cavity. From the lower edge of the head, work three to four straight stitches, into a point, for the mouth parts.

2. Using a yarn darner, insert the wire tails of the detached wings through the abdomen at the points as marked on the outline below. Insert the forewing first, stitching the unbent wire tails behind the head (hold the tails with tape until they are trimmed). Then insert the hindwing and carefully bend the wire back under the abdomen and stitch to secure (*do not trim the wires until the grasshopper is finished*). Position the detached wings over the surface wings.

3. A bronze snakeskin collar (pronotum) covers the insertion points of the detached wings. First cut a collar template from paper (or a sticky note) and check for size (it lies next to the head and needs to reach from the top edge of the abdomen to just over the lower wing insertion point). Then cut a collar shape from bronze snakeskin using the template as a guide. With nylon thread in a sharps needle, apply the snakeskin shape with small stab stitches, first working a stitch at each corner (next to the head), then stitching the top edge of the snakeskin in place with two or three stitches.

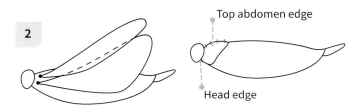

Top abdomen edge

Head edge

LEGS

The grasshopper legs are formed by wrapping 12cm (4¾in) lengths of 30-gauge green-covered wire with one strand of medium olive thread, following the instructions provided for each leg. Apply the front leg first, then the back leg and finally the middle leg.

FRONT LEG

The broader first segment of the front leg (closest to the abdomen) is formed by wrapping over two thicknesses of wire.

1 Tie a length of medium olive thread to the wire, 1cm (⅜ in) from one end, leaving one short tail and a longer tail of thread to use for wrapping. Holding on to the shorter tail, wrap the wire for 2mm (¹⁄₁₆in) with the longer tail of thread, then bend the wire in the middle of the wrapped section and squeeze the wires together (the wrapped bend will be the abdomen end • of the leg).

2 Trim the short end of the wire to 4mm (⅛in), then, starting at the bend, wrap over both wires (enclose then trim the short tail of thread) and continue wrapping over the single wire until the wrapped section measures at least 2cm (¾in). Secure the wrapping thread with a knot, retaining the tails of wire and thread.

Wrapped tail

3 Using tweezers, bend the wrapped wire into three segments to form a front leg shape, using the leg outline diagram as a guide (the wrapped bend • corresponds to • on the diagram). Bend the wire at the end of the 'foot' at right angles towards the background (this wrapped tail of wire will be taken through to the back at the stem).

4 Apply the leg by stitching the • end over the corresponding point • at the edge of the abdomen (use medium olive thread in a sharps needle to take a thread through the bend in the wire • and through to the back to secure). At the same time, insert the 'foot' end of the wire through the stem to the back with a yarn darner, adjusting the bends in the legs if required. The wire tail is bent back under the 'foot' and secured with small stitches using the retained thread tail (always wrap more wire than required to ensure a neat end to the leg). Trim the wire.

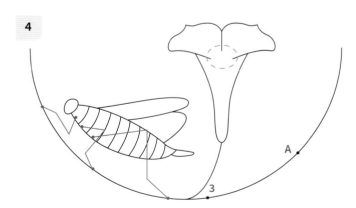

BACK LEG

The broader first segment of the back leg (closest to the abdomen) is formed by wrapping over three thicknesses of wire.

1 Tie a length of medium olive thread to the wire, 4cm (1½in) from one end, leaving one short tail and a longer tail of thread to use for wrapping. Holding on to the shorter tail, wrap the wire for 2mm (1⁄16in) then bend the wire in the middle of the wrapped section and squeeze the wires together (the wrapped bend will be the abdomen end • of the leg).

2 Bend the short end of the wire again, 1.3cm (½in) away from the wrapped bend – trim the tail to fit in the resulting space (three thicknesses of wire). Then, starting at the wrapped bend, wrap over the three thicknesses of wire (enclose then trim the short tail of thread) and continue wrapping over the single wire until the wrapped section measures at least 4cm (1½in). Secure the wrapping thread with a knot, retaining the tails of wire and thread.

3 Using tweezers, bend the wrapped wire into three segments to form a back leg shape, using the leg outline diagram as a guide (the wrapped bend • corresponds to • on the diagram). Bend the wire at the end of the 'foot' at right angles towards the background (this wrapped tail of wire will be taken through to the back at the stem).

4 Apply the leg by stitching the • end over the corresponding point • at the edge of the abdomen (use medium olive thread in a sharps needle to take a thread through the bend in the wire • and through to the back to secure). At the same time, insert the 'foot' end of the wire through the stem to the back with a yarn darner, adjusting the bends in the legs if required. The wire tail is bent back under the 'foot' and secured with small stitches using the retained thread tail. Trim the wire.

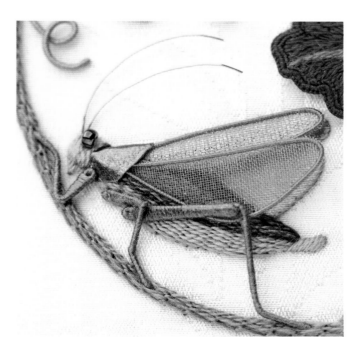

MIDDLE LEG

Work the middle leg as for the front leg. When applied it will slightly overlap the back leg.

ANTENNAE

Fold a 10cm (4in) piece of brass wire in half and insert through the head with a small yarn darner. Secure at the back. Shape the wire into a curved shape by pulling through your fingers, then trim to the desired length.

Finally, trim the wire tails of the detached wings.

TEMPLATES

Shown at actual size.

These templates are also available to download from the Bookmarked Hub: www.bookmarkedhub.com. Search for this book by title or ISBN: the files can be found under 'Book Extras'.

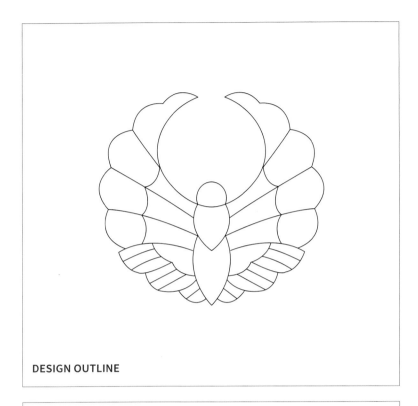

DESIGN OUTLINE

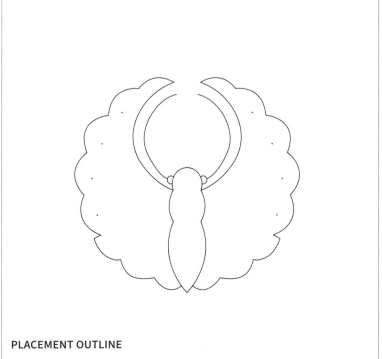

PLACEMENT OUTLINE

1 SLATE BUTTERFLY, PAGE 30

Body padding outlines

Head leather outline

Abdomen leather outline

Forewing padding outlines

2 COPPER BUTTERFLY, PAGE 40

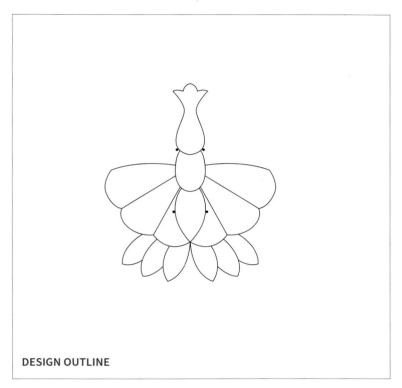

DESIGN OUTLINE

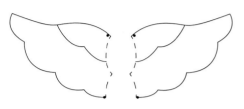

Detached wing outlines

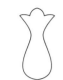

Head leather outline

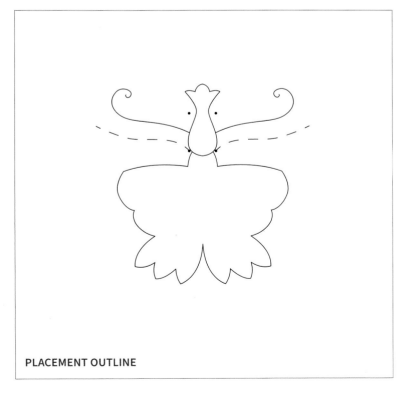

PLACEMENT OUTLINE

Head and body padding

3 AMETHYST BUTTERFLY, PAGE 52

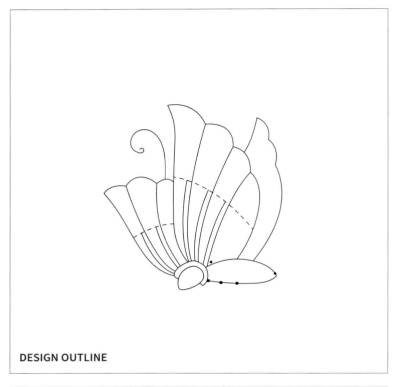

DESIGN OUTLINE

Detached wing outline

Abdomen padding outlines

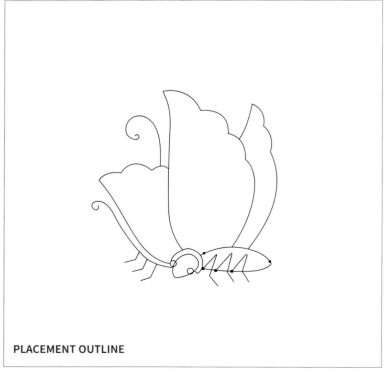

PLACEMENT OUTLINE

Head padding outlines

Head and abdomen leather outlines

Detached leg outlines

4 GOLD BUTTERFLIES, PAGE 64

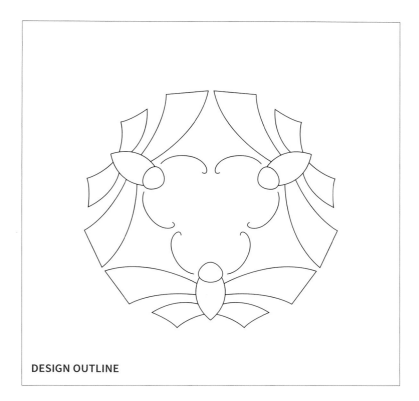

DESIGN OUTLINE

Body padding outlines

Body leather outline

Forewing padding outlines

5 PINK PLUM BLOSSOM, PAGE 74

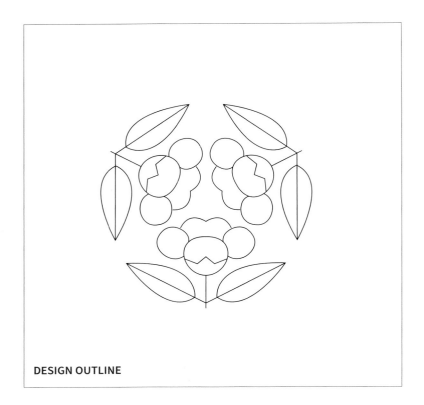

DESIGN OUTLINE

Leaf padding outlines

6 GREEN JAPANESE GINGER PLANT, PAGE 82

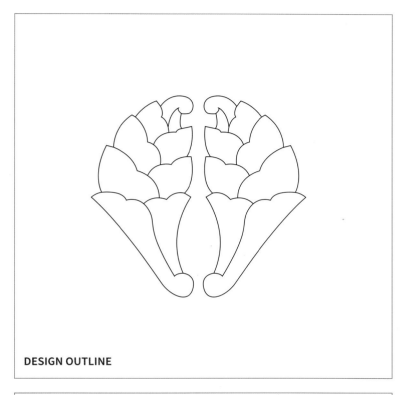

DESIGN OUTLINE

Segment padding outlines

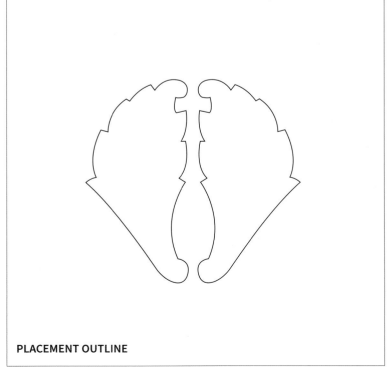

PLACEMENT OUTLINE

Segment 4 leather outlines

7 ORANGE CHRYSANTHEMUMS, PAGE 90

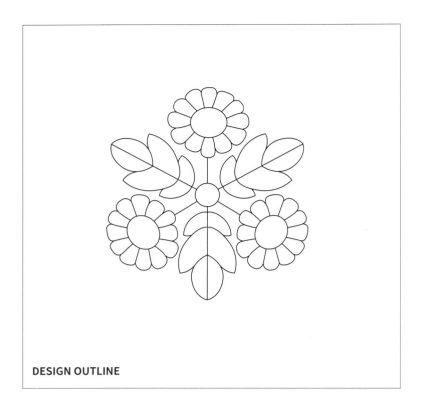

DESIGN OUTLINE

Flower centre padding outlines Flower centre leather outline Centre circle padding outline

8 CHERRY BLOSSOM AND LADYBIRD, PAGE 98

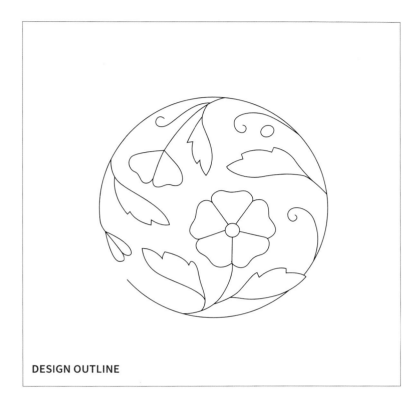

DESIGN OUTLINE

Detached bud petal outline

Detached flower petal outline

Detached wing-cases outline

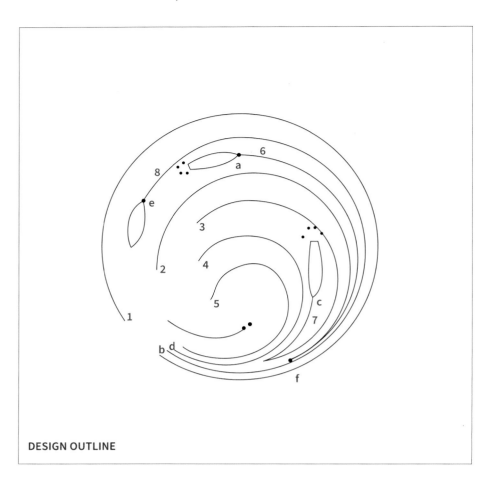

DESIGN OUTLINE

DETACHED PETALS – RIGHT IRIS

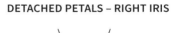

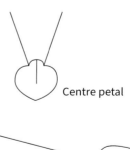

Centre petal

Left-side petal

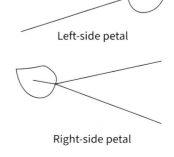

Right-side petal

MAYFLY DETACHED WING OUTLINE

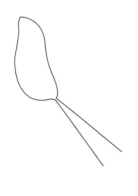

DETACHED PETAL OUTLINES – LEFT IRIS

Centre petal

Right-side petal

Left-side petal

10 PEONY AND BUMBLE BEE, PAGE 122

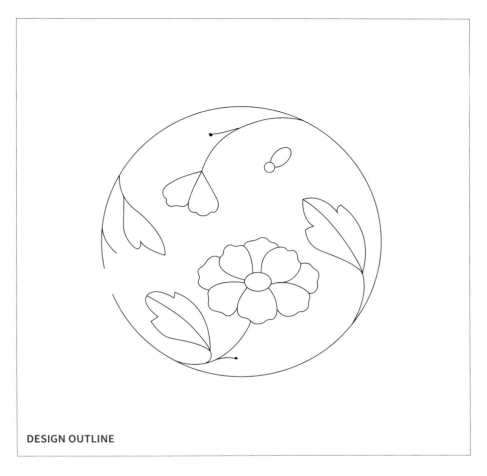

DESIGN OUTLINE

DETACHED LEAF OUTLINES

Upper detached leaf outline

Right detached leaf outline

Lower detached leaf outline

DETACHED PETAL OUTLINES

Centre petal

Centre-side petal

Outer petal

Bud petal

DETACHED BEE WING OUTLINES

Forewings

Hindwings

WEB DIAGRAM

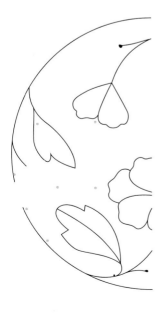

DESIGN OUTLINE

**PLACEMENT OUTLINE FOR
PRAYING MANTIS**

Detached leaf outline

Lotus-bud padding outline

Detached lotus-petal outline

Detached bud sepal outlines

Lotus seed-pod padding outlines

Detached mantis-wing outlines

12 MORNING GLORY AND GRASSHOPPER, PAGE 156

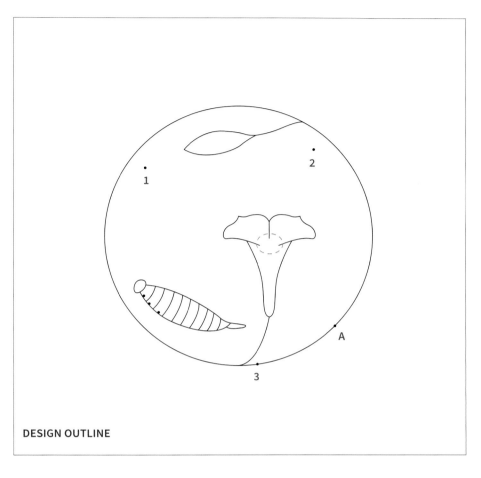

DESIGN OUTLINE

**GRASSHOPPER –
DETACHED WING OUTLINES**

Forewing

Hindwing

**GRASSHOPPER –
SURFACE WING OUTLINES**

Forewing

Hindwing

**GRASSHOPPER –
LEATHER COLLAR SHAPE**

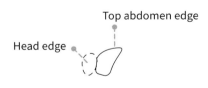

Top abdomen edge

Head edge

DETACHED LEAF OUTLINES

1 2 3

**GRASSHOPPER –
DETACHED LEG OUTLINES**

Front leg Middle leg

Back leg

MORNING GLORY BUD PADDING

**MORNING GLORY – DETACHED FLOWER-
PETALS OUTLINE**

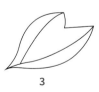

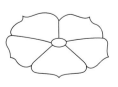

BIBLIOGRAPHY AND FURTHER READING

I have referred to the following for information and inspiration:

The Matsuya Piece-Goods Store. *Japanese Design Motifs: 4260 Illustrations of Japanese Crests*. Dover Publications Inc., New York, 1972.

Amstutz, Walter. *Japanese Emblems and Designs*. Dover Publications Inc., New York, 1994.

Bailly, Sadrine. *Japan, Season By Season*. Abrams, New York, 2009.

Baird, Merrily. *Symbols of Japan*. Rizzoli International Publications, Inc., New York, 2001.

Dower, John. *The Elements of Japanese Design*. Weatherhill, Boston, 1971.

Earle, Joe. *Japanese Art and Design*. V&A Publications, London, 1986.

Jackson, Anna. *Japanese Textiles*. V&A Publications, London, 2000.

Kaiyama Kyusaburo. *The Book of Japanese Design*. Crown Publishers Inc., New York, 1969.

Lowenstein, Tom. *Haiku Inspirations*. Duncan Baird Publishers, London, 2006.

Motoji Niwa. *Japanese Traditional Patterns (1)*. Graphic-sha Publishing Company Ltd., Tokyo, 1990.

EMBROIDERY

Christie, Grace. *Samplers and Stitches*, B T Batsford, London, 1920.

Enthoven, Jacqueline. *The Stitches of Creative Embroidery*, Reinhold Publishing, New York, 1964.

Thomas, Mary. *Dictionary of Embroidery Stitches*, Hodder and Stoughton, London, 1934.

GOLDWORK

Chamberlin, Ruth. *Beginner's Guide to Goldwork*. Search Press Ltd, Great Britain, 2006.

Dawson, Barbara. *The Technique of Metal Thread Embroidery*. B T Batsford Ltd, London, 1982.

Dean, Beryl. *Ecclesiastical Embroidery*. B T Batsford Ltd, London, 1958.

Everett, Hazel. *Goldwork Techniques, Projects and Inspiration*. Search Press Ltd, Great Britain, 2011.

Lemon, Jane. *Metal Thread Embroidery*. B T Batsford Ltd, London, 1987.

STUMPWORK

Nicholas, Jane. *Stumpwork Embroidery A Collection of Fruits, Flowers, Insects*. Milner, Australia, 1995.

Nicholas, Jane. *Stumpwork Embroidery Designs and Projects*. Milner, Australia, 1998.

Nicholas, Jane. *Stumpwork Dragonflies*. Milner, Australia, 2000.

Nicholas, Jane. *Stumpwork, Goldwork & Surface Embroidery Beetle Collection*. Milner, Australia, 2004.

Nicholas, Jane. *The Complete Book of Stumpwork Embroidery*. Milner, Australia, 2005.

Nicholas, Jane. *Stumpwork Medieval Flora*. Milner, Australia, 2009.

Nicholas, Jane. *Stumpwork Embroidery – Turkish, Syrian and Persian Tiles*. Milner, Australia, 2010.

Nicholas, Jane. *Stumpwork Butterflies & Moths*. Milner, Australia, 2013.

Nicholas, Jane. *Shakespeare's Flowers*. Milner, Australia, 2015.

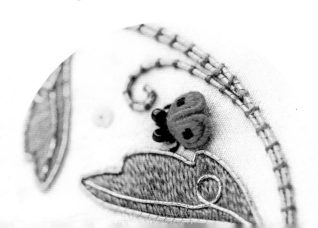

CREDITS

The *mons* included on the project opener pages for each of the 12 projects are from *Japanese Design Motifs : 4260 Illustrations of Japanese Crests.* Compiled by the Matsuya Piece-Goods Store. Dover Publications, New York, 1972.

Butterfly *mon*, pages 31 and 41
Japanese Design Motifs, page 155.

Chrysanthemums *mon*, page 91
Japanese Design Motifs, page 178.

Butterfly *mon*, page 53
Japanese Design Motifs, page 153.

Cherry-blossom *mon*, page 99
Japanese Design Motifs, page 168.

Japanese design motifs featuring the butterfly, page 53
Japanese Design Motifs, page 154–155.

Iris *mon*, page 109
Japanese Design Motifs, page 72.

Butterfly *mon*, page 65
Japanese Design Motifs, page 154.

Peony *mon*, page 123
Japanese Design Motifs, page 28.

Plum-blossom *mon*, page 75
Japanese Design Motifs, page 110.

Lotus *mon*, page 137
Japanese Design Motifs, page 24.

Ginger plant *mon*, page 83
Japanese Design Motifs, page 189.

Morning glory *mon*, page 157
Japanese Design Motifs, page 166.

Images provided by the Victoria and Albert (V&A) Museum are from Earle, Joe. *Japanese Art and Design*. V & A Publications, London, 1986.
© Victoria and Albert Museum, London

Kimono for a woman, page 10
Victoria and Albert Museum FE.11-1983
Plate 56, Page 91.

Shop door-curtain (*noren*), page 11
Victoria and Albert Museum FE.50-1982
Plate 170, Page 174.

INDEX